from bauhaus to aspen

from bauhaus to aspen
herbert bayer and modernist design in america

gwen f. chanzit

With a Note on Herbert Bayer and
the Denver Art Museum by
Daniel Libeskind

Co-published with the Denver Art Museum

Johnson Books
BOULDER

Originally published in 1987 by University Microfilms Inc.,
Ann Arbor, Michigan 48106

Published by Johnson Books, a subsidiary of Big Earth Publishing,
1880 South 57th Court, Boulder, Colorado 80301.
Visit our website at www.JohnsonBooks.com. E-mail: books@jpcolorado.com.
Co-published with the Denver Art Museum.

Cover design by Mary Junda
Cover image: Herbert Bayer, *in search of times past*, 1959,
 mixed media photocollage comprised of gelatin silver prints, half tone
 elements, and hand applied gouache and black ink. 9 1/2 × 13 3/8 inches,
 The Ginny Williams Family Foundation, The Collection of Ginny Williams.
All Herbert Bayer images reproduced in this book are copyright Herbert Bayer Estate
 © 2004 Artists Rights Society (ARS), New York / VG Bild-Kunst, Bonn

9 8 7 6 5 4 3 2 1

Library of Congress Cataloging-in-Publication Data
Chanzit, Gwen Finkel, 1948–
 [Herbert Bayer and modernist design in America]
 From Bauhaus to Aspen: Herbert Bayer and modernist design in America / Gwen
F. Chanzit.
 p. cm.
 Previously published: Herbert Bayer and modernist design in America. Ann
Arbor, Mich.: UMI Research Press, c1987
 Includes bibliographical references and index.
 ISBN 1-55566-329-X
 1. Bayer, Herbert, 1900– 2. Artists—United States—Biography. 3. Modernism
(Art)—United States. I. Title: Herbert Bayer and modernist design in America.
II. Title.
 N6537.B24C5 2005
 709'.2—dc22 2004023586

Printed in the United States

To Richard and Adam

Contents

Figures

Works by Herbert Bayer, © 2004 Artists Rights Society (ARS),
New York / VG Bild-Kunst, Bonn

Color Plates

All Works by Herbert Bayer, © 2004 Artists Rights Society (ARS), New York / VG Bild-Kunst, Bonn

1. Beadwork Design, 1923/30
2. *schwebende plastik*, 1925/8
3. Mural for Stairwell, Bauhaus Building, Weimar, 1923
4. Design for a Newspaper Kiosk, 1924
5. Bauhaus Circle of Friends Letterhead, 1925
6. Study for "universal type," 1925
7. *a wind system*, 1939/29
8. *interstellar exchange*, 1941/2
9. Brochure for Herbert Bayer Design Studio, New York City, ca.1940
10. *Harper's Bazaar* magazine cover, 1940
11. *window by the desk*, 1944/44
12. *unfolding stratum*, 1944/33
13. Untitled ("herd of sheep along curves of mountains"), ca.1948
14. Untitled (landscape studies), 1948
15. Untitled (sketches for butterfly paintings), ca.1947
16. *sketches for butterfly paintings*, 1947/76
17. Untitled (Independence Pass), 1948
18. *sketch for butterfly paintings*, 1947

A Note on Herbert Bayer
and the Denver Art Museum
by Daniel Libeskind

Herbert Bayer is a fascinating figure. He connects the laboratory of modernism in the Bauhaus with a new horizon. Particularly consequent is his struggle to transform the political and social context of Weimar and Dessau to the vital marketplace of American democracy.

He does to 2-D graphic and design work what Mies van der Rohe did to architecture. And what better homage to this illustrious figure than to have found a home in Colorado at the cutting edge of the Rockies.

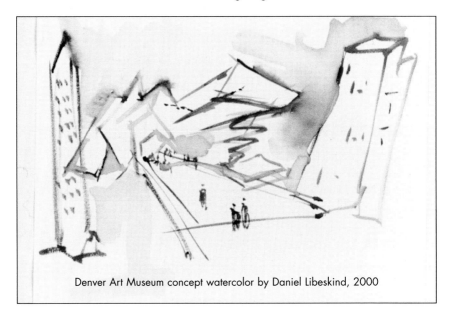

Denver Art Museum concept watercolor by Daniel Libeskind, 2000

The Herbert Bayer Collection and Archive

The Denver Art Museum's Herbert Bayer Collection and Archive is an extensive and unique repository of works by and about Herbert Bayer who was first a student and later a master at the Bauhaus. Founded in 1980, this Collection and Archive contains around 8,000 works of art and design as well as extensive documentary material, much of it unpublished. Every period of the artist's lengthy and multifaceted career is represented.

Cataloging System
Herbert Bayer Collection and Archive
Denver Art Museum

b Books, catalogs, announcements, pamphlets, magazines, documents
 (Advertising brochures and pamphlets, see gr. 3)
 b.1 Books by Bayer about his work
 b.2 Books, pamphlets, and non-art exhibition catalogs with design work by Bayer
 (graphics, typography, jacket) or reproducing his work in another context
 b.3 Books and pamphlets devoted to Bayer
 b.4 Books and pamphlets referring to Bayer or including selections from his writing
 b.5 Assorted books from Bayer's personal library
 b.6 Catalogs and brochures of Bayer's one-artist exhibitions or exhibitions
 designed by Bayer
 b.7 Catalogs and brochures of group exhibitions that include Bayer
 b.8 Exhibition catalogs and brochures about other artists from Bayer's personal
 library
 b.9 Announcements and invitations to Bayer's exhibitions (one-artist and group);
 other announcements designed by Bayer
 b.10 Periodical and newspaper articles featuring Bayer or his writing
 b.11 Other periodical and newspaper articles and clippings from Bayer's personal
 library
 b.12 Documents and literature about *50 Jahre Bauhaus*
 b.13 Corporate and nonprofit organization publications designed by Bayer
 b.13a ARCO business reports
 b.13b ARCO publications unrelated to business
 b.13c Aspen Institute for Humanistic Studies publications
 b.14 Documents relating to Herbert Bayer Collection and Archive, Denver Art
 Museum
 b.15 Bayer's appointment datebooks
 b.16 Books acquired after Bayer's death relative to him, but not solely on him

de Designs for Bayer's large-scale projects (including site maps and photographs used in
 the design process)
 de.1 Aspen projects
 de.2 ARCO and Anaconda projects
 de.3 Other large-scale projects

dr Drawings, including pastels and drawings with color washes
 (Drawings for graphic designs, see gr. 2)
 (drawings for exhibition designs, see ex)
 (drawings for furniture, see f)

ex Exhibition design
 (Exhibition models, see sc)

f Furniture design

gr Graphics
 gr.1 Original prints
 gr.2 Original graphic designs for advertisements, illustrations, posters, packaging,
 and logos
 gr.2a Logos for the Broadmoor Hotel (Colorado Springs) and all promotional
 designs for skiing and recreation
 gr.2b Jamestown Festival designs
 gr.2c Preliminary drawings for *world geo-graphic atlas*
 gr.3 Advertisements, magazine illustrations, posters, packaging, and other graphics
 in printed and manufactured form
 gr.3a Container Corporation of America, Great Ideas series
 gr.3b Other CCA advertisements
 gr.3c Noreen advertisements and packaging
 gr.3d Chlorodont advertisements
 gr.3e Personal Christmas cards
 gr.3f Stationery, business cards, postcards, menus, etc.
 gr.3g Magazine and catalog covers, book jackets
 gr.3h Aspen travel brochures
 gr.3i Large posters
 gr.3j ARCO, The Ideal/The Real series
 gr.3k Graphics designed by other artists from Bayer's personal collection

p Paintings, including watercolors
 (color washes over drawings, see dr)
 (painted preliminary studies for graphic designs, see gr.2)

ph Photography
 ph.1 Fine art photography
 ph.2 Photographic documents of places, buildings, sculpture, objects, and events
 (photographic documents of exhibitions, see ex)
 (working site photographs used in design projects, see de)

sc Sculpture and models

t Textiles and jewelry
 t.1 Designs for textile patterns
 t.2 Pattern-generating devices
 t.3 Fabric samples
 t.4 Designs for clothing and jewelry
 t.4a "Aspen silver" designs
 t.5 Tapestry
 t.6 Jewelry

ty Typography
 ty.1 Original designs for typography
 ty.2 Printed typography

Additional documentary material is filed in the Archive, but not cataloged by the system above

Preface to the 2005 Edition

Many changes have taken place since the first publication of this volume in 1987. Most spectacularly, the fall of the Berlin wall in 1989 opened new lines of communication throughout a reunified Germany, offering easy access to archival material that today yields fresh scholarship on the Bauhaus. On a more personal note, last year Joella Bayer passed away at the age of 96. For many years after her husband's death in 1985, Joella continued to keep the Herbert Bayer Studio and efficiently manage myriad responsibilities, as she had for so many years. Two sons, Javan Bayer of Denver and Jerrold Levy of Tucson, preceded their mother in death, passing away within six months of each other in 2001 and 2002. When Joella Bayer moved from the house and studio she and Herbert maintained in Montecito, Javan and his wife Britt took on the responsibilities with organization, good will, and a sense of humor. Today, the last of the immediate family, Jonathan Bayer, admirably carries on the many responsibilities of the Bayer estate from his London base.

Other changes include the remarkable burgeoning of the Denver Art Museum's Herbert Bayer Collection and Archive from around 2,000 long-term loans from Herbert Bayer at its formation in 1980, to a current permanent collection of some 8,000 accessioned works in all media, plus extensive documentary materials; to my knowledge, this is the largest repository of a single Bauhaus artist. Within two years of Herbert Bayer's death, Joella Bayer gifted many paintings, drawings, and archival materials; in subsequent years she followed with substantial gifts of art in 1991, 1997, and 2003. Last year, the bulk of her remaining work was bequeathed to the Collection and Archive, along with documents and files from the Herbert Bayer Studio.

Another big change since 1987 came with the sale of the Atlantic Richfield Company (ARCO) to BP Corporation, and the dispersal of the ARCO collections. Although some Bayer art from ARCO collections found their way to the auction houses, many very significant gifts came to the Herbert Bayer Collection and Archive. Notable among these, the most significant and exemplary collection of Bayer's work—assembled by the artist to represent his

full oeuvre, has come, intact, from the Breakers (ARCO's former executive training center in Santa Barbara; see chapter 9). The beautifully-sited *walk in space painting* remains on the grounds of the Breakers, now owned by the Biltmore Hotel. Bayer's *double ascension* has recently been repainted, remaining on the site of the former ARCO Plaza in Los Angeles. The *chromatic gate* across from the public beach at Santa Barbara, funded and championed by Bayer admirers after his death, remains a popular landmark. Happily, the smart renovations at the Aspen Institute for Humanistic Studies in Aspen, Colorado, continue Bayer's vision and spirit.

Scholarship on Bayer has increased proportionate to the growing history of design in general, and of the art and design of the Bauhaus in particular. When I first undertook this study, I acknowledged its pioneering spirit in the hope that others would follow. At the time of the original publication, there were only a handful of major texts—Bayer's own then-twenty-year-old *Herbert Bayer, Painter, Designer, Architect*; and Arthur Cohen's perceptive *Herbert Bayer: The Complete Work*, written at the same time my book was in process. Of additional note are two fulsome Bauhaus-Archiv exhibition catalogs on Bayer (1982 and 1986) and Bernhard Widder's fine and beautifully illustrated volume on Bayer's architecture, sculpture, and earthworks, *Herbert Bayer, Architektur / Skulptur / Landschaftsgestaltung* (2000). I also published the 288-page *Herbert Bayer Collection and Archive at the Denver Art Museum* in 1988, which now records only about a third of our current holdings.

This new edition, co-published by the Denver Art Museum and Johnson Books, retains my original text from 1987. (Readers may note some of the changes referred to above: at the Aspen Institute renovations included replacing Bayer's music tent and chalets, and relocating his *kaleidoscreen*; the sale of the Atlantic Richfield Company to BP Corporation led to the dispersal of art from all ARCO offices worldwide.) New technology and additional funding allow me to add, in this edition, a large section of new color images—an important addition to a study on Bayer, who made a meticulous, lifelong study of color.

As the Denver Art Museum looks forward to occupying its new Frederic C. Hamilton Building, designed by world-renowned architect Daniel Libeskind, we anticipate installing many more selections from the extraordinary Herbert Bayer Collection and Archive. I am grateful to Daniel Libeskind for his contribution to this volume and I look forward with excitement and anticipation to seeing Bayer's work in this important twenty-first century museum space. I feel certain that Bayer, himself, would have welcomed the opportunity to install in Libeskind's dynamic spaces.

I am indebted to the University of Michigan Research Press (UMI) and Stephen Foster for enabling this study to first go to press in 1987. I thank the

Denver Art Museum and Johnson Books for this republication. This edition would not have been possible without the generous funding of Patty Cadby Birch, a wonderful individual to whom I owe a debt of gratitude. Denver Art Museum Director Lewis Sharp and Chief Curator Timothy Standring have been supportive at every turn of this project. Special thanks go to the Mark and Polly Addison Curator Dianne Vanderlip for all her support over the past twenty-four years; to Michael Johnson, who lent assistance with numerous details involving the Bayer Collection; and to Vicki Aybar-Sterling, Sharon Kermiet, Stephanie Sibley, Angela Steinmetz, and Charles Pietraszewski, all of the Denver Art Museum. I owe special thanks to Denver Art Museum head of photography, Carole Lee, and to photographer Jeff Wells, who deserves enormous thanks for the outstanding color photographs that make up the new section in this book. Kirbie Crowe and Karen Ruthberg assisted in numerous photographic reproduction tasks. Both the University of Denver and the Denver Art Museum provided a three-month sabbatical in support of this project, for which I am grateful. At Johnson Books, I thank Jerry Johnson and Mira Perrizo for believing in republishing *Herbert Bayer and Modernist Design in America* and for allowing me to undertake the project; Robert Sheldon and Stephen Topping also provided important advice and expertise. My research at the Wolfsonian-Florida International University was aided by Francis Luca and Nicholas Blaga; Melissa Smith Levine was helpful in providing rights to documentary photographs now in the collection of the Wolfsonian-Florida International University. Many thanks to Silvia Ros, who skillfully produced photographs of those exhibition design documents.

Special, warm thanks go to Jonathan Bayer, Miranda Townsend, and Britt Bayer, whom I consider close personal friends. I thank my husband, Richard, and son, Adam, for their love and encouragement in this and every venture. As in 1987, I am indebted to many people for numerous kinds of assistance; any errors or omissions are my own.

Gwen F. Chanzit
Denver, Colorado
2005

Acknowledgments

I owe debts to many people who helped make this study possible. First, Stephen Foster's advice, insight, and encouragement over the years have been invaluable. His example has served to inspire, and his direction and belief in my work have been important to me, beyond measure.

My interest in Herbert Bayer's work intensified in 1980 when I was hired by the Denver Art Museum to organize a Herbert Bayer Collection and Archive from some 2500 objects that the artist had given the museum. I am especially indebted to Dianne Perry Vanderlip, Curator of Contemporary Art, who believed in me enough to hire me and to allow me independence to develop the project, and eventually to curate the collection. The entire Denver Art Museum staff deserves my thanks for assistance in ways too many to enumerate. I especially thank Lewis Story, Associate Director, and Marlene Chambers, Director of Publications, for their advice and encouragement. Also I am grateful to Lloyd Rule and Cynthia Nakamura of the photography department for their continued assistance. Needless to say, my work could not have been done without access to all of the materials contained in the Herbert Bayer Collection and Archive.

My work also would have been impossible without the warm and generous support of Herbert and Joella Bayer. Over the past several years they graciously opened their files, their home, and their lives to me. Access to Bayer's private sketchbooks was especially valuable, as were the many illuminating discussions I had with them both. I think of them with gratitude and warmest feelings. Herbert Bayer, born in 1900, died in 1985, shortly after this study was completed. His passing was a great loss, especially to the world of art and design. Joella Bayer continues her energetic support in numerous ways for which I am grateful.

My research was greatly facilitated by the Kress Travel Grants awarded me by the faculty of the University of Iowa in 1982 and 1983. I thank them for their support. David De Harport also deserves thanks for his able work in producing much of the photography for this study. I am also indebted to

the late Arthur A. Cohen for generously providing preliminary, unedited transcripts of his long interviews with Herbert Bayer (an oral history program of the Archives of American Art) undertaken in preparation for his book, *Herbert Bayer, The Complete Work* (MIT, 1984). I enjoyed our discussions about Bayer's work and greatly regret his passing.

The staffs of several institutions were helpful in providing materials for research. Acknowledgment is made to the library of the University of Illinois at the Chicago Circle Campus where I was allowed access to the Manuscript Collection's material relating to the Institute of Design/New Bauhaus, Chicago. The staff of the Museum of Modern Art, New York, was particularly helpful, especially since my research in 1982 took place during the renovation of their facility. The departments of the Registrar, Exhibitions, and Photography were generous with their time and with their files which were critical to my understanding of Bayer's exhibition design. I also thank the staff of the Museum of Modern Art Library for help in finding important material related to Bayer and the Bauhaus. I am grateful to all of these people for their assistance. Any errors and shortcomings in this study are my own.

I thank my parents for their unfailing love and encouragement. The loving support of my husband Richard and son Adam has meant everything, especially during the absences which this work required of me.

Author's Note

Herbert Bayer's belief in a unitary alphabet lead him to adopt the practice of using only lowercase letters. In both business and personal use, Bayer continued throughout his life to adhere to this practice. Hence, titles of Bayer artwork and direct quotes from his writing appear here in lower case. The exception to Bayer's lower case rule is the personal pronoun, "I," which Bayer eventually readmitted into writing because he felt it was more readable than the peculiar looking solitary "i." In this volume I have adhered to the editorial practice of each individual source, duplicating the case as it appears in the original version.

Titles of paintings, drawings, and sculpture by Bayer are followed in the list of figures and in the captions by a year and a number. Bayer devised this method of identification as a personal inventory system. The number following the date indicates the position of the work within that year's production. For example, *shadow of a line,* 1981/13 was the thirteenth painting of the year 1981.

Bayer's prolific and multidisciplinary work has encouraged numerous written responses, and from many sectors, some well apart from those usually concerned with the art world. The result is a plethora of disparate written material referencing Bayer. The attached bibliography should not be considered comprehensive, but is a selected bibliography of sources germane to the present study.

Herbert Bayer, 1982
(Photograph by Jim McHugh)

from bauhaus to aspen

Prologue

Herbert Bayer's position in American art and design is unique. A former Bauhaus student and master in Germany, Bayer did not belong to any artistic circle in America. Bayer practiced Bauhaus directives more consistently than any other of his Bauhaus colleagues. He never limited himself in media, preferring to work across traditional lines to infuse modern life with integrated systems of design at every level. In the United States, Bayer worked independently, maintaining ties with his former Bauhaus associates, but seeing them only rarely. Despite the fact that Bayer was trained at the Bauhaus and that he worked for several years in New York City, he was associated with major artistic centers only early in his career. Most of his American years were spent in Aspen, Colorado, a small town isolated in the Rocky Mountains, and only recently a cultural center in its own right.

Bayer's activities were hardly those of a recluse. Yet rather than taking his place in a large art center, Bayer worked independently within the circle of big business where he became artistic "guru" to corporate leaders.[1] Bayer's Bauhaus-inspired commitment to integrating good design into all sectors of modern life led to important collaborations with American industry, the kind of collaboration that had been encouraged at the Bauhaus. The late 1940s were an extremely fortuitous time for him to enter American business circles. In the postwar climate of optimism and wealth, Bayer's expertise was eagerly sought by energetic corporate magnates.

Bayer lived in Aspen beginning in 1946 (sometimes commuting to Chicago) and became indispensable in the plans of Walter Paepcke, chief executive of the Chicago-based Container Corporation of America. He was instrumental in realizing Paepcke's dream of effecting a union of art and industry within Container Corporation and in the historic mining town of Aspen, where Paepcke hoped to create a quasi-utopian, educational/cultural retreat for business executives. At Aspen, Bayer played a seminal role as designer and educator at the Aspen Institute for Humanistic Studies. He designed the physical structure of the Institute and had a key part in developing forums

on cooperation between art and industry and on the role of the arts in society. Aspen provided an idyllic setting where artists and businessmen could meet on equal terms. Bayer was admired for his work at Aspen, and his high-level position at Container Corporation earned him the respect not only of certain artists, but also of businessmen who sought his advice on the grounds of the Institute.

After leaving Container Corporation in 1965, Bayer put his expertise at the service of the Atlantic Richfield Company, spearheaded by its chairman, Robert O. Anderson, whom Bayer had met through the Aspen Institute. Because of his involvement with these two corporations at the highest level of decision-making, Bayer was able to implement on grand scale many of his ideas about art in society.

Although Bayer operated from a position of influence within corporations, he was quite distant from most of the American art world, headquartered in New York City. For many years a dichotomy grew: according to those in corporate circles, Bayer was an internationally celebrated, major artistic innovator. Among the *cognoscenti* of contemporary American art, however, Bayer was not given the serious consideration he deserved. Only recently, since "design" and "corporate art" have finally become acceptable within serious art circles, has Bayer's work begun to be reevaluated.

Assessing Bayer's artistic career in America requires the reconciliation of these two disparate views of the artist and a determination of his correct position within the context of American art and design. Was Bayer unfairly neglected because of his separation from the mainstream art community? Were the uninitiated corporations prematurely adulating the first person who introduced them to good art and design? Was Bayer an "artist's artist," one to whom other artists looked for direction even though his own work was largely undervalued by critics and writers? Perhaps until recently the American art world was not ready to openly accept an artist who approached the design of tapestries and office louvers with the same seriousness as the creation of a painting on canvas. The art world may not have been able to place its trust in a man who worked simultaneously across a gamut of artistic endeavors, many of which produced functional works in the service of society. Sorting out these discrepancies in the assessment of Herbert Bayer's oeuvre constitutes the major thrust of the present study.

In evaluating Bayer's contributions to American art and design, I will commence with a brief look at the European background that provided his early training, his important Bauhaus experience, and his first professional work. I then will consider Bayer's later activity, analyzing his American experience, which began in exhibition design and continued in graphics, typography, environmental design, architecture, painting, and sculpture. After examining

individual areas of the artist's oeuvre, I will attempt to assess Bayer's historical position in the development of twentieth-century American art and design, reaching the ultimate conclusion that Bayer's greatest impact lay in the transmission, adaptation, and application of European avant-garde design principles to this country.

This evaluation has been particularly difficult due to a dearth of comparative material. Although much has been written on Herbert Bayer, substantial "literature" is still limited. Of well over a hundred articles on Bayer, only a handful probe beyond a superficial account of his work. Perhaps because of his unique position in a wealthy and glamorous resort town and in large powerful corporations, the media has been inclined to simply feature this artist as they would a well-known celebrity. Until very recently, even serious writing about Bayer did not yield much of substance. An occasional exhibition catalog provided good, if limited information. Bayer's own book, *herbert bayer, painter, designer, architect,* (Reinhold, 1967) provided important documentation although, necessarily, without critical analysis. Finally, some excellent new sources have appeared in the past few years (see Cohen, *Herbert Bayer, The Complete Work,* and two catalogs published by the Bauhaus-Archiv, Berlin, 1982 and 1986).[2] Yet with some exception, even this newer treatment has not gone much beyond providing a linear account of Herbert Bayer's life and accomplishments. Perhaps Bayer's tremendous range of artistic achievements over more than sixty years has so obfuscated standard critical categories that commentators have felt justified in isolating his accomplishments and treating them separately. But such "tunnel vision" does not best serve Bayer or an understanding of the milieu in which he worked. It may also explain how surveys of modern art could have largely overlooked Bayer while material specifically on Bayer considered him to be a major innovator in graphic design and typography, exhibition design, environmental design and sculpture, and design within corporations. These viewpoints need to be reconciled and the issues clarified.

Bayer's geographic isolation from the major American artistic centers, as well as from the historians and critics who determine which artists receive attention in serious artistic circles, certainly contributed to his lack of proper recognition. Bayer also may have unwittingly contributed to the problem. Authors who requested information were referred to a file of carefully worded "statements." Published interviews often were edited by the artist, and he even frequently had a hand in choosing who wrote about his work.[3] Bayer's energy, involvement, and thoroughness were his strengths, but perhaps his active role in working closely with authors may have actually hindered the best critical assessment of his work. Bayer's involvement may have been a logical result of the unusually important decision-making positions that he held.

He had so much more influence than most artists in guiding corporate direction that it probably seemed only natural to him to have a part in what was written about him as well. To complicate matters, it was not until quite recently that corporate patronage and the entire field of design were given serious attention among scholars. Perhaps Bayer's reputation, while advancing within the corporate structure, suffered within scholarly circles because of the very positions that enabled him to become influential.

This study applauds Bayer's important role as a transmitter and adapter of European modernist design to the United States. Whether he was the sole originator of each principle he fostered is less significant than the critical role he played in bringing those principles to American design, and in the subsequent transformation of design in this country.

Recognizing the deficiencies in the literature on Herbert Bayer and on the history of modern design in America, the present study attempts to break new ground, to place Bayer among his contemporaries in American art and design, to distinguish his accomplishments from those of others, and to consider his place in history, with the hope and expectation that it will be followed by subsequent studies building upon this and other preliminary works.

1

Herbert Bayer and the Bauhaus

Herbert Bayer's adult life was shaped by the experience of the Bauhaus. It is impossible to imagine the direction his career might have taken without the lessons of that school. Even more than other Bauhaus artists, Bayer committed himself to the school's doctrine of integrating good design into *all* facets of modern life. Working within the structures of modern society, Bayer recognized that industry and the machine were integral to it. Bayer worked in a multiplicity of media, including painting, photography, typography, sculpture, architecture and interior design, exhibition design, and graphic design, in all of them working towards fulfilling his desire to create well-designed, integrated environments. Comparing the diversity of his artistic output with that of other former Bauhaus artists, Bayer's use of a variety of media without regard to traditional distinctions between the so-called "fine" and "applied" arts stands out. He went beyond others in embracing Bauhaus goals in his integrated designs for entire buildings and architectural complexes.

It is useful to consider why, after only a few years at the Bauhaus, Bayer should have devoted his entire adult life to its vision. Two factors suggest plausible reasons for his commitment, one relating to Bayer's background before he came to the Bauhaus and the other to Bayer's career experience in the United States. The first factor allowed the young artist to be particularly amenable to the Bauhaus philosophy, and the second enabled him to carry it through in practical application.

By Bayer's own statement, he came to the Bauhaus quite naïve and unschooled in the arts. He had grown up in a rural Austrian mountain environment and although he had intended to study art at the academy in Vienna, his father's premature death in 1917 negated that possibility.

In lieu of art school, Bayer became an apprentice, first under the architect Georg Schmidthammer in Linz, Austria, and then under the architect Emanuel Margold in Darmstadt, Germany.

i was enthusiastic at every opportunity of seeing the creations of the "viennese seces-sion" and of the "viennese workshops." anything i learned of art or art history i gathered from a few books. i entered the arts and crafts workshop of architect schmidthammer in linz, as an apprentice for a design career. here i at once came face to face with some of the issues of my later interests. i became aware of names like gustav klimt and egon schiele, architect hans hoffman [sic] and the "werkbund." lacking further opportunities in an austrian provincial town, in 1919 i moved to darmstadt, germany, to work with the ar-chitect emanuel margold, of the viennese school, at the artists colony on the "mathildenhöhe." i arrived there in lederhosen and set to work among the art nouveau buildings in the wake of the "art decorative" artists, who had gathered there at the invita-tion of the art-minded prince of hessen before world war I.[1]

Although Bayer was introduced at an early date to relevant fields of design such as package design, design of interior spaces, mosaics, and graphics (then of a "decorative expressionist style"),[2] he became dissatisfied with current solutions to these issues and with "the superficial, beautifying and decorating attitude."[3] Already the young artist seemed to be searching for a more integrated, relevant approach to problems of design. It was precisely this approach that would become the hallmark of the Bauhaus.

During Bayer's apprenticeship with Margold in Darmstadt,[4] the artist at-tended a weekly gathering of friends for intellectual stimulation and exchange of ideas. For the first time, Bayer was introduced to Wassily Kandinsky's book, *Concerning the Spiritual in Art,* which had been published in late 1911.[5] At the same time Bayer saw the visionary proclamation with the Feininger wood-cut announcing the new art school at Weimar and mistakenly assumed that Kandinsky was already there (Kandinsky, in fact, did not arrive at the Bauhaus until 1922). The influence of Kandinsky's book combined with the publicity about the new art school, including an exaggerated rumor about admittance procedures told to Bayer by Margold,[6] excited Bayer sufficiently to give up his apprenticeship and to leave Darmstadt for the Bauhaus at Weimar. This action was no small commitment, as he had no financial resources, only a firm affinity for the ideas to which he had just been introduced.

Reading Kandinsky's little book, one is struck by the flowery prose and quixotic idealism of its message. It seems difficult to reconcile these metaphysical, lofty ideas with Herbert Bayer's later practical applications. It would be easy to explain his excitement by the fact that Bayer was still a country boy from Austria in his late teens when he first read Kandinsky's book, and that he had not yet been exposed to much in the way of sophisticated formal art theory or practice. Yet beyond this facile explana-tion, it is interesting to realize that Kandinsky's book must have elicited a fun-damental but latent response from Bayer. Hindsight allows us to recognize that throughout Bayer's career there was always a side of the artist—

seemingly anomalous considering his productivity in sophisticated corporate circles—that retained the fresh naivete of youthful idealism and simple pleasures. This more spiritual side of the artist may be responsible for the freshness of his artistic life even after six decades of production, and may be what he found about studio painting that revitalized his creative faculties, enabling him to return to other projects, renewed.[7]

The seeds of Bayer's ideas about art for the betterment of society are found in Kandinsky's idealist theories presented in *Concerning the Spiritual in Art.* Of course, the premise that the arts can and should serve society was also a primary tenet of the Bauhaus itself. Comparing some ideas presented by Kandinsky with later statements by Bayer is instructive. In doing so, we see how close in thought Bayer was to Kandinsky and just why it is no accident that he, to the end of his life, considered Kandinsky his primary mentor.

Kandinsky outlined the artist's responsibility to his public in terms of a threefold duty:

> The artist is not born to a life of pleasure. He must not live idle; he has a hard work to perform. . . .
>
> The artist has a triple responsibility to the non-artists: (1) He must repay the talent which he has; (2) his deeds, feelings, and thoughts, as those of every man, create a spiritual atmosphere which is either pure or poisonous. (3) These deeds and thoughts are materials for his creations, which themselves exercise influence on the spiritual atmosphere. The artist is not only a king, as Peladan says, because he has great power, but also because he has great duties.[8]

Bayer, in a statement of 1979, concurred: "the bauhaus implanted in me such a sense of duty, you see, not just to go and paint for my own pleasure, but to devote myself to dealing with the design problems of our time."[9] In 1980, Bayer asserted, "the artist of our time cannot afford to be entirely self-indulgent in his work, but has responsibilities in the shaping of our visual world."[10]

Both in his writing and in the 1923 collage *mit kopf, herz und hand* (fig. 1), Bayer repeatedly referred to the importance of the integration of head, heart, and hand in the creation of art. Bayer's continued reference to these three integral parts of creation is related to ideas expressed in Kandinsky's book,[11] and is, of course, also in line with ideas eventually presented to Bayer at the Bauhaus. Bayer stated:

> the creative process is not performed by the skilled hand, alone, or by the intellect alone, but must be a unified process in which "kopf, herz und hand" (head, heart, and hand) play a simultaneous role. we were, especially in the early years of the bauhaus, conscious of the need of a unity, as this visualization of mine suggests.[12]

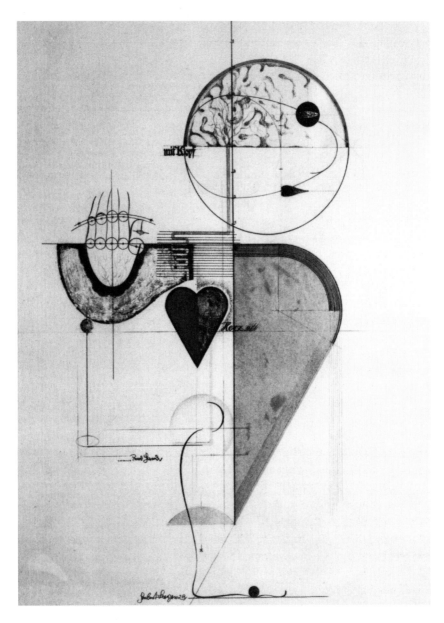

Figure 1. Herbert Bayer, *mit kopf, herz und hand*, 1923/29
Collage and mixed media, 22" × 15-3/4"
(Formerly collection Irene Bayer)

Herbert Bayer's predilection towards a particular color of blue that appears often in his work was so pronounced that the term "Bayer blue" has come into the Bayer terminology. Bayer also stated that from the beginning, blue was his "favorite color."[13] It is interesting that the color blue had special significance to Kandinsky, who wrote that "the power of profound meaning is found in blue."[14]

Despite Bayer's affinity for Kandinsky's ideas and art, there are some points of departure. In *Concerning the Spiritual in Art,* Kandinsky stated:

> If we begin at once to break the bonds which bind us to nature, and devote ourselves purely to combination of pure colour and abstract form, we shall produce works which are mere decoration, which are suited to neckties or carpets.[15]

While Kandinsky denigrated the "mere" decoration of neckties and carpets, Bayer took to heart the full egalitarian spirit of the Bauhaus and embraced all areas of design. He did, in fact, design both neckties and carpets. In a letter of 1972 he defended his work in the medium of the carpet (against someone who had called him a "rug designer").[16] Probably Kandinsky himself would not have written derogatorily about carpets and neckties *after* his tenure at the Bauhaus, where weaving was a respected medium.

Kandinsky's influence on Bayer was significant. His little book provided an important jolt to the young Bayer. Even more important, it prompted Bayer to come to the Bauhaus. When Kandinsky arrived at the Bauhaus, he again provided an important influence, this time directly, through his teaching.

Because he arrived at the Bauhaus without prior formal art training, Bayer had no early ideology. His "clean slate" was ready for that which the Bauhaus presented. In addition to lacking any formal art training, Bayer knew almost nothing about art history or theory, except what he could glean from books borrowed from friends.[17] Since art history was never a part of the curriculum at the Bauhaus itself, Bayer also did not receive any kind of comparative study of the arts there. Itten alone used examples of the old masters for his analytical study of painting in the preliminary course.[18] As a result, Bayer's education and experience at the Bauhaus were quite insular. He was shaped virtually exclusively by what he learned there. Further, even late in life Bayer described himself as "impressionable."[19] If simply reading Kandinsky's *On the Spiritual in Art* could have impressed him sufficiently to change the entire direction of his life, one can well imagine the influence exerted every day by the excited, talented thinkers with whom he lived and worked at the school. It is easy to understand how, living within the Bauhaus community, Bayer soon embraced its attitude.

Later, in the United States, Bayer eventually became responsible for the design programs of entire corporations. Twice the artist had rare, almost unique opportunities to implement all that he had absorbed at the Bauhaus, to create a large-scale system of total design within an international corporation. For others who had been at the Bauhaus, the school's goals certainly must have dimmed under pressure to make a living in the arts. Most worked within one area, be it graphic design, architecture, or some other single field in which they could excel and establish a reputation. The extreme freedom which was accorded Bayer first within Container Corporation of America and later within Atlantic Richfield, to implement good design in all areas of the corporation, was extraordinary. It allowed Bayer to continue to work in all media, from painting and graphic design to sculpture, tapestry design, and the design of interiors, always with the knowledge that he had a constant patron. The Bauhaus lesson encouraged him to project a vision first for Container Corporation and later for Atlantic Richfield. Unequivocably, the Bauhaus was the most significant experience of Bayer's formative development and was the force that guided all of his future life.

Bayer's training at the Bauhaus was somewhat less structured than the norm. The "required" preliminary course, so closely associated with the Bauhaus educational curriculum, was not a part of Bayer's own course of study. When Bayer arrived at the Bauhaus in the fall of 1921, it already was past mid-semester. After applying for admission, his work was reviewed by the admissions committee which at the time consisted of Walter Gropius and Paul Klee. Although Bayer was accepted for immediate matriculation, it was near the end of the semester and he could not join the preliminary course. Bayer was advised to apply for a workshop (to which students normally applied after the preliminary course) and to audit as many of the sessions of the preliminary course as he could.[20]

Bayer joined the wallpainting workshop and, by his own recollection, never received much of the preliminary course training, only attending Johannes Itten's class twice and Klee's twice.[21] Even after Kandinsky arrived at the Bauhaus in the middle of 1922, Bayer did not seek out more basic education from the man whom he admired so much. Bayer described himself as a rather shy student, and this predisposition may have made it difficult for him to pursue additional instruction. He did not attend Kandinsky's new course in composition and color,[22] although he was in Kandinsky's wallpainting workshop, an experience that was extremely important to Bayer.[23] It was Kandinsky, also, to whom Bayer felt closest personally.

For the wallpainting workshop Bayer worked in fresco and sgraffito. In addition to projects completed at the school, Bayer, like other students,

painted commissioned projects in the town of Weimar, including projects for schools, apartments, houses, and a lecture hall.

In a statement of 1978, Bayer summarized his experience in the wall-painting workshop as a three part lesson:

1. experimenting in many techniques on the walls of the workshop under the guidance of the master of technique (werkmeister). experimental designs for painting houses and walls, super graphics, outdoor advertising, etc., some of them executed on the walls of the workshop.
2. theoretical teaching consisting mostly in discussions with the form master on color organizations, color systems, psychology of color as propounded in kandinsky's book "about the spiritual in art." (being personally very interested in color theories, i studied the systems of goethe, philip otto runge and ostwald. unexpectedly, i had to tell about my knowledge in this area during the verbal examination before the board of the guild in order to receive my journeyman's document.) later in dessau, i had the pleasure to invite wilhelm ostwald to give a lecture and to introduce the color system.
3. practical work, painting exteriors and interiors, among them sommerfeld house, berlin, designed by gropius. this was a way of earning an income for a minimal existence.[24]

In 1923 Bayer participated in the first exhibition of the Bauhaus,[25] which he described as follows:

We decided because of so many attacks against the Bauhaus, to show what we were doing. . . . And to show that we were producing something. And so the whole school was involved in this show because it became more than a show—it was really a whole week of art. . . . Schlemmer produced his "Theaterische Ballet" and Stravinsky was produced and there was an exhibition of paintings at the museum, of paintings of other artists of a contemporary nature. But the main focus was the exhibition at the Bauhaus, in the workshops and wherever there was room.[26]

As part of the Bauhaus exhibition and celebration, the Van de Velde building of the Weimar Bauhaus received some "redecoration" by the students in the workshops. Bayer's own assignment was to execute posters for the exterior and to create a series of murals on the walls of the stairwell.[27] He explained his design (fig. 2) as follows:

wassily kandinsky was the form master of this workshop. his theories of the primary forms, circle, square, triangle, and their relationship to the primary colors, blue, red, and yellow, were predominant in discussions and influenced the students. it was accepted that red was the color of the square, yellow the color of the triangle. there were different opinions whether the blue was the color of the circle or of the square. I personally believed in blue as the most esoteric color to correspond with the form symbolic of infinity, of the innermost and mystery. I was also considering the qualities of lightness, brightness, depth and weight in the three colors.

Figure 2. Herbert Bayer, Mural for Stairwell, Bauhaus Building, Weimar, 1923

I dedicated each floor to one of the colors, rising from the deeper blue color on the first floor through the powerful aggressive red to the light and floating yellow composition with triangles on the third floor. variations in the surface were added by treating some areas with a glossy finish.[28]

The year 1923 was also the year that Bayer left the Bauhaus for a period of travel, a *Wanderjahr* which, in fact, lasted for a year and a half. With fellow Bauhaus student, Josef "Sepp" Maltan, he took a train south from Berchtesgaden, Germany, as far as the Brenner Pass. From there the two hiked down to Rome, doing odd jobs along the way to support themselves. They worked as house painters and painted some stage backdrops. They also visited Naples, Palermo, and Sicily, where they spent three or four months before beginning the return trip, again through Naples and Rome. This time they took the train as far as Berchtesgaden, where Bayer and his friend painted houses for the summer.[29] This trip opened the young man's eyes to the marvels of past civilizations; he later said of this trip, "it was a venture which left a more lasting imprint than my later travels."[30] At summer's end, Bayer left his friend and returned to the Bauhaus which was about to move to Dessau. Gropius offered Bayer a teaching position at the new school.[31]

There had been no typographic workshop at the Weimar Bauhaus, only a small, manual graphic printing shop. When the Bauhaus moved to Dessau and Bayer became director of the new workshop, machinery and typefaces were acquired, and a full, mechanized commercial workshop took form under Bayer's direction. Earlier, at Weimar, Bayer had been interested in graphic design and typography. He had worked independently in the graphic printing shop, where Kandinsky printed small lithographs, and it was at Weimar that Bayer conceived his influential "universal alphabet."

With the new facility at Dessau, typography and graphic design became a part of the regular curriculum under Bayer. The Bauhaus for some time had sought to make the workshops as self-supporting as possible.[32] In keeping with this goal (which included both the making of models that industry later would produce and the accepting of direct job commissions from industry), Bayer ran the school's new typographic workshop in part as a commercial typographic plant that filled the printing needs of local businesses and gave students important practical experience. In accepting direct job commissions the students were paid a small fee which, although minimal, enabled many students who had virtually no other income to remain at the school.[33]

Bayer is especially well known for developing new typographic formats which aided the execution and perception of the printed word. It seems likely that in this he was addressing some ideas presented by László Moholy-Nagy, who had come to the Bauhaus in the spring of 1923. Although Bayer left

for Italy at the end of that year, certainly Moholy-Nagy's ideas were known to him.

Some of Bayer's developments in typography and graphic design seem to be direct responses to an essay written by Moholy-Nagy in 1924, published two years later in the periodical *Offset, Buch und Werbekunst*.[34] In this work, Moholy-Nagy recognized the fundamental importance of the machine to modern typography and the need to reconcile modern printing forms with it, to create forms distinct from those of handwriting. He also proposed the creation of typographic formats that took greater account of the laws of visual perception, a concern central to Bayer's work. In speaking of the visual effects of the printed image and its importance in conveying meaning, Moholy-Nagy presented ideas germinal to Bayer's accomplishments:

> Whereas typography, from Gutenberg up to the first posters, was merely a (necessary) intermediary link between the content of a message and the recipient, a new stage of development began with the first posters. . . . One began to count on the fact that form, size, color, and arrangement of the typographical material (letters and signs) contain a strong visual impact. The organization of these possible visual effects gives a visual validity to the content of the message as well; this means that by means of printing the content is also being defined pictorially. . . . This . . . is the essential task of visual-typographical design.[35]

Although these ideas are not unique to Moholy-Nagy, and were recognized by numerous other modernists from Apollinaire and Marinetti to the Dadaists and Constructivists, Bayer's closest source, without question, was Moholy-Nagy. Further, the application of these principles to commercial areas of graphic design are wholly consistent in the work of Bayer and Moholy-Nagy. Finally, Moholy-Nagy's essay calls for a "unitary type of lettering, without small and capital letters; letters unified not only in size but also in form"[36] and for a "practical type face of the right size that is clearly legible, has no individual peculiarities, is based on a functional, visual form, and has neither distortions nor curlicues."[37] Bayer's creation of typographic formats and of a streamlined typeface using only lower case letters seems to be a response to and an enlarging of Moholy-Nagy's ideas as expressed in this essay of 1924.

During his tenure as master of typography and graphic design, Bayer worked towards developing a new typographic style that would be easier to execute and easier to perceive. He sought to apply the kinetics of vision to improving visual communication. He developed a streamlined, machine-inspired sans serif typeface that eliminated the anachronistic tails on letters which were residuals of the strokes of handwriting; he encouraged Gropius

to use the lower case for all Bauhaus typography, which became the rule after 1925; he divided pages of type into narrow columns to allow easier movement of the eye across the written lines; he used color highlighting to visually emphasize important passages; and he advocated regular spacing of letters and words across type to achieve a natural, rather than a justified, right margin. With all of these innovations, Bayer was concerned with the ocular physics of perception; ease of perception guided the typographical changes he promoted. Just as in graphics he relied on the power of the immediate bold statement, devoid of extraneous detracting material, he looked for the immediate impact of layout on a printed page. In typography, function guided his form.[38]

To appreciate just how revolutionary was the new typography, one need only make a visual comparison between a design for stationery executed by Bayer in 1918 while apprenticing with Schmidthammer in Linz[39] and a Bauhaus design of his (figs. 3 and 4). The earlier image retains the heavy gothic script with clear influences of decorative Jugendstil, the style of the Wiener Werkstätte, while the later expresses the spare clean lines of a machine-inspired form.

The clean lines and economy of design developed in and fostered by the Bauhaus remained with Bayer after he left the school. In 1928 he departed from the Bauhaus to pursue a design career in Berlin, and his work during the next ten years in that city clearly reflects Bayer's Bauhaus experience, an experience that remained at the core of his activity until the end of his life.

Bayer often explained that he left the Bauhaus because he was anxious to put into practice what he had learned in school. Further, he felt that the transition he had made at the Bauhaus between student and teacher was too easy, that he was too young and his background too insular to teach without more outside practical experience.[40] Beyond this, however, Bayer confided that budgetary cuts imposed by the German government had constrained the Bauhaus to the point that some faculty would have to leave.[41] Bayer felt that he was ready to go, as did Gropius, Marcel Breuer and Moholy-Nagy, all of whom left in that year, and a new era commenced at the Bauhaus under the directorship of Hannes Meyer.

The Bauhaus impact on Herbert Bayer is visibly demonstrated in his modern design style. But at least as important, the Bauhaus undoubtedly implanted in Bayer an understanding of the special nature of a community of thinkers. Surely the Bauhaus experience guided Bayer's aspirations for Aspen, Colorado; in a sense, Aspen succeeded by becoming a place where creative minds congregated. As Bayer stated: ''we made something out of Aspen and the people came to us, they didn't have to go to Europe to see somebody.''[42] Gropius's belief in the value of teamwork, which guided the

Figure 3. Herbert Bayer, Stationery Page, 1918
(Collection Bauhaus-Archiv, Berlin)

Figure 4. Herbert Bayer, Stationery Page, 1924
(Herbert Bayer Collection and Archive, Denver Art Museum;
Gift of the Estate of Herbert Bayer)

structure of the Bauhaus experience,[43] also must have been of immeasurable help to Bayer in his later work with large corporate teams. Given Bayer's background, it must have seemed natural to direct artists and craftsmen in collaborative efforts to create systems of unified design throughout corporations, including graphics, interior design of corporate offices, and elaborate exteriors with sculptured environments. Finally, virtually all of Bayer's active life was guided by the Bauhaus tenet that the artist cannot afford the luxury of situating himself apart from society, but that he has a duty to work from within society's structure to better it. Surely this goal is reflected in his designs for large-scale projects such as parks, highway and surf sculpture, and designs for beautifying an oil refinery, and in his corporate graphics and interiors, as well as in his plans for Aspen.

Bayer's career has been so closely aligned to Bauhaus ideals that one cannot begin to understand his artistic life without also understanding the Bauhaus experience. Even as late as 1961, forty years after entering the Bauhaus, Bayer wrote a poem, ''homage to gropius,'' shining with the artist's undiminished spirit of excitement about the Bauhaus.[44] And just as the Bauhaus gave Herbert Bayer direction of purpose, Bayer himself has set an example of what positive results could be achieved by adhering to Bauhaus tenets. These tenets supported Bayer throughout his career.

2

Bayer's Post-Bauhaus Years in Europe, 1928–1938

Ten years elapsed between the time Bayer left the Bauhaus and the time he immigrated to America. During those fruitful years, 1928 to 1938, Bayer established himself as a first-rate design professional. Even though it was the Bauhaus experience for which he was best known when he arrived in New York, he had advanced his independent professional career substantially during those subsequent ten years. In 1938 Bayer arrived in New York a confident, experienced designer with an extensive background in European avant-garde design from a decade of professional practice in an important urban center.

When Bayer left the Bauhaus, in June of 1928, he relocated in Berlin to begin a career as a designer. Berlin was a logical choice, a large city which was known for its vitality not only politically, but also culturally and economically. In Berlin Bayer maintained contacts with other former Bauhaus people-turned-Berliners, notably Moholy-Nagy, Gropius, and Breuer, the latter with whom Bayer traveled to Greece in 1934, on a visit which impressed him tremendously, and which encouraged him to feel a strong affinity for classical art (whose images he soon incorporated into his own work).

Arriving in Berlin, Bayer began by working freelance, and he took his work to the newly opened Berlin office of *Vogue.* The art director was the well-known designer Agha, who liked Bayer's work so much that he offered Bayer his own position as art director of German *Vogue,* since Agha himself preferred to return to Paris.[1]

During Bayer's tenure as art director for *Vogue* in Berlin, he maintained a professional relationship with Walter Maas, head of the Paris branch of the Dorland Advertising Agency, an international firm with primary offices in London, whose Paris office was responsible for *Vogue* advertising. When *Vogue* closed its Berlin office, Bayer was invited to work for Dorland International.[2] The artist recalled that he was told, ''You do all the work for us, but you are free for yourself . . . just call it 'Studio Dorland.'''[3] Bayer was amenable to this arrangement as it allowed him extraordinary freedom and

independence while affording him the advantages of an important professional association. He stated, "I wanted an impersonal signature, and certain things which I did personally, I always said 'by Dorland.'"[4]

Bayer did use the Dorland name in his graphic work of those years, but an examination of the Dorland mark on some graphics done by the studio shows that Bayer sometimes included his name after "Dorland," and sometimes he used a monogram "Y" in a box after "Dorland." This was Bayer's manner of adding his own mark to works which he wished to identify as his own, without signing them.[5]

Bayer produced an impressive body of graphic work in Berlin under the Dorland name, including advertisements for clothing and fabrics for such clients as AGB Stoffe and Venus and extensive graphic campaigns to sell health aid products such as Chlorodont toothpaste, Vasenol foot powder and Adrianol Emulsion nosedrops. He designed covers for the magazine *Die neue Linie* and a large outdoor billboard to promote it, and he produced the well illustrated catalog for the large health-oriented exhibition in Berlin, "Das Wunder des Lebens" (1932). In Berlin Bayer was able to extend his activity in the area of typography, designing a typeface which went into production by the Berthold Type Foundry, for whom Bayer also produced calendars and other graphics.

Although graphic design and production no doubt engaged the majority of Bayer's time and were the source of his income, Bayer also painted and directed his energies toward a new exploration of photographic possibilities as well. Like other Bauhäusler, Bayer had done some independent easel painting at the Bauhaus, although he recalled that he never showed his work to anyone there, nor did he know much of contemporary avant-garde styles. It was in Berlin that Bayer first became aware of the modern movement in painting, finally becoming acquainted with what was going on in the world's major art centers; for example, he knew nothing of the Paris art world until his Berlin years.[6] During those years, Bayer's own painting began to flourish. He found that he could make time in the evenings for painting, time that he could not garner while he was at the Bauhaus.

In Berlin Bayer created two portfolios of photographs for which he is well known among photographic historians today. Of course photography had been of interest to those at the Bauhaus ever since Moholy-Nagy's arrival in 1923. Even though photography was not officially a part of the Bauhaus curriculum until the appointment of Peterhans in 1929, Moholy-Nagy had been experimenting with the photogram and other techniques at Weimar. His book *Malerei, Photographie, Film* was published in the Bauhaus Books series at the beginning of the Dessau period.[7] Bayer himself demonstrated a familiarity with new photographic techniques while at the Bauhaus. His 1928 cover for the magazine *Bauhaus* (created in 1927, fig. 5), was an ex-

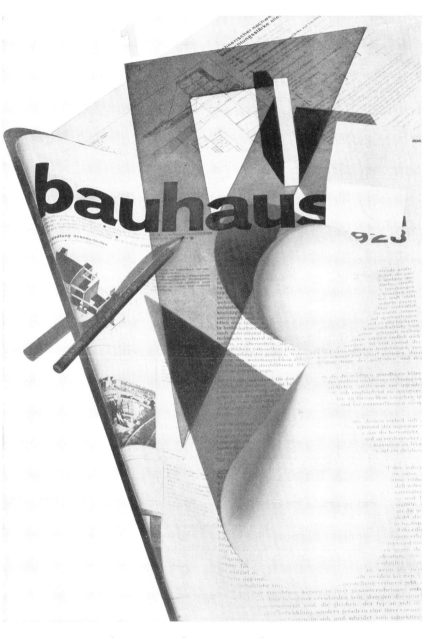

Figure 5. Herbert Bayer, *Bauhaus* Magazine Cover
January 1928 Issue (design, 1927)
Photomontage
(Herbert Bayer Collection and Archive, Denver Art Museum)

pression, through photographic processes, of what the *Bauhaus* magazine was about. This image was a still life photograph of an assemblage combined *prior* to photography, rather than combined through photomontage (later Bayer would refer to a work created by this technique as a *fotoplastik*).[8] Bayer's 1923 Bauhaus dance poster (fig. 6) was a playful Dada-inspired announcement using photography and montage techniques. Other images indebted to Dada experimental precedents include two Bayer invitations to Bauhaus events (figs. 7 and 8).[9]

In Berlin Bayer used photography as an integral part of his graphic design, and at times he employed a photographer to assist in the studio. He also continued to photograph images and sites in a conventional manner, as he had earlier. And he applied his knowledge of experimental photographic techniques in creating a group of noncommercial photographs of an unusual nature. The result was two portfolios of enigmatic images, photomontages and *fotoplastiken,* subjective in feeling, sometimes approaching the ambiguity of Surrealism. Some photomontages, such as *profil en face* from 1928 (fig. 9), are clearly related to painting and to his graphic work of the time. Many express irony through juxtaposition, such as *lonely metropolitan* (1932, fig. 10), an image of raised hands with eyes superimposed onto the palms, placed before the facade of a building, and *look into life,* whose framing of the landscape recalls Duchamp's *Pharmacie.* These ironic juxtapositions reflect Surrealist vocabulary with some of Bayer's dreamlike images (*self portrait,* 1932, fig. 11) mirroring those of the Surrealists.

Bayer's *fotoplastiken,* composed of still life assemblages combined prior to photography and sometimes reworked with airbrush (to create areas of clouds, for example), often are rich in surface texture. Characteristically there is a spatial ambiguity which creates an unsettling dialectic between the two-dimensional and the three-dimensional. These also are related to Surrealist images. For example, Bayer's *fotoplastik, metamorphosis* (1936, fig. 12), resembles Magritte's Surrealist painting of five years earlier, *Mental Calculus* (1931, fig. 13).[10]

Bayer's photography and painting of the thirties are related, with a congruity of expression beneficial to both. His photographs of the thirties may best be seen as another dimension of the artist's exploration of current pictorial problems. It was in Berlin that Bayer was finally becoming exposed to avant-garde ideas other than those of the Bauhaus, and he was working through these new ideas in more than one medium.[11]

Finally, in Berlin Bayer became experienced in the field of exhibition design.[12] It was no doubt because of his extensive experience in this field during the years 1928–38 that Bayer was entrusted with his first job in New

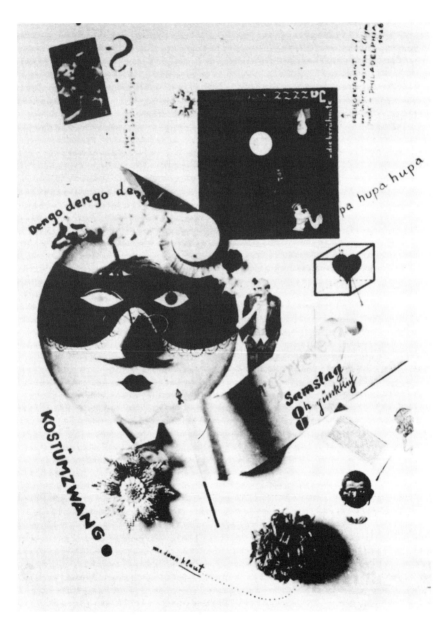

Figure 6. Herbert Bayer, Poster for Bauhaus Dance, 1923
Collage

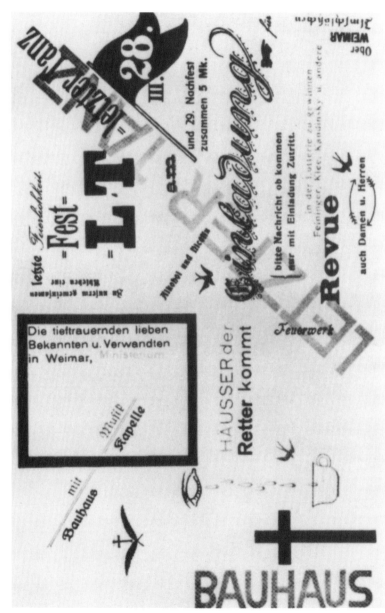

Figure 7. Herbert Bayer, Invitation to Last Bauhaus Dance in Weimar, 1925

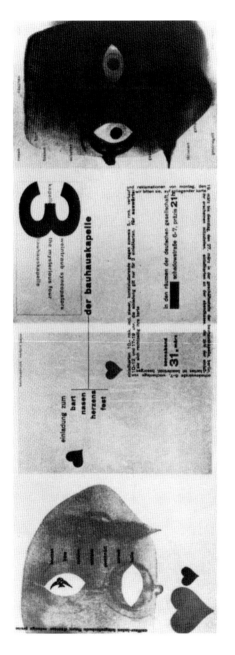

Figure 8. Herbert Bayer, Invitation to Bauhaus "Beards, Noses, and Hearts" Festival in Berlin, 1929

Figure 9. Herbert Bayer, *profil en face*, 1929
Photomontage, 12-1/4" × 10-1/4"
*(Herbert Bayer Collection and Archive, Denver Art Museum;
Gift of the Estate of Herbert Bayer)*

Figure 10. Herbert Bayer, *lonely metropolitan*, 1932
Photomontage, 14″ × 11″
*(Herbert Bayer Collection and Archive, Denver Art Museum;
Gift of the Estate of Herbert Bayer)*

Figure 11. Herbert Bayer, *self portrait*, 1932
Photomontage, 14″ × 11″
(Herbert Bayer Collection and Archive, Denver Art Museum;
Gift of the Estate of Herbert Bayer)

Figure 12. Herbert Bayer, metamorphosis, 1936
Fotoplastik, 11″ × 14″
(Herbert Bayer Collection and Archive, Denver Art Museum;
Gift of the Estate of Herbert Bayer)

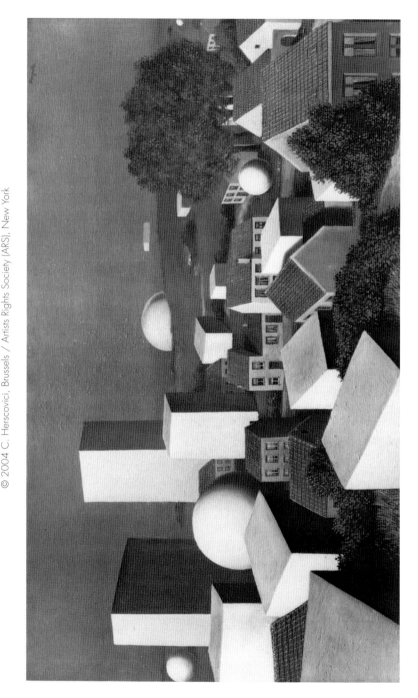

Figure 13. René Magritte, *Mental Calculus* (a.k.a. *Mental Arithmetic*), 1931
Oil, 26" × 45-3/4"
(Private collection)
© 2004 C. Herscovici, Brussels / Artists Rights Society (ARS), New York

York, organizing and designing the important exhibition "Bauhaus 1919–1928" at the Museum of Modern Art. During Bayer's Berlin years, he had participated in the design of some nine or ten exhibitions, roughly one per year.

The first year that Bayer left the Bauhaus, 1928, he participated in the landmark "Pressa" exhibition at Cologne, organized by El Lissitzky. From the "Pressa" experience, Bayer realized a new freedom of materials and technique, a new fluidity of style, and a new large scale. Display became environment with exciting three-dimensional dynamism. Bayer followed up his lesson by attempting to systematize the new approach into an orderly program, while maintaining the fluidity of Lissitzky's example.

Two years later, in 1930, Bayer was invited by Walter Gropius to collaborate on the design for the Deutscher Werkbund section of the "Exposition de la Société des Artistes Décorateurs" at the Grand Palais, Paris. Bayer designed two rooms of the five allocated to the German section. Gropius designed a lounge and Breuer and Moholy-Nagy each prepared a room of displays. The exhibition presented German industrial design, modern furniture, and commodities. As Hans Wingler has stated, "Though the items on display by no means consisted of Bauhaus products exclusively, the German section turned into an excellent manifestation of its program."[13]

In addition to collaborating on these well-known exhibitions, Bayer also contributed to planning and installing exhibitions for the Berthold Type Foundry, 1930; the German Cork Industry, 1931, on which he collaborated with Breuer; traveling exhibitions and a municipal exhibition in Berlin, 1935; a traveling exhibition for the wallpaper industry in Hamburg, 1936; and a gas and water exhibition in Leipzig, 1937.[14]

By the time Bayer left Europe in 1938, he was one of only a handful of artists experienced in new exhibition techniques, and had established himself as an innovative and productive designer of exhibitions. With expertise in this new field added to his reputation as a first-rate graphic designer, Bayer arrived in New York an experienced professional. His successful work for industry in Germany paved the way for his later work in the United States. For the thirty-eight-year-old Bayer, the United States offered an opportunity to launch a new career. For America, Bayer's presence, and that of his European colleagues, meant that new avant-garde design methods would be introduced firsthand and assimilated to create a more sophisticated fabric of American design, beginning a new era in American design.

Color Plates
All Works by Herbert Bayer

Plate 1. Beadwork Design, 1923/30
Watercolor, ink, and graphite on paper
19 x 15¾ inches
Herbert Bayer Collection and Archive, Denver Art Museum
Gift of Joella Bayer

Plate 2. *schwebende plastik*, 1925/8
Gouache on paper
19½ × 15½ inches
Herbert Bayer Collection and Archive, Denver Art Museum
Gift of Joella Bayer

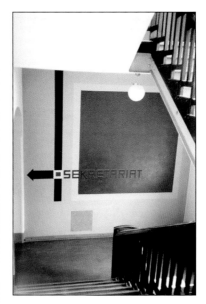

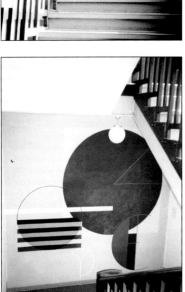

Plate 3. Mural for Stairwell, Bauhaus
Building, Weimar, 1923

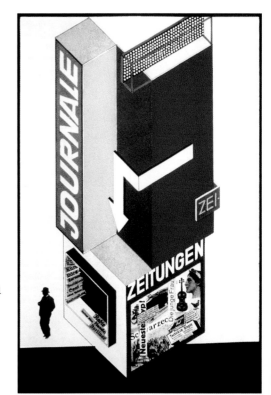

Plate 4. Design for a Newspaper Kiosk, 1924
Tempera and collage
25⅜ × 13⁹⁄₁₆ inches
Bauhaus-Archiv, Berlin

Plate 5. Bauhaus Circle of Friends Letterhead, 1925
Printed
11 ¹¹⁄₁₆ × 8 ⅛ inches
Herbert Bayer Collection and Archive
Gift of the Estate of Herbert Bayer

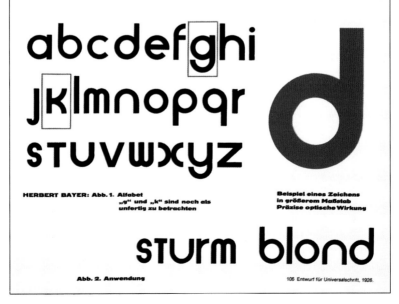

Plate 6. Study for "universal type," 1925

Plate 7. *a wind system*, 1939/29
Watercolor on paper
11¾ x 7 inches
Herbert Bayer Collection and Archive, Denver Art Museum
Gift of Joella Bayer

Plate 8. *interstellar exchange*, 1941/2
 Oil on canvas
 66 × 37 inches
 Herbert Bayer Collection and Archive, Denver Art Museum
 Gift of Joella Bayer

Plate 9. Brochure for Herbert Bayer Design Studio, New York City, ca. 1940
Printed
9 × 9 inches
Herbert Bayer Collection and Archive, Denver Art Museum
Gift of the Estate of Herbert Bayer

Plate 10. *Harper's Bazaar* magazine cover, 1940
Printed
13 × 9¾ inches
Herbert Bayer Collection and Archive, Denver Art Museum
Gift of the Estate of Herbert Bayer

Plate 11. *window by the desk*, 1944/44
42 × 50 inches
Oil on canvas
Collection of Britt Bayer

Plate 12. *unfolding stratum*, 1944/33
Oil on canvas
20¼ × 27 inches
Herbert Bayer Collection and Archive, Denver Art Museum
Gift of BP Corporation

Plate 13. Untitled ("herd of sheep along curves of mountains"), ca.1948
Colored pencil and graphite on paper
9¼ × 12½ inches
Herbert Bayer Collection and Archive, Denver Art Museum
Gift of Joella Bayer

Plate 14. Untitled (landscape studies), 1948
Pastel, colored pencil, and graphite on paper
9 × 11¾ inches
Herbert Bayer Collection and Archive, Denver Art Museum
Gift of Joella Bayer

Plate 15. Untitled (sketches for butterfly paintings), ca.1947
 Crayon/colored pencil, graphite and watercolor on paper
 12 x 15¾ inches
 Herbert Bayer Collection and Archive, Denver Art Museum
 Gift of Joella Bayer

Plate 16. *sketches for butterfly paintings*, 1947/76
 Crayon/colored pencil and graphite on paper
 15¾ x 12 inches
 Herbert Bayer Collection and Archive, Denver Art Museum
 Gift of Joella Bayer

Plate 17. Untitled (Independence Pass), 1948
Colored pencil and graphite on paper
9¼ × 12½ inches
Herbert Bayer Collection and Archive, Denver Art Museum
Gift of Joella Bayer

Plate 18. *sketch for butterfly paintings*, 1947
Crayon/colored pencil on paper
7⅝ × 10¾ inches
Herbert Bayer Collection and Archive, Denver Art Museum
Gift of Joella Bayer

Plate 19. *moon over wings*, 1947/4
Oil on canvas
25⁹/₁₆ × 25⁹/₁₆ inches
Herbert Bayer Collection and Archive, Denver Art Museum
Gift of the Estate of Herbert Bayer

Plate 20. *colorado mural*, 1948/67
Oil on unstretched canvas
8 × 10 feet
Herbert Bayer Collection and Archive, Denver Art Museum
Gift of the Estate of Herbert Bayer

Plate 21. Study for "positive-negative grass sculpture," 1954/111
Pastel, graphite and collage on paper
19¾ × 25¾ inches
Herbert Bayer Collection and Archive, Denver Art Museum
Gift of Joella Bayer

Plate 22. Study for "mound with ring of water," 1956/14
Crayon/colored pencil and graphite on paper
12½ × 19 inches
Herbert Bayer Collection and Archive, Denver Art Museum
Gift of Joella Bayer

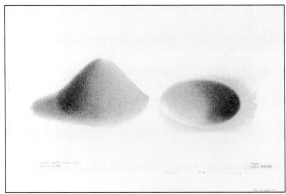

Plate 23. Study for "positive-negative, earth sculpture (mound and hole)," (1954)–1978/27
Crayon/colored pencil and ink on paper
19 × 26 inches
Herbert Bayer Collection and Archive, Denver Art Museum
Gift of Joella Bayer

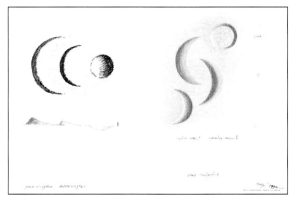

Plate 24. Studies for "grass sculpture, moonscapes, negative crescent, 2 positive crescents," 1970/102
12½ × 19 inches
Crayon/colored pencil and ink on paper
Herbert Bayer Collection and Archive, Denver Art Museum
Gift of Joella Bayer

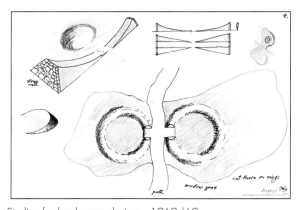

Plate 25. Studies for landscape designs, 1969/69
Crayon/colored pencil and ink on paper
12½ × 19 inches
Herbert Bayer Collection and Archive, Denver Art Museum
Gift of Joella Bayer

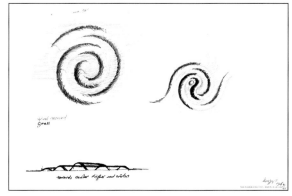

Plate 26. Studies for grass spiral mounds, 1969/68
Crayon and ink on paper
12½ × 19 inches
Herbert Bayer Collection and Archive, Denver Art Museum
Gift of Joella Bayer

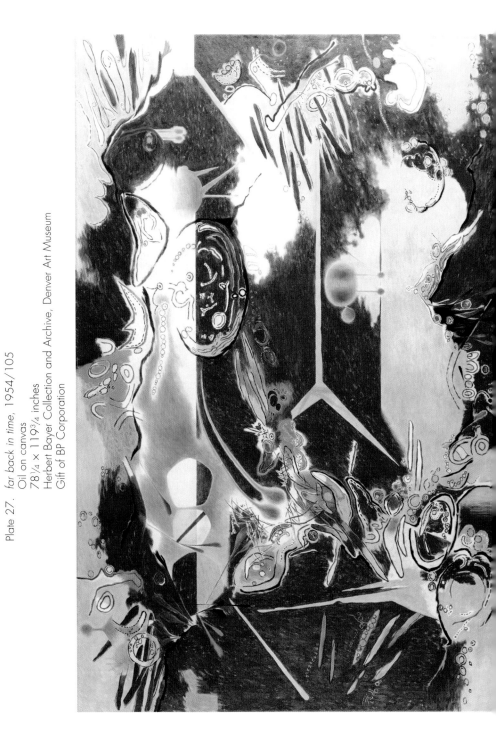

Plate 27. *far back in time*, 1954/105
Oil on canvas
78¼ × 119¾ inches
Herbert Bayer Collection and Archive, Denver Art Museum
Gift of BP Corporation

28. Hotel Jerome, Aspen travel brochure, 1950
Printed
8½ × 4 inches
Herbert Bayer Collection and Archive, Denver Art
Museum
Gift of the Estate of Herbert Bayer

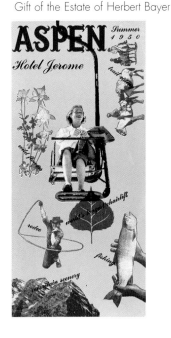

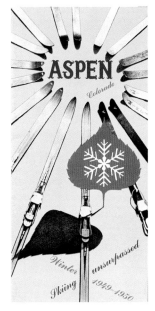

Plate 29. Aspen travel brochure, 1949
Printed
8¼ × 4 inches
Herbert Bayer Collection and Archive, Denver Art
Museum
Gift of the Estate of Herbert Bayer

30. "Ski in Aspen" travel brochure, n.d. (probably 1946–51)
Printed
8½ × 3¾ inches
Herbert Bayer Collection and Archive, Denver Art
Museum
Gift of Joella Bayer

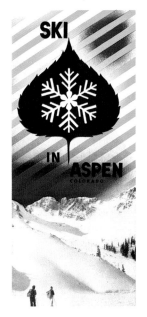

Plate 31. "Colorado Ski Country USA" brochure, 1965
Printed
8½ × 3¾ inches
Herbert Bayer Collection and Archive, Denver Art
Museum
Gift of the Estate of Herbert Bayer

Plate 32. *chromatic interlocking* (tapestry design), 1966/59
Acrylic and watercolor on paper
7⅛ × 7⅛ inches
Herbert Bayer Collection and Archive, Denver Art Museum
Gift of Joella Bayer

Plate 33. *four warped squares*, 1972/13
Oil on canvas
40 × 40 inches
Herbert Bayer Collection and Archive, Denver Art Museum
Gift of Joella Bayer

Plate 34. *four chromatic intersections,* 1970/20
Oil and bronze on canvas
60 × 60 inches
Herbert Bayer Collection and Archive, Denver Art Museum
Gift of Joella Bayer

Plate 35. *structure with four squares*, 1971/72
Acrylic and gold leaf on canvas
30 × 30 inches
Herbert Bayer Collection and Archive, Denver Art Museum
Gift of BP Corporation

Plate 36. *chromatic gates on yellow* (study), 1968/57
Acrylic on paper
6¼ × 23⅛ inches
Herbert Bayer Collection and Archive, Denver Art Museum
Gift of BP Corporation

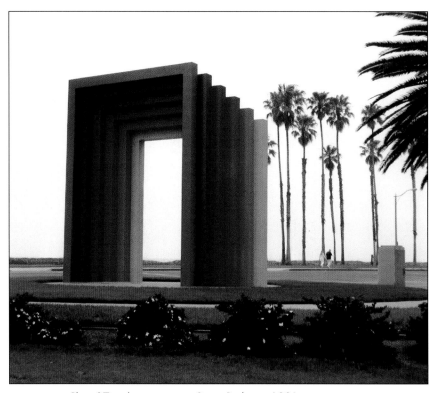

Plate 37. *chromatic gate*, Santa Barbara, 1991
(based on a maquette made by Bayer in 1975)
21 ft. high
City of Santa Barbara

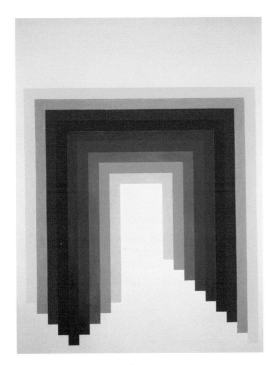

Plate 38. *chromatic gate*, 1969/20
Oil on canvas
79¾ × 60 inches
Herbert Bayer Collection and Archive, Denver Art Museum
Gift of Marcor Housing Systems, Inc., Denver

Plate 39. *egress with appendix*, 1973/59
Acrylic on canvas
80 × 80 inches
Herbert Bayer Collection and Archive, Denver Art Museum
Gift of BP Corporation

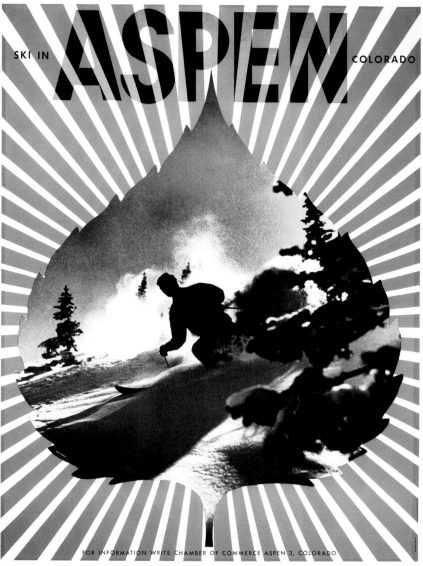

Plate 40. "Ski in Aspen" poster, 1946
Printed
43^{11}/$_{16}$ × 34 inches
Herbert Bayer Collection and Archive, Denver Art Museum
Gift of the Estate of Herbert Bayer

Plate 41. *aspen trees*, 1957/51
Oil on canvas
32 1/16 × 40 inches
Herbert Bayer Collection and Archive, Denver Art Museum
Bequest of Norva M. Bray

Plate 42. *articulated wall*, Denver Design Center, 1985
Prefabricated concrete, painted, with interior vertical steel support
85 ft. high
Herbert Bayer Collection and Archive, Denver Art Museum
Gift of Century Court Associates, Ltd.

Plate 43. *agitated*, 1973/67
Acrylic on canvas
50 × 50 inches
Herbert Bayer Collection and Archive, Denver Art Museum
Gift of Joella Bayer

Plate 44. *star* (tapestry), 1983/3
Wool
60 × 84 inches
Herbert Bayer Collection and Archive, Denver Art Museum
Gift of Mrs. Vesta S. V'Soske

Plate 45. *cosmographic I* (tapestry), 1980
Wool
84 × 175 inches
Herbert Bayer Collection and Archive, Denver Art Museum
Gift of BP Corporation

Plate 46. *relative to the point of view, 1977/67*
Acrylic on canvas
50 × 50 inches
Herbert Bayer Collection and Archive, Denver Art Museum
Gift of Joella Bayer

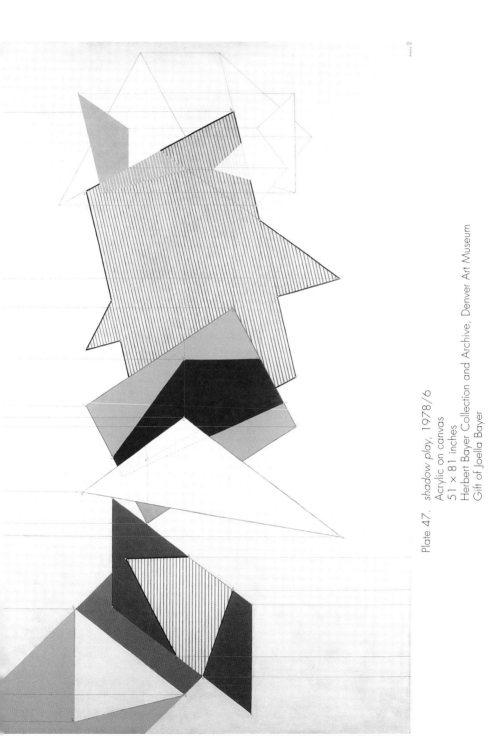

Plate 47. *shadow play*, 1978/6
Acrylic on canvas
51 × 81 inches
Herbert Bayer Collection and Archive, Denver Art Museum
Gift of Joella Bayer

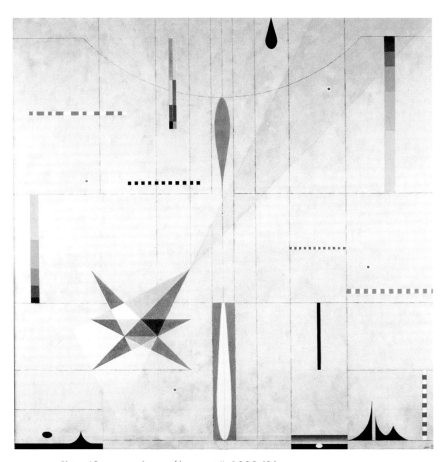

Plate 48. *according to fibonacci II*, 1980/21
Acrylic on canvas
69¾ x 69¾ inches
Herbert Bayer Collection and Archive, Denver Art Museum
Gift of BP Corporation

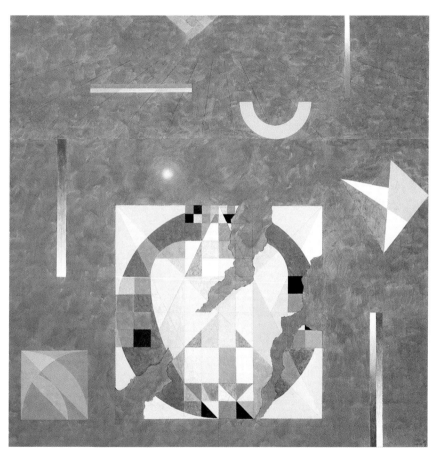

Plate 49. *fragments II*, 1983/5
 Acrylic on canvas
 50 × 50 inches
 Herbert Bayer Collection and Archive, Denver Art Museum
 Gift of Joella Bayer

Plate 50. Herbert Bayer in his Studio, Montecito, California, ca.1981
Photograph by Paul Hobson

3

Early Painting

i consider myself to be primarily a painter, and painting is the continuous link connecting the various facets of my work. if one is born to paint, one has to paint.
—Herbert Bayer, *herbert bayer, painter, designer, architect*

Although Herbert Bayer is known best for his achievements in design, it is revealing to learn that he always thought of himself first as a painter.[1] This self-image may be due in part to some unspoken but lingering value judgments about the inherent superiority of the fine arts. Notwithstanding the Bauhaus equation of the fine and applied arts, old values probably do not disappear entirely.[2] Bayer may well have considered himself first a painter because of the fact that during virtually his entire life, regardless of what turns his other projects may have taken, he always continued to paint.

Painting, as a continuous solitary activity, provided a setting in which Bayer's ideas could ferment, ideas which often found expression in other media as well. Because of the special relationship between Bayer's painting and the rest of his work, it is useful, by way of introduction, to note briefly the direction of his early painting.

Bayer's paintings are known far less widely than his graphics, environmental sculpture, or even his tapestries, which often are found hanging in public spaces. Although Bayer paintings are displayed in many European museums, they have been less collected by American museums. One reason for Bayer's minimal recognition here may be that he had ready patrons; Container Corporation collected many of Bayer's earlier paintings, and over the past decade and a half Atlantic Richfield has purchased so many Bayer works that his paintings hang not only in its offices worldwide, but also at the Breakers, an ARCO executive conference center in Santa Barbara which is a showcase of Herbert Bayer art. Room after room of his work is displayed, making it literally a private Herbert Bayer museum. But while a corporation may be a voracious collector and a lucrative patron for an artist, most of

its collections are never seen publicly, and it seems to have been the case that Bayer's best paintings were taken out of public view before they had opportunity to receive critical attention. Additionally, many of the individual collectors who acquired Bayer's paintings were residents of Aspen, which by the late 1950s and early 1960s had become a mountain community for the very affluent. Most of the works collected in Aspen have remained there, without having been exhibited in major museum shows. So while Bayer was extremely successful on the one hand in selling his canvases, the market for his work was an unusually closed circle, which resulted in minimal public visibility. Further, with such a supportive localized market, there was little reason for him to actively seek out new galleries to promote his work.[3]

Bayer's earliest paintings were mostly watercolors, productions of an untutored youth in Austria but remarkably pleasing with a delicate sensitive manner and careful rendering of light and shadow. His early subjects were the natural landscape and its rustic architecture, the surroundings of his youth.

By 1920, the year before Bayer's arrival at the Bauhaus, some of his landscapes, such as two painted in the city of Enns in 1920, had taken on a more robust, colorful character, perhaps influenced by the palette of German Expressionism. Some works were marked by elements of Jugendstil and the Vienna Secession, which he greatly admired. Yet it was not until Bayer arrived at the Bauhaus at the age of twenty-one that he received his first formal training as a painter.

Easel painting, we know, was never a part of the Bauhaus curriculum. In line with the school's philosophy of integrating the arts into a unified whole, painting instruction was directed entirely to murals, which wedded painting and architecture. In Kandinsky's wallpainting workshop Bayer honed his natural painting abilities and learned principles of color and form, especially in exercises corresponding to Bauhaus concerns about the relationship between the three primary colors and elemental shapes of the triangle, circle, and square.[4] What Bayer learned at the Bauhaus, particularly from Kandinsky, influenced all of his subsequent painting. In addition to Kandinsky's formal abstraction, Bayer also was influenced during his Bauhaus years by De Stijl and by Russian Suprematism, as we observe in works such as *the five*, of 1922 (fig. 14).[5]

After his Italian sojourn and his tenure as Bauhaus master in typography and graphic design, Bayer embarked on a new design career in Berlin in June 1928.[6] Between 1928 and 1938 in Berlin, Bayer was able to arrange more time for private studio work. With his introduction to modernist art developments and with his active role in exhibition design, typography, photography, and graphic design, Bayer discovered a wealth of material

Figure 14. Herbert Bayer, *the five*, 1922/8
Gouache and collage, 18″ × 14-1/4″
(Collection Estate of Joella Bayer)

from which to build a personal pictorial vocabulary. Additionally, during these ten years he continued to rework ideas to which he had been exposed at the Bauhaus. In his small gouache on paper of 1934, *shadow over cone* (fig. 15), for example, Bayer created an image that had a precedent in his 1927 photographic image for the January 1928 *Bauhaus* magazine cover, in which the cylinder, cube, and cone cast shadows against an open magazine page.

The year 1928 seems to have been particularly prolific. Many ideas which had been germinating finally were realized once Bayer could make more time for easel painting. (At the Bauhaus he had been too busy to devote much time to fine art, due to the demands of school projects and of earning money to provide for his basic necessities.)[7] In many works of 1928, such as *park of flat trees, tender picture E, world of letters* (fig. 16), *hand and frames, cloud picture,* and *world on boards* (fig. 17), Bayer used familiar elements such as trees, clouds, and letters, subjects Alexander Dorner referred to as "working signs."[8] But what Bayer did with these ostensibly easy-to-read objects was to confound rational order; to position them within a spatially ambiguous, artificial, nonmeasurable pictorial structure. These crisply drawn images reveal a kinship to de Chirico and to the Surrealists to whom Bayer already had been exposed.[9] Careful scrutiny provides other sources which are even closer to Bayer's own experience; sources which support an analysis of these works as being quite independent, fresh creations owing much more to Bayer's interdisciplinary approach to art-making than to any school or style.

Exhibition design, for example, seems to have provided a source for the flat members of *park of flat trees* and *world on boards,* which resemble the flat wooden wall structures forming the architecture of exhibition space. *Tender picture E* and *world of letters* include images of die-cast metal type pieces which Bayer used in his graphic studio. Even the simple bold outlines of *hand and frames, abstraction,* and *cloud picture* resemble the sparse lines of clean graphics more than any painterly style of brushwork.

Photography also provided an important source for Bayer's painting. In *studio beach* of 1928 (fig. 18), Bayer included an actual photograph from which his drawn image derived; this he pasted collage-fashion onto the painted surface. Dada collage of course was well known at the Bauhaus through Kurt Schwitters[10] and as we have seen, Bayer himself had made a playful collage for a Bauhaus dance poster in 1923.

Bayer's own fine art photography of the late 1920s and early 1930s yielded the two portfolios already mentioned of photomontages and *fotoplastiken.* These Surrealist-related images informed many of his paintings

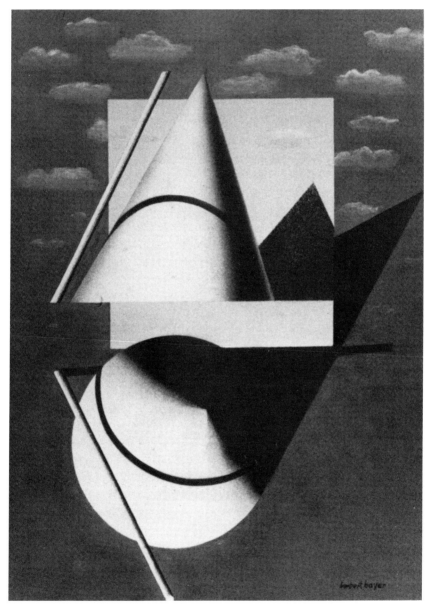

Figure 15. Herbert Bayer, *shadow over cone*, 1934/3
Gouache, 14″ × 11″
(Private Collection)

Figure 16. Herbert Bayer, *the world of letters*, 1928/29
Watercolor, 18" × 26" (destroyed during World War II)
(Formerly collection Lady Clifford Norton)

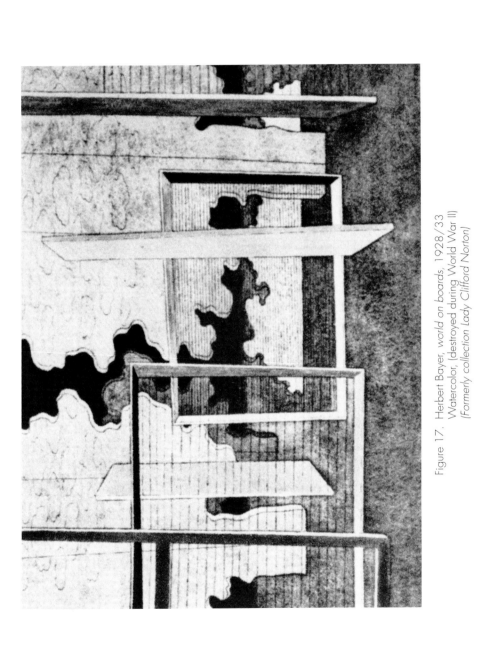

Figure 17. Herbert Bayer, *world on boards*, 1928/33
Watercolor, (destroyed during World War II)
(Formerly collection Lady Clifford Norton)

Figure 18. Herbert Bayer, *studio beach*, 1928/30
Gouache with collage, 17-1/2" × 12"
(Collection Estate of Jean F. Levy)

of the period, some of which depict identical objects, such as farm implements remembered from his youth, clouds, and bones. In the paintings one sees trompe l'oeil illusionism with shadows cast from painted objects resembling those cast from actual objects seen photographed in the portfolios.

By borrowing devices from one medium and applying them to another, Bayer created a new, inventive pictorial vocabulary. As a result, the paintings of this period, which include Surrealist elements, disjunctures in space, and devices borrowed from photomontage, are particularly dense and suggestive. During this period Bayer's paintings approach Surrealism as closely as they ever do, but they always remain distanced from a true Surrealist image, maintaining the conscious act of pictorial organization and creation over any subconscious orientation. Most probably Bayer had already come in contact with Surrealist works and had developed an affinity for their forms; but rather than adopting the style intact, he developed his own personal vocabulary of subjects and forms which he adapted within his own quasi-Surrealist pictorial structure.

By the end of the 1930s and during the 1940s Bayer moved away from earlier romantically oriented works, turning to paintings which explored movements in time and space, specifically atmospheric, geological, and meteorological conditions and the new science of aerodynamics.[11] These paintings include many chartlike, diagrammatic forms. Sometimes vectors exploding across canvases energize surfaces,[12] while in other works clouds and flamelike forms intermingle with quasi-Surrealist forms that remind one of weather stations, the title Bayer used for a 1939 painting (fig. 19), airplane routes, meridians, and geological and interplanetary forms. One title, *interstellar communication* (1939, fig. 20), appears to be related to a book by the same name by A. G. W. Cameron. A review of this book is pasted into Bayer's own 1943 sketchbook.[13]

Movements within the earth's crust were explored during this period, particularly as they related to mountains. During a 1944 winter visit to Vermont, Bayer became especially fascinated by the inner structure of mountains and he responded with a series he called convolutions (fig. 21). In addition to the convolutions, other related works bear geological titles, such as *laniferous landscape,* 1944; *ice quake,* 1944; *exfoliation,* 1944; *undulation in pink,* 1947. Two large murals executed during the 1950s refer to these studies, which continued into the decade of the fifties: the *verdure* mural at the Graduate Commons Building at Harvard University, 1950, and the sgraffito mural completed with the assistance of friends at the Aspen Institute Seminar Building, 1953.[14] These studies also fed conceptually into one of Bayer's most ambitious graphic projects, the *world geo-graphic atlas,* which he pro-

Figure 19. Herbert Bayer, weather station, 1939/12
Oil, 11-5/8" × 15-5/8"
(Herbert Bayer Collection and Archive, Denver Art Museum;
Gift of the Estate of Herbert Bayer)

Figure 20. Herbert Bayer, *interstellar communication*, 1939/14
Oil, 20" × 30"
(Private collection)

Figure 21. Herbert Bayer, convolutions in white #1, 1950/4
Oil and collage, 10" × 23"
(Herbert Bayer Collection and Archive, Denver Art Museum;
Gift of Joella Bayer, photograph by Soichi Sunami)

duced over a period of more than five years, published by Container Corporation of America in 1953.[15]

During the 1950s Bayer developed several painting styles, ranging from Surrealist-inspired works such as freely painted automatistlike images recalling works of Matta and Masson and a cosmic series of cometlike soft forms reminiscent of some Miró compositions to an abstract architectural series of bold planes. Continuing his Bauhaus involvement with problems of structure he also began a series of paintings he called linear structures during the decade of the 1950s (fig. 22). Problems of color and structure are of course Bauhaus issues to which Bayer returned throughout his life. The replacement of swirling, restless surfaces by more reductive, intellectually calculated ones continued in Bayer's work. A notation in Bayer's sketchbook of 1956 considers this issue of color and form, and foreshadows his later color studies with reduced form, the chromatics:

> color is the primary medium of the painter. but color cannot exist without form . . . how far can form be reduced? what are the properties of color? what spatial realities can be created with color and how would they relate to forms? how much do quantities influence the qualities of color?[16]

By the early 1960s Bayer had added moonlike symbols to his rigid structural elements, and he once again grappled with Bauhaus problems of compositional interrelationships of color and form. For a short time in the mid-1960s, after the death of Bayer's only daughter Julia, color was banished from his canvases. The monochromes, in gradations of grey or brown, such as *suspended* (1965, fig. 23), are polished structural studies in light and shadow which resemble gleaming surfaces of tubular metal members.

Color returned to Bayer's canvases with a brilliantly hued, hard-edged series which he called chromatics, resounding with an exuberance of color. But despite unabashed display of intense color, pigments were never applied expressively or subjectively. Both the particular chromatic assignments and the formal structure of the surface design were carefully orchestrated according to a master plan. One of Bayer's favorite progressions used in his painting structure is a precise mathematical system called a Fibonacci progression, after the thirteenth-century mathematician and astronomer of the same name (see fig. 24).[17] In stating, "I . . . have left aside the conventions of the pictorial in order to develop color concepts and to bring forward the self-expressive reality of pure color,"[18] Bayer stressed the "self-expressive" nature of his pure color. Even though Bayer's color is exuberant in this series of canvases, it is never freely expressed by the artist; it is applied methodically, not emotively, in a manner as structured as the flat design. Although this is

Figure 22. Herbert Bayer, *on the way to order,* 1954/69
Oil, 32" × 40"
(Collection Mr. and Mrs. Robert O. Anderson)

Figure 23. Herbert Bayer, *suspended*, 1965/9
Acrylic, 60" × 60"
(Herbert Bayer Collection and Archive, Denver Art Museum;
Gift of the Estate of Herbert Bayer)

Figure 24. Herbert Bayer, *curve from two progressions*, 1974/33
Acrylic, 30-1/4" × 30-3/16"
*(Herbert Bayer Collection and Archive, Denver Art Museum;
Gift of the Estate of Herbert Bayer)*

Figure 25. Herbert Bayer, *chromatic gate*, 1969/20
Oil, 80" × 60"
*(Herbert Bayer Collection and Archive, Denver Art Museum;
Gift of Marcor Housing Systems, Inc.)*

a seeming contradiction, one needs to realize that by the term "self-expressive" Bayer indicated that pure colors *themselves* are self-expressive, without any manipulation. With this understanding of Bayer's intentions, we realize that again his Bauhaus training asserted itself in a carefully planned order of color and form:[19]

> the pure colorfulness of the spectrum is the starting point. I recognized two psychological qualities of the primary colors: warm and cool. I divided the warm scale into divisions going from yellow through red to purple and in the cool scale leading from yellow through green to blue. placing the scales opposite each other or running in opposite directions or the two scales running parallel produced unexpected results. the neighboring opposites testifying to the relativity of color in nearly endless vistas of variations opened up a long view. when seen in detail, there appears less emphasis on harmony and more evidence of contrast and vibrations because complimentary [sic] effects appear naturally from the positioning of opposites.[20]

Although Bayer stated with regard to his chromatics that he wanted to "forget all my previous work and thought and to start again fresh and new at zero,"[21] we see that even this later series is inexorably tied to Bauhaus concerns. The chromatics are especially indebted to Kandinsky's training, recalling the same issues of Bayer's mural from the 1923 Bauhaus wallpainting workshop—the psychological relationship between color and form.

The chromatics, such as *chromatic gate* (1969, fig. 25), culminated Bayer's exploration of Bauhaus lessons; in them he demonstrated his total mastery of the lessons of that school. But while all of the artist's paintings up through the chromatics built upon what he had learned at the Bauhaus, his last series, the anthologies, *exceeded* Bauhaus lessons. In the anthologies, to which we will turn in a later chapter, Bayer synthesized all that he worked through in a lifetime and moved beyond Bauhaus ideology to a higher, personal, mature language of painting.

If the paintings prior to Bayer's anthologies were not always pathbreaking, they served an important function. They enabled Bayer to experiment with ideas not immediately applicable to other media. Because of the special relationship of his paintings to his other work, this review of directions in his early canvases better prepares us for approaching Bayer's work in other media, and for examining the relationship between the fine and commercial aspects of his oeuvre.

The Relationship between the Fine Arts and Commercial Work in Herbert Bayer's Oeuvre

It is useful to consider the special nature of Bayer's imagery, specifically the relationship between the forms of Bayer's "fine" art and those of his commercial work, and to examine the source of his unusual ability to integrate these two aspects of his work. Bayer's creative direction was based on the Bauhaus premise that no one art form was inherently better than any other, whether it be painting, photography, graphic design, or weaving. The school's curriculum was predicated on a belief that by integrating all forms of art and design among themselves and into the structures of modern life, the condition of the world would improve. Not choosing to be the proverbial ivory tower where young adults could hide away to master anachronistic art forms, the Bauhaus instead embraced industry and the machine and strove to teach a functional approach to design in the modern world. Herbert Bayer's approach to art and design was formed, almost exclusively, by this Bauhaus philosophy, and his values and attitudes toward the position of art in the world continually reflected his Bauhaus experience.

Because Bayer had been among the handful of early students of the Bauhaus who returned to the institution as masters,[1] he and his colleagues were exceptionally aware of the importance of uniting the dual set of skills which in the early days of the school required two separate masters to teach the "craft" and "form" in each workshop. He was part of a new generation of broadly educated artists who made no distinction between manual and formal abilities. Beginning with the Bauhaus tenet that no qualitative hierarchies exist which distinguish any of the so-called "fine" and "applied" arts, Bayer went one step beyond what the Bauhaus taught and beyond any other previous application or interpretation of Bauhaus ideas.

Like other Bauhaus students, Bayer mastered a variety of artistic disciplines which could be used in creating integrated structures.[2] But beyond mastering and practicing enough disciplines to fill the curriculum of a typical art

school, Bayer merged traditionally separate disciplines in a remarkable way. In breaking down barriers between the arts, Bayer successfully borrowed devices traditionally associated with one medium and ingeniously applied them to another, creating a rich pictorial vocabulary imbued with fresh vitality. The freedom with which Bayer allowed one discipline to inform another resulted in unexpected, fertile blending; a new language of form became Bayer's fortunate legacy of working in many media simultaneously while allowing himself to move freely between them. During the years 1928–38, while working as a designer in Berlin, Bayer began to see the exciting results of his multidisciplinary approach. No doubt his success with the 1928 *Bauhaus* magazine cover combining photography and typography encouraged Bayer to continue experimenting with unusual combinations of media in finding original solutions to artistic problems.[3]

While working in Berlin, Bayer used photography for commercial purposes. He found in the photographic image a means of achieving an impersonal statement for graphic art. This impersonality almost always eluded the hand-drawn image, which contained unintentional peripheral meaning because of the inevitable presence of personal style. He likened the impersonality of a camera image to that of machine-made typography and welcomed its use in graphic production.

At the same time, Bayer involved himself with "fine art" photography. Creating photomontages and *fotoplastiken* no doubt had an impact on his commercial work as well, with similar images appearing in his graphics and photography, as well as in his paintings of the period. These years also were a time of discovery for Bayer of both the history of art and of modernist developments in the art world. Although art history was not a part of the Bauhaus curriculum, nor was any study of current artistic developments unrelated to the Bauhaus mode (i.e., movements other than Constructivism, De Stijl, etc.),[4] Bayer's natural intellectual curiosity asserted itself. During his Berlin years he educated himself about other movements such as Cubism and Surrealism, the latter having more impact on him than the former, and this new knowledge certainly found its way, however indirectly or unintentionally, into his work of the time. The ten years in Berlin, largely minimized in accounts of Bayer's life, sandwiched between the well-known Bauhaus years and the artist's new beginnings in America, may have been some of the most significant in providing a place and time for ideas to germinate. This period brought exposure to a variety of experiences and ways of thinking, an abundance of work assignments in which to try new solutions, and time for private studio work, which had been almost impossible at the Bauhaus, all providing an arena in which exceptional artistic growth was fostered. The resulting body of work shows Bayer as a master at integrating seemingly unrelated material

for maximum effect. The disjunctures and unusual relationships found in Bayer's work call to mind developments within Surrealism, but in Bayer's case, more often than not, the direct impetus did not come from Surrealism per se; the multilayered effect of Bayer's imagery can be more accurately linked to a free spirit of energetic creation with an artist exploring a number of media at one time.

There are some direct corollaries between forms included by Bayer in more than one medium, and even some identical imagery in painting, photography, and graphic design. For example, we have seen that the 1928 *Bauhaus* magazine cover was the precedent for Bayer's 1934 gouache *shadow over cone*. In the paintings *tender picture E* and *the world of letters,* both from 1928, letters appear as if lifted directly from a set of die-cast type used in graphic production; they are propped up in a kind of shallow stage setting in the former, and in the latter they float within a pictorial structure of spatial ambiguity. The following year, 1929, a similar letter of the same type design appeared in a photomontage entitled *profil en face*. In fact, the same reversed "R" appears in the 1928 *world of letters* and the 1929 *profil en face.*

The contrived, if unmeasurable stage settings found in the photomontage *profil en face* and the watercolors *world of letters, park of flat trees,* and *world on boards* share similar sources. It is easy to make connections between these and works by de Chirico which are visually similar, sharing a similar stage-set-like imagery. Yet further consideration encourages one to make the more logical connection between these images and the simultaneous spatial concerns with which Bayer was then grappling, those of designing exhibition structures with similar flat skeletal members. Bayer's artistic growth relied on allowing one medium to feed material to another for a rich source of image and symbol.

In *studio beach,* a mixed media combination of gouache and collage, Bayer included not only the drawn image of a woman seated in a studio set foreground of a hand-drawn landscape, but also the photograph from which the drawn model and pose derived, commenting on the levels of reality and of image source in his works of the period.

Certain imagery appears and reappears throughout Bayer's work. We have already seen the repeated use of the letter, or more specifically, the metal die-cut type piece, an element from the world of graphic design which found its way into painting and photography. Images of bones appear simultaneously in painting and photography, as do depictions of farm implements hung against stable walls. Bones are the subject of Bayer's 1930 photomontage *bone and fruit piece;* his *fotoplastik* of six years later, *bones with sea* (1936); and his gouache, *remembrance,* and oil, *bones,* both of

1930. Clouds enter so many works of the time that only a few will be mentioned: the gouache *cloud picture* (1928); a watercolor, *world of letters;* the gouache and collage *studio beach;* the photomontages *profil en face* and *monument* (1932, fig. 26).[5]

It is quite possible that these images of bones and clouds originally found their way into Bayer's oeuvre because of their association with dreams and the subconscious, the metaphors of Surrealism, a movement which had such widespread influence that in Berlin Bayer scarcely could have ignored it. Yet other forms which appear regularly are more directly related to the artist and particularly to his personal childhood memories. The images of stable walls, with their interesting, often biomorphic shapes, at first seem closely related to the dreamy, biomorphicized forms of Surrealism. But even though it probably was exposure to Surrealist examples that encouraged Bayer to explore these forms at that particular time, the forms themselves are easily traced to Bayer's memories of his *Wandervogel* days in Austria:

> my fascination and admiration of the old peasant houses dates back to my *wandervogel* days (1916–1919) when I was hiking through the austrian countryside. of special interest were the barns and stables into which were cut windows of various and ornamental shapes, which are probably of baroque origin. these "windows" serve as vents for the hay stored in the barns and are called *dunstlöcher*. against those walls are leaning or hanging on hooks all sorts of implements . . . shovels, rakes, harrows, thrashing clubs, ladders, hooks, poles to hang the hay to dry in the fields, ropes, etc.[6]

Again one finds a subject used concurrently in a variety of media. From 1936 there are two gouaches derived from the image of stables, *wall picture* and *stable windows with rope* (fig. 27), and two relief sculptures of wood and wood cement, *wall sculpture with two holes* and *wall sculpture*. Two oils with similar themes are *barn windows* of 1936 and *deposition* of 1940 (fig. 28). In photography, many compositions based on the stable wall appeared, including *stable wall* (fig. 29) and *wall with shingles,* both of 1936.

While the images of stable walls are quite personal, other images have been used by Bayer precisely because of their universal, anonymous quality. They are neither significant to Bayer personally, nor are they evocative of anything beyond themselves, as are the forms of Surrealism. Alexander Dorner recognized this quality in Bayer's use of the eye, the hand, letters, etc., which Dorner called "common signs."[7] Bayer also used well-known images from the history of art whenever it suited his need. He felt that these images, having been a part of our culture for so long, were emotionally neutral in the same way that a piece of machine-made typeface or a photograph could be impersonal. Today many of these images have become so hackneyed that Bayer's pastiche use of them sometimes appears amusing. Nonetheless,

Figure 26. Herbert Bayer, *monument*, 1932
 Photomontage, 14″ × 11″
 *(Herbert Bayer Collection and Archive, Denver Art Museum;
 Gift of the Estate of Herbert Bayer)*

Figure 27. Herbert Bayer, *stable windows with rope*, 1936/8 Gouache, 13-1/2" x 18" (Herbert Bayer Collection and Archive, Denver Art Museum; Gift of the Estate of Herbert Bayer)

Figure 28. Herbert Bayer, *deposition*, 1940/2
Oil, 36" × 42"
(Collection Britt Bayer; photograph by Javan Bayer)

Figure 29. Herbert Bayer, *stable wall*, 1936
Fotoplastik, 11" × 14"
(Herbert Bayer Collection and Archive, Denver Art Museum;
Gift of the Estate of Herbert Bayer)

from the standpoint of some fifty years ago, this was a serious use of famous images. Some of those that were adapted for Bayer's graphic production are: Polykleitis' *Doryphorous* (fig. 30), into the cover design for the Berlin exhibition "Das Wunder des Lebens" (1935, fig. 31); Myron's *Discobolos* (fig. 32) into a Chlorodont toothpaste advertisement (fig. 33); Praxiteles' *Hermes* (fig. 34) into an advertisement for Adrianol Emulsion nosedrops (fig. 35); Pisa's famous campanile, the leaning tower (fig. 36); emphasizing the ability of a medical product, Bellergal, to stabilize, inserted into a pamphlet for the product (fig. 37); Botticelli's *Venus* (fig. 38) in an advertisement for Noreen hair products (fig. 39).

Not only direct imagery but also style was taken by Bayer from the "fine" art realm and applied to commercial work. As easily as Bayer allowed letters and photographic effects from the commercial genre to enter paintings and drawings such as *world of letters* and *studio beach,* styles found in modern painting also infused Bayer's graphics and brought to them an interest which invited prolonged attention, a quality beneficial to graphics with a message to deliver.

Two modern masters to whom Bayer appears to have responded in graphics are de Chirico and Magritte. De Chirico's *The Song of Love* (fig. 40), with its own adaptation of a classical head, seems to be the source for the male head in Bayer's 1943 exhibition display *Imagineering* (fig. 41). In a graphic campaign for Cohama neckties of the same time, 1943–45 (figs. 42 and 43), a de Chirico-esque space is transformed in the graphic dialectic. Sharp linear recessions into space highlight the presentation of this company's neckwear, which looms large in comparison to smaller figures, reminiscent of those found in de Chirico compositions (fig. 44). Bayer indicated an early knowledge of de Chirico, a fact that supports this connection.[8]

In another clothing advertisement, of 1937, Bayer created a Magritte-like composition of a Surrealist-inspired landscape inhabited by smartly suited male figures (fig. 45). Bayer stated that while he was in Berlin he became familiar with the work of this Belgian Surrealist, through a Belgian magazine that previously had published one of his own paintings.[9]

Other advertisements that seem to have been inspired by examples in painting are advertisements for Delvinal Sodium sleeping aids and for Noreen hair color. The sources for these works, of 1940 and 1953, respectively, are less direct than in previous examples. The Delvinal advertisement (fig. 46) surely finds its source in the dream imagery of Surrealist forms. In fact, it looks very much like Max Ernst's later painting *Le Jardin de France* (1962, fig. 47). Bayer's graphic image shares the dreamy nocturnal atmosphere of the Ernst, but Bayer adds scientific data to the seductive image to promote a product surely capable of luring one to sleep.[10]

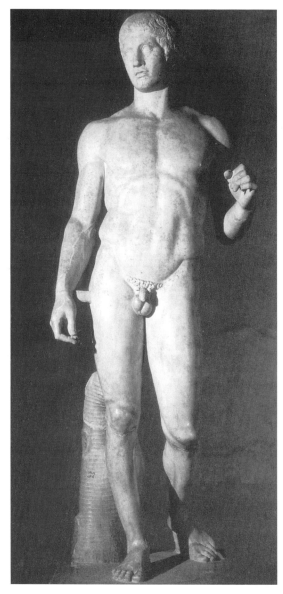

Figure 30. Polykleitis, *Doryphorous,*
ca. 450 B.C.
Marble; Roman copy
(Museo Nazionale, Naples)

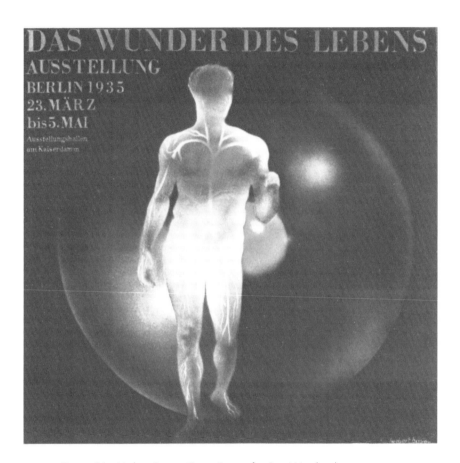

Figure 31. Herbert Bayer, Cover Design for *Das Wunder des
Lebens* Exhibition Catalog, 1935
*(Herbert Bayer Collection and Archive, Denver Art Museum;
Gift of the Estate of Herbert Bayer)*

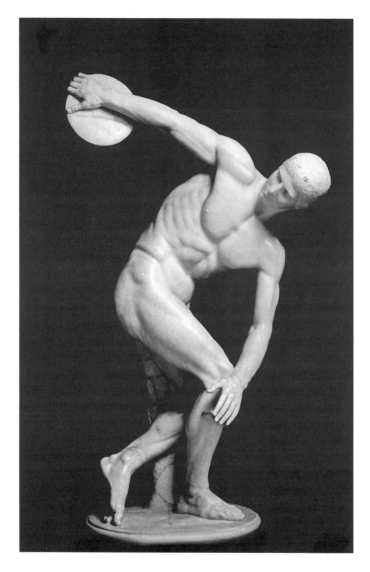

Figure 32. Myron, *Discobolos*, ca. 450 B.C.
Marble; Roman copy
*(photograph courtesy Ministero per i Beni e le Attività Culturali—
Soprintendenza Archeologica di Roma)*

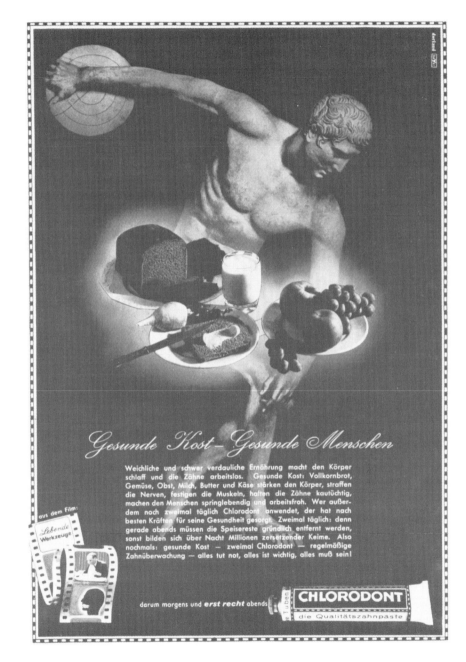

Figure 33. Herbert Bayer, Chlorodont Toothpaste Advertisement, 1937
(Herbert Bayer Collection and Archive, Denver Art Museum;
Gift of the Estate of Herbert Bayer)

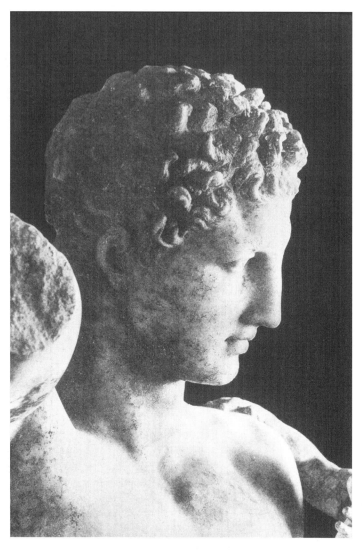

Figure 34. Praxiteles, *Hermes,* ca. 340 B.C.
Marble
(Museum, Olympia)

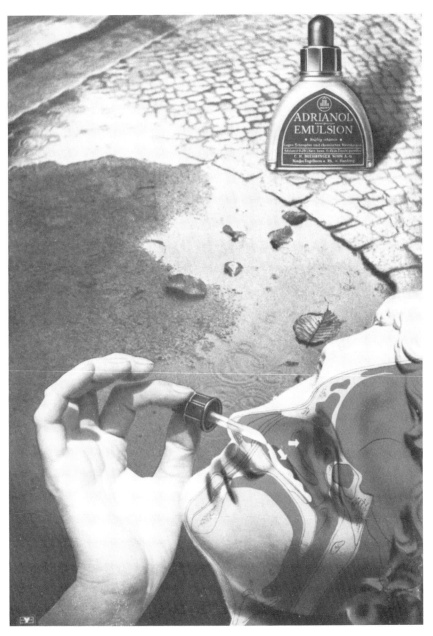

Figure 35. Herbert Bayer, Adrianol Emulsion Advertisement, 1935
(Herbert Bayer Collection and Archive, Denver Art Museum;
Gift of the Estate of Herbert Bayer)

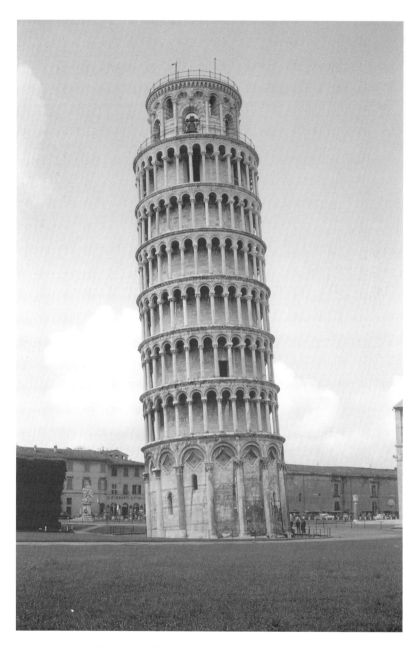

Figure 36. Campanile, Pisa, Italy, 1053–1272

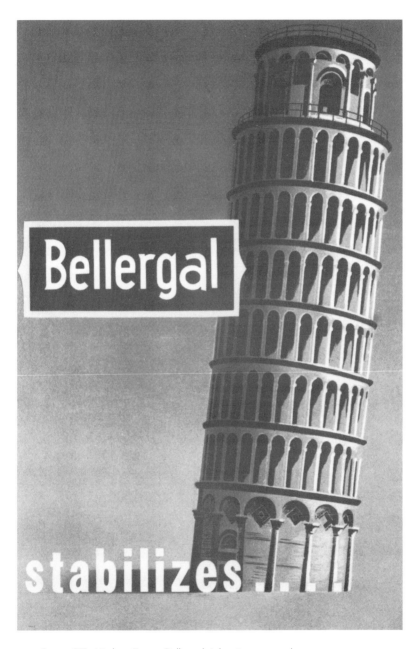

Figure 37. Herbert Bayer, Bellergal Advertisement, n.d.
(Herbert Bayer Collection and Archive, Denver Art Museum;
Gift of the Estate of Herbert Bayer)

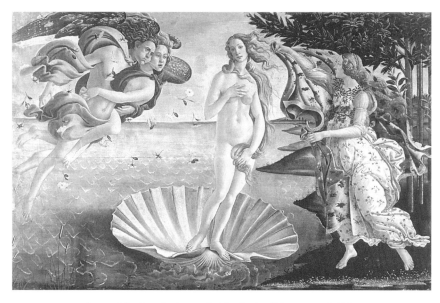

Figure 38. Sandro Botticelli, *The Birth of Venus*, ca. 1482
Tempera, 68″ × 109″
(Galleria degli Uffizi, Florence)

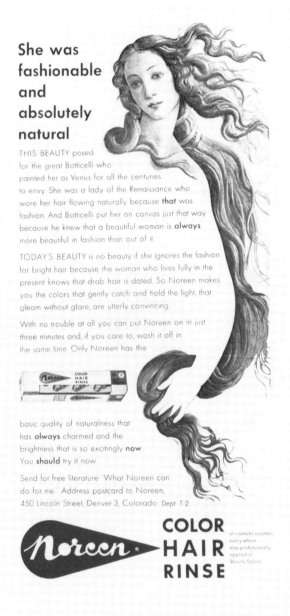

She was fashionable and absolutely natural

THIS BEAUTY posed for the great Botticelli who painted her as Venus for all the centuries to envy. She was a lady of the Renaissance who wore her hair flowing naturally because *that* was fashion. And Botticelli put her on canvas just that way because he knew that a beautiful woman is **always** more beautiful in fashion than out of it.

TODAY'S BEAUTY is no beauty if she ignores the fashion for bright hair because the woman who lives fully in the present knows that drab hair is dated. So Noreen makes you the colors that gently catch and hold the light, that gleam without glare, are utterly convincing.

With no trouble at all you can put Noreen on in just three minutes and, if you care to, wash it off in the same time. Only Noreen has the

basic quality of naturalness that has **always** charmed and the brightness that is so excitingly **now**. You **should** try it now.

Send for free literature "What Noreen can do for me." Address postcard to Noreen, 450 Lincoln Street, Denver 3, Colorado Dept T-2

Noreen • COLOR HAIR RINSE

at cosmetic counters everywhere. also professionally applied in Beauty Salons

Figure 39. Herbert Bayer, Noreen Advertisement, 1953
*(Herbert Bayer Collection and Archive, Denver Art Museum;
Gift of the Estate of Herbert Bayer)*

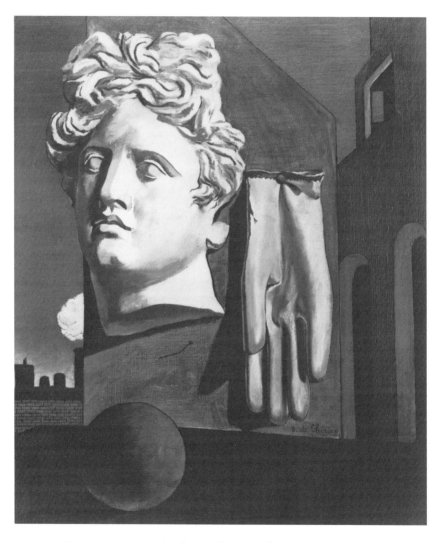

Figure 40. Giorgio de Chirico, *The Song of Love,* 1914
Oil, 28-3/4" × 23-3/8"
*(Collection The Museum of Modern Art, New York City;
Nelson A. Rockefeller Bequest)*
© 2004 Artists Rights Society (ARS), New York / SIAE, Rome

Figure 41. Herbert Bayer, *Imagineering Display*, Packaging Exhibition, New York, 1943

Figure 42. Herbert Bayer, Cohama Necktie Advertisement, 1943–45
(Herbert Bayer Collection and Archive, Denver Art Museum;
Gift of the Estate of Herbert Bayer)

Figure 43. Herbert Bayer, Cohama Necktie Advertisement, 1943–45
(Herbert Bayer Collection and Archive, Denver Art Museum;
Gift of the Estate of Herbert Bayer)

Figure 44. Giorgio de Chirico, *Evangelical Still Life*, 1917–18
Oil, 35-1/2″ × 23-5/8″
(Private collection)
© 2004 Artists Rights Society (ARS), New York / SIAE, Rome

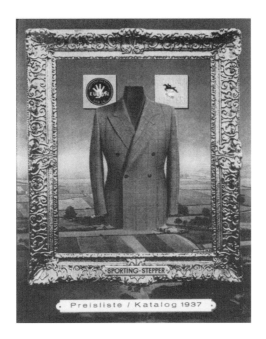

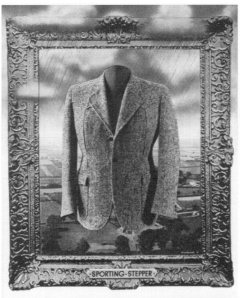

Figure 45. Herbert Bayer, Sporting Stepper
Advertisements, 1937
(Herbert Bayer Collection and Archive,
Denver Art Museum;
Gift of the Estate of Herbert Bayer)

Figure 46. Herbert Bayer, Delvinal Sodium Advertisement, 1940
(Herbert Bayer Collection and Archive, Denver Art Museum;
Gift of the Estate of Herbert Bayer)

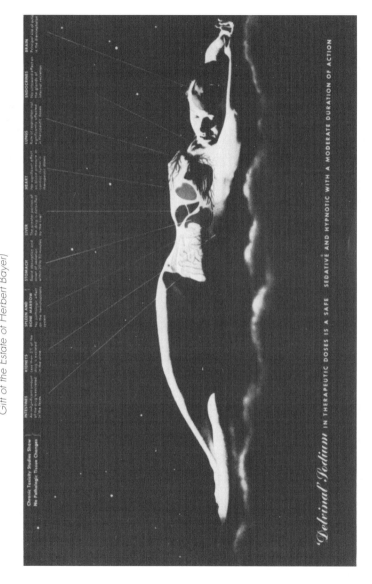

Figure 47. Max Ernst, *Le Jardin de France*, 1962
Oil
(Musée National d'Art Moderne, Centre Georges Pompidou, Paris)
© 2004 Artists Rights Society (ARS), New York / ADAGP, Paris

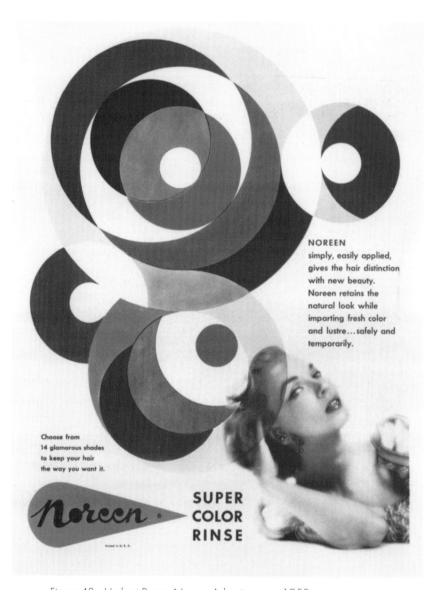

Figure 48. Herbert Bayer, Noreen Advertisement, 1953
(Herbert Bayer Collection and Archive, Denver Art Museum;
Gift of the Estate of Herbert Bayer)

Figure 49. Sonia Delaunay, *Robe simultanée*, 1913
 Lacquer on paper, mounted on cardboard, 12" × 10-3/4"
 (Kunsthalle Bielefeld, Germany)

She wore ornaments to put color in her hair

IN OLD JAPAN...this charming coiffure was combed over wires, ornamented with silver and coral by a dozen dedicated hairdressers. Once perfected, the lady who wore it couldn't change a single lock. It was fashion, but it was a fixture.

TODAY...when color in hair is an absolute fashion, Noreen Color Hair Rinse lets you do *everything* about it yourself. Only with Noreen can you change *to* fashion in just three minutes and change *fashion* just as quickly because Noreen washes out just as fast as it goes on. Among the fourteen convincing Noreen colors there are several glorious shades of blondeness, more than one way to be a redhead, burnishes to make a brunette newly exciting, even magic to turn gray hair an alluring silver. Now you can change until you find the *perfectly* becoming color, and you may find several. Do make the Noreen-change for the beautiful, today. Send for literature and a FREE Noreen sample offer. Address postcard to Noreen, Inc., 450 Lincoln St., Denver, 3, Colo., Dept. G1

Noreen ®

COLOR HAIR RINSE

At cosmetic counters everywhere
Also professionally applied in beauty salons

Figure 50. Herbert Bayer, Noreen Advertisement, 1953
*(Herbert Bayer Collection and Archive, Denver Art Museum;
Gift of the Estate of Herbert Bayer)*

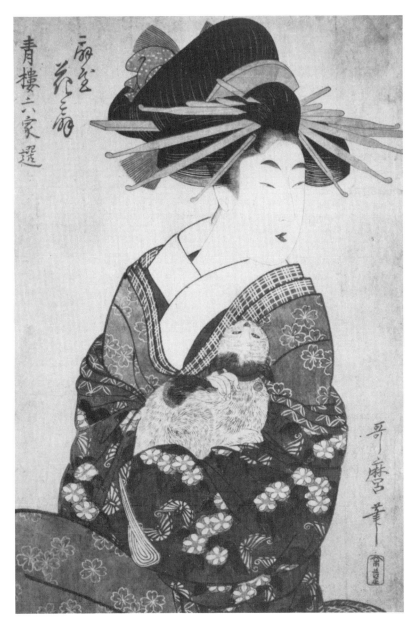

Figure 51. Kitagawa Utamaro, *The Yujo Hanaogi Holding a Cat,*
18th Century
Japanese woodblock print.

The colorful spherical designs of some of Bayer's 1953 Noreen advertisements (fig. 48) call to mind the paintings of Robert and Sonia Delaunay (fig. 49) and of the Abstraction-Creation group. One wonders if Bayer had these sources in mind, or if by the 1950s this painting style had already become such a part of the modernist milieu that he could transfer it to graphics quite without intention. Finally, another Noreen advertisement (fig. 50) reflects female images seen in Ukiyo-e prints (fig. 51).

In exercising the freedom to incorporate images and styles from the fine arts into commercial work and from commercial work back into the fine arts, Bayer's results were exceptional. His early fertile blending provided surprising combinations which even today catch our attention and make us think. Herbert Bayer took the lesson of the Bauhaus, that all the arts should be valued equally and should be used side by side in integrated structures, and pushed it one step further. Not content with merely practicing many art forms, Bayer combined what he knew about one medium with that of another and his images in all media profited. In order to understand the exceptional nature of Bayer's early works, this unique relationship between the forms of his so-called "fine" and "commercial" art needs to be recognized as a special source for his imagery and style.

5

Bayer's Life in America

Bayer's American years may be divided into three periods based on his geographical location. Between the years 1938 and 1946 Bayer lived in New York City. The Aspen, Colorado years followed, from 1946 to 1975. Finally, in 1975 Bayer moved to Montecito, California, where he resided until his death in 1985.

Pasted into one of Bayer's early sketchbooks is a calendar page torn from a datebook. The date is "Montag, 26 Juli 1937." Scrawled across the page are the words "leave for america."[1] Although Bayer did not immigrate until 1938, this 1937 date refers to a visit which proved extremely important in deciding the course of his future in the United States. Bayer described the purpose of this visit: "to look around and go to . . . [a] meeting that we had up in Providence about the forthcoming Bauhaus exhibition at the Museum of Modern Art . . . and also to settle on the status of the New Bauhaus in Chicago."[2] Beyond Bayer's original objectives, the meeting in Providence, Rhode Island, where Gropius had rented a house for a few summer weeks, was particularly fortuitous for him.

In addition to Bayer, the group in Providence included Walter Gropius, Marcel Breuer, Alexander Dorner, László Moholy-Nagy, Mary Cook (later to become Mrs. Edward Larrabee Barnes), and John McAndrew, then curator of architecture and industrial art at the Museum of Modern Art.[3] At this meeting it was decided that Bayer, who was due to return to Europe, would be responsible for collecting and shipping material for the Bauhaus exhibition. Upon his return to the United States he also would organize the exhibition, write the catalog, and design the exhibition space. This important assignment was without doubt the most significant factor enabling Bayer's fast recognition in this country.[4]

Returning to New York in 1938, Bayer set to work putting together the Bauhaus exhibition. He recalled working long into the nights in an office in the basement of Rockefeller Center, where the Museum of Modern Art then

was located.[5] He was almost single-handedly responsible for the exhibition, receiving virtually no assistance from Gropius and only minimal assistance with the text from Mrs. Gropius.[6] Bayer's recollections of working alone are corroborated by letters in which Gropius apologized for leaving him to work alone on the project.[7]

Bayer had intended to accept an offer tendered by Moholy-Nagy to join the faculty of the New Bauhaus in Chicago. But aboard ship on his way to New York, Bayer received word that the school would soon close because of deteriorating finances; they had lost large sums in the stock market.[8] Nonetheless, he arrived in America with optimism.

Soon after his arrival, the artist also met his future wife Joella Haweis Levy (the former Mrs. Julien Levy), whom he married in 1944.[9] Not only was Joella Bayer a constant source of personal strength and guidance to him over the years, but she was such a part of the New York cultural climate in the early years that she helped Bayer make the transition to this country.

Bayer spent his first eight American years in New York. "I was impressed by America, impressed by the idea of freedom. I took out my citizenship papers the same day I arrived."[10] He lived in the city and spent summers on Long Island where he shared a rented house with José Luis Sert, who wrote the 1942 anthology, *Can Our Cities Survive?*, for which Bayer produced a dust jacket design incorporating photomontage. For at least some time in 1942–43, he shared a house in the city with Stamo Papadaki.[11] He remained close to his former Bauhaus colleagues, especially Gropius and Breuer, and he spent considerable time with Siegfried Giedion, helping him with the layout and order of his now well-known books.[12] But as is probably the case with most recent emigrés, Bayer felt alone and displaced in New York, a feeling which could only have been amplified by his generally melancholic personality and an unsatisfactory relationship with his daughter, a result of estrangement from his former wife. Although he immediately adopted the English language, avoiding the more typical habit of speaking to fellow Germans in their native tongue, Bayer found it difficult to adjust to customs of the New World, especially the crowded streets and the American lack of public modesty.[13] In addition to enduring financial difficulties, he became ill, losing thirty pounds in early 1943.[14] In a sketchbook entry of 1943, the artist revealed his unhappy feelings about his life in America: "I have gotten so terribly irritated in the course of these last four years I am not living, I only drag myself along, unhappy, sad and unsmiling. There is no joy in anything. . . . here I feel completely uprooted."[15] In another entry of the same year he wrote: "how can I stop that nonsense of a life and live my years conscious of the hours and not just racing against time and myself. nothing left at the end?"[16]

In New York Bayer designed three major exhibitions for the Museum of Modern Art, "Bauhaus 1919–1928" (1938), "Road to Victory" (1942), and "Airways to Peace" (1943). He also designed some lesser-known Museum of Modern Art exhibitions such as "Arts in Therapy." But despite the wide public exposure accorded by these exhibitions, Bayer's mainstay remained, as it had been in Germany, advertising work. In 1942 he produced some well-received graphic projects, including his full color advertisements and large booklet for General Electric Company, produced through the N. W. Ayers Company. Bayer's booklet was highly regarded by contemporary designers as a pioneering work.[17] He became chief art director of the John Wanamaker Department Store (1941–42), the J. W. Thompson Advertising Agency (1944), and Dorland International (1945–46).[18] In 1945 he designed an exhibition for Container Corporation of America, Chicago, "Art in Industry." Bayer had done graphics for Container Corporation as early as 1938, and by 1946 he began a full-time commitment to working with Walter Paepcke, the company's chairman.

Bayer moved to Aspen, Colorado in 1946 to implement Paepcke's vision of creating a cultural retreat for business executives. As design consultant for the development of Aspen and as consultant and architect for the Aspen Institute for Humanistic Studies, Bayer's name soon became synonymous with the cultural development of that mountain community. Beginning in 1946 Bayer also was design consultant to Container Corporation of America, serving as chairman of its department of design from 1956 until 1965.[19] Toward the end of the 1960s, Bayer also designed the international traveling exhibition, "Fifty Years Bauhaus."

By 1966, Bayer had become the art and design consultant for another of America's large corporations, the Atlantic Richfield Company, directing design and aesthetic concerns throughout its worldwide locations. Like his previous relationship with Walter Paepcke, Bayer's relationship with Robert O. Anderson, chairman of the board of Atlantic Richfield Company, became particularly close, both personally and professionally. Bayer's influence in the company was pervasive and continues to be seen at all levels.

In 1975 Bayer left Aspen because of declining health and relocated to Montecito, California, near Santa Barbara.[20] Here he divided his time between Atlantic Richfield responsibilities, other environmental projects, and painting.

In America Bayer continued to work in many of the same areas as in Germany, but in Europe he was within avant-garde circles, while in the United States he was an anomaly. His innovations became forces for change in this country. We shall examine the various aspects of his career here, attempting to determine America's influence on Herbert Bayer and especially Herbert Bayer's position within and impact on American art and design.

6

Graphic Design and Typography

Innumerable problems await the talents of designers who can make the complicated appear simple, make the abstract and invisible, pictorial.
—Herbert Bayer, *herbert bayer, painter, designer, architect*

Visual communication is the unifying concept guiding all of Bayer's design work. In every design, whether for advertising, exhibitions, or environments, designers reach audiences through visual communication, ordering the parts of a whole to achieve a unified, directed statement. The visual relationship between a design and those who see it is paramount, especially in two-dimensional work in graphics and typography, which lack other experiential elements such as time and space. Rather than the evolving experience of an exhibition or environment comprising a series of events, the impact of a graphic design is instant. (Certainly we recognize the movement of the eye across a composition and across type, but the immediate visual impact is the primary and lasting one.)

Bayer was at the center of early investigations into avant-garde design concepts and recognized early the immediate power of well-designed graphics from studying the psychology of visual communication in flat design work. He was a particularly forceful spokesman for the new graphics and typography in America, precisely because he had been present at its early evolution in Europe. By the time he left for America, Bayer had practiced the newest design concepts for a decade and a half, had founded and run the graphic printing workshop at the Dessau Bauhaus, and had been in close association with virtually all of the great innovators in the field including El Lissitzky, László Moholy-Nagy, Theo van Doesburg, and Jan Tschichold.

The new language of graphics and typography matured during the late teens and the twenties and flourished between the wars. Yet precedents for this new vision may be found in the previous century. Although at their inception these early examples were viewed as anomalies, in retrospect one

understands that early experiments foreshadowed later graphic innovations. For example, in the nineteenth century the German poet Arno Holz (1863–1929) used nonconformist devices such as omitting punctuation or using multiple punctuation marks for deliberate emphasis. In 1866 Lewis Carroll experimented with the idea of figurative (concrete) poetry for his "Mouse's Tale" in *Alice in Wonderland.* Here the type configuration created the image of a mouse's tail extending down the page. Mallarmé's 1897 poem "Un Coup de Dés" (A Throw of the Dice) consisted of a twenty-page, seven-hundred-word poem of unexpected typographic arrangement.[1]

Apollinaire's book *Calligrammes,* of 1918, is probably the best known early exploration of concrete poetry. But in fact, sporadic explorations of typographic pictures predate even the nineteenth century. Nevertheless, it was the collective effort in the twentieth century to develop a new language of form that provided a favorable milieu in which the new typography and graphics could be systematized and explored within a larger, liberated context.

The Futurist vision had called for dynamic typography, free of the traditional typographic structure of horizontals and verticals. Marinetti's article in the June 1913 issue of the journal *Lacerba* announced a typographic revolution against harmony and the classical tradition. Dada further liberated typographic design with experimentation utilizing not only chance but also the planned creation of concrete typography, continuing from Apollinaire. Dada use of photomontage for dynamic juxtaposition further increased visual impact. Raoul Hausmann, John Heartfield, and Hannah Höch's montage effects, and Kurt Schwitters's less politically motivated Merz pictures opened new expressive possibilities with unconventional means.

All of these experiments were liberating precedents which cleared the way for a new language of typography and graphics. By deconstructing the traditional order of the printed page, a new order could emerge.

A new order found its way into poster design, a medium whose form found favor in the late years of the nineteenth century and whose popularity did not wane in the twentieth. From as early as about 1905 and for the next twenty years, Lucien Bernhard and his associates at the Berlin office of the printing firm Hollenbaum and Schmidt developed a poster format of flat, reduced, but descriptive shapes with sparse sans serif lettering. Bernhard's poster style introduced a standard format of a product name and a simplified image on a flat ground. By 1910 a typeface design based on Bernhard's sans serif lettering style was produced by the Berthold Type Foundry in Berlin.

In his book *A History of Graphic Design,* Philip Meggs points out radical differences between the design of World War I posters by the Central Powers (Germany and Austria-Hungary), which relied on powerful symbolic shape

and pattern, and those of the Allies, which were more illustrative with literal rather than symbolic images.[2] Confirmation of this analysis may be found in a comparison of James Montgomery Flagg's famous 1917 American recruitment poster (fig. 52) with the words "I Want You" (based on Alfred Leete's British recruiting poster of Lord Kitchener of two years earlier) with a German poster of the same year by Julius Gipkens, advertising an exhibition of captured airplanes (fig. 53). It would not be until the influx of European modernist artists, among them Bayer, that American posters would demonstrate such powerful, intense graphics.

Russian Constructivism was one of the most potent forces for new design after World War I. Rodchenko and especially Lissitzky, who moved to Berlin in 1921, were particularly influential. With postwar Germany developing as a center for ideas of the Russian "experiment," De Stijl, Dada, and Bauhaus, the new language developed rapidly across international lines.

Lissitzky's unprecedented experimentation with graphic design and photomontage effects led the way for Russian avant-garde ideas to enter western Europe. He had studied in Darmstadt early in the century and later was a frequent visitor to the Bauhaus, which had already become a center for experimentation. His investigations became well known, finding their way not only into such European enterprises as a 1924 double issue of *Merz*, but even into the radical American little magazine *Broom*, which commissioned title pages and graphics from the artist in 1922.

The year 1924 saw the collaborative publication by Lissitzky and Arp of *The Isms of Art*, which heralded new typographic modes for the modern movement: three-column vertical grids defined text, three-column horizontal grids shaped the title page, and sans serif typography was put into service for all.

De Stijl influence also was potent, with the Dutchman van Doesburg its most ardent spokesman. Moving to Weimar in 1921, he remained until 1923, teaching classes in De Stijl philosophy which were attended predominantly by Bauhaus students.[3] De Stijl typography eliminated curved lines, organized type into tight rectangular blocks, sought asymmetrically balanced layouts based on an open, implied grid, and utilized sans serif types. Red was favored as a second color because of its ability to compete with the otherwise dominant black print. In September of 1922 the energetic van Doesburg convened the International Congress of Constructivists and Dadaists in Weimar. Among those who attended were Lissitzky, Schwitters, and Moholy-Nagy.

By the mid-twenties a new graphic language which relied on several mutually sympathetic modernist modes had crystallized. If we can name a single physical center for the exchange of these new ideas, surely it would

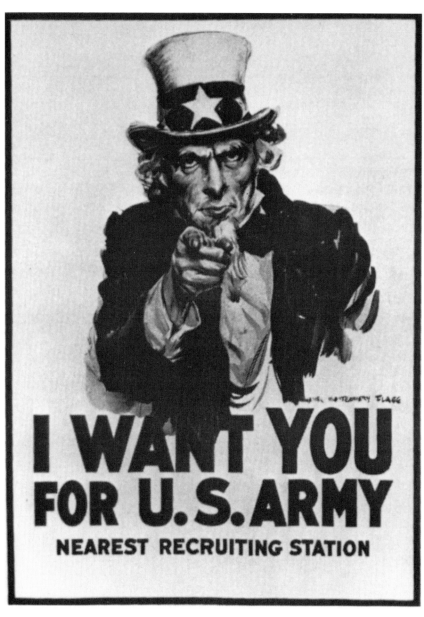

Figure 52. James Montgomery Flagg, Recruitment Poster, 1917

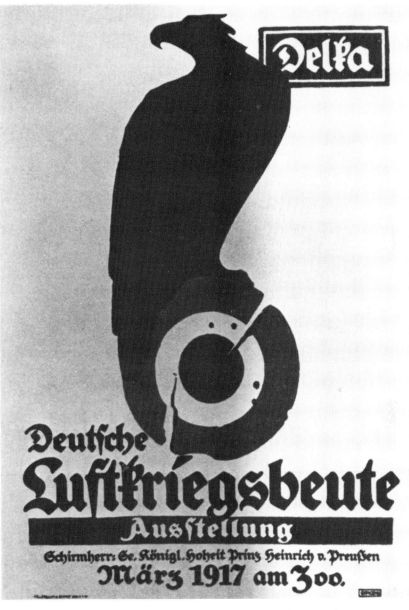

Figure 53. Julius Gipkens, Poster for Exhibition of Captured
Airplanes, 1917

be the Bauhaus. And clearly Bauhaus masters were responsible for promoting the new style. For example, the short-lived periodical *i10,* edited by Arthur Lehning and published between January 1927 and July 1929, reflected forms of De Stijl and Bauhaus. Moholy-Nagy created the first cover (with the help of César Domela) and assisted in planning the layout.

As director of the graphic printing workshop, Bayer could scarcely have been uninvolved in this exciting experimentation. Indeed, examples of Bayer's graphic production from 1923 to his departure in 1928 confirm that he was developing his own graphics and typography along these same modernist lines. His work demonstrates simple geometric design, sans serif type, and the use of red as a contrasting color (see figs. 54 and 55).

Jan Tschichold was the person most responsible for introducing the new typography to a wide audience. Tschichold saw the 1923 Bauhaus exhibition and was extremely impressed by its statement. He assimilated Bauhaus and Constructivist concepts in "the new typography." During the 1920s he wrote articles and books to explain these new ideas to a wide audience of printers, typesetters, and designers. Bayer not only knew Tschichold, but assisted him in some writing; and Tschichold used some of Bayer's work to illustrate his texts. The two met while Bayer was in Weimar and Tschichold was living in nearby Leipzig. Their first meeting was in Leipzig, where Bauhaus students periodically went to visit the fairs. Later the two also met in Weimar and they discussed Tschichold's idea for a publication for *Typographische Mitteilungen.* Tschichold published an issue on the "Elementare Typographie" (1925) for which Bayer helped choose selections to be published.[4] Bayer was cited and his work reproduced in this issue, as well as in Tschichold's 1928 *Die neue Typographie. Ein Handbuch für zeitgemäß Schaffende.*

During the 1920s many German geometrically constructed, sans serif typefaces were designed. In Holland, Switzerland, and Czechoslovakia (where Ladislav Sutnar worked before immigrating to the United States) modern graphics also flourished. In England, Eric Gill's 1931 book *Essay on Typography* advocated ragged, unjustified lines. Henry C. Beck's 1933 use of bold graphics and color in the new London underground map was another outgrowth of this international modernist typographic revolution. The new typography enabled farsighted designers to develop a functional, rational visual style which continues to influence design even into the late twentieth century.

As we have seen, this movement was international in scope and derived from considerable European modernist sources from Apollinaire and Marinetti to Dada, De Stijl, and Russian Constructivism. The latter two sources began the graphic revolution which matured in the atmosphere of the Bauhaus as it became a physical center for the new ideas and practitioners. Bayer's

position at the Bauhaus placed him squarely within the development of this new language of graphic form.

By the time of the 1923 Bauhaus exhibition "Art and Technology, A New Unity," the expressive, romantic early years of the Bauhaus had given way to a new emphasis on applied modern design. The year 1923 also marked Itten's replacement by László Moholy-Nagy, the Hungarian Constructivist. This personnel change in a sense symbolized the new direction of the school. In place of Itten's mysticism, Moholy-Nagy brought to the Bauhaus a spirit of free experimentation in typography, graphics, and photography, all of which intermingled in the service of visual communication. He saw graphic design, particularly the poster, evolving towards what would come to be known as the *typophoto,* integrating word and photographic image to communicate an immediate message. Cognizant of the graphic potential of photography, Moholy-Nagy wrote in 1923 that photography in poster design could free the viewer from depending on any other person's interpretation.[5] This notion became central to Bayer's method, particularly in his Berlin years (1928–38) when he put his ideas into commercial practice.

＊ While Moholy-Nagy experimented with these ideas in 1923, Herbert Bayer was completing his student days at the Bauhaus, spending much of his time independently investigating problems in graphics and typography, though at this time there was neither a specialized course nor a functional workshop for it. Even before Moholy-Nagy arrived, Bayer was working within the newest design theories, as is evidenced by the two posters, two postcards, and directional signs which he produced for the 1923 exhibition (figs. 56 and 57). Even earlier work, such as Bayer's designs (never produced) for a light poster for the roof of a stained glass workshop (1922, fig. 58), indicates strong Constructivist and De Stijl influences in a geometric, clean design with sans serif type. Between 1924 and 1928, except for the interruption of his Italian sojourn, Bayer was busy perfecting his functional graphics. Stationery for Puka Reklame (1924), a catalog of Bauhaus products (1925), the Fagus Schaftmodelle folder (1925), a poster for a lecture by Hans Poelzig (1926), a book jacket for Kandinsky's book *Punkt und Linie zu Fläche* (1926), his poster for Kandinsky's sixtieth birthday exhibition (1926, fig. 59), and an invitation to the opening of the Bauhaus building, Dessau (1926) all evidence Bayer's mastery of avant-garde graphics and typography. The graphic designs for projected Regina toothpaste kiosks and for cigarette brand P (fig. 60), as well as for an open streetcar station with newsstand and an advertising sign for the electric company with flashing lights (all 1924) indicate that Bayer not only was assimilating Constructivist and De Stijl principles in flat graphics, but that he was ready to expand these concepts into functional three-dimensional structures with billboard graphics. While Bayer was still a student, Gropius had encouraged his independent

DAS BAUHAUS IN DESSAU

Dessau, Mauerstraße 36 Fernruf 2696 Diskontogesellschaft Filiale Dessau

KATALOG
DER
MUSTER

VERTRIEB
durch die

Figure 54. Herbert Bayer, Cover for Bauhaus Products Catalog, 1925

BAUHAUSBÜCHER

KANDINSKY

PUNKT UND **LINIE** ZU **FLÄCHE**

2. AUFLAGE

Figure 55. Herbert Bayer, Book Jacket for Bauhaus Book 9,
Kandinsky's *Punkt und Linie zu Fläche*, 1926
*(Herbert Bayer Collection and Archive, Denver Art Museum;
Gift of the Estate of Herbert Bayer)*

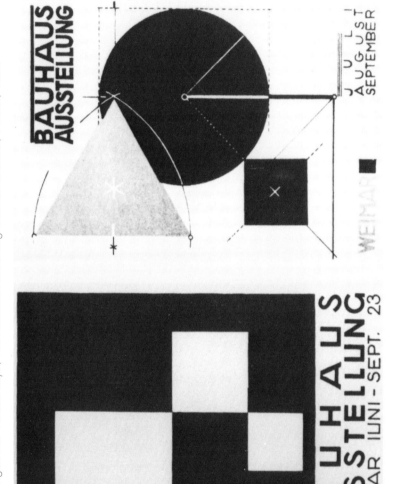

Figure 56. Herbert Bayer, Two Postcards Announcing Bauhaus Exhibition, Weimar, 1923

Figure 57. Herbert Bayer, Poster (Directional Sign)
for Bauhaus Exhibition, Weimar, 1923

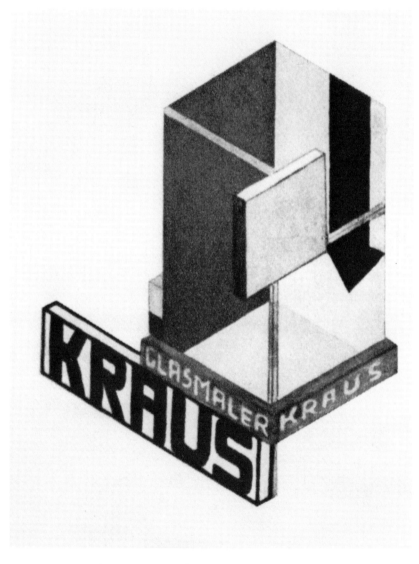

Figure 58. Herbert Bayer, Project for Light Poster for Stained Glass Workshop, Weimar, 1922

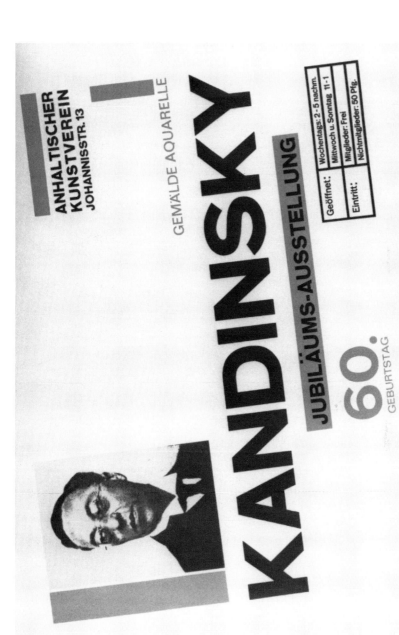

Figure 59. Herbert Bayer, Poster for Kandinsky Exhibition, 1926
24-1/8″ × 33-5/8″
(Herbert Bayer Collection and Archive, Denver Art Museum;
Gift of the Estate of Herbert Bayer)

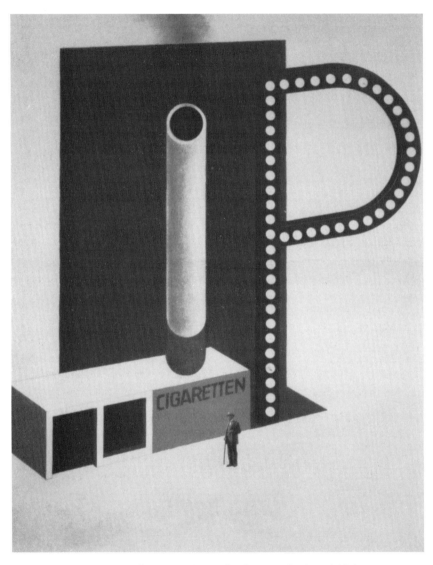

Figure 60. Herbert Bayer, Project for Cigarette Pavilion, 1924

typographic explorations. It was Bayer who designed the cover for the first Bauhaus book, the collaborative effort by Gropius and Moholy-Nagy, *Staatliches Bauhaus in Weimar 1919–1923.*

When the Bauhaus relocated to Dessau, Bayer formed and became master of a new workshop in typography and graphics. Bayer's workshop demonstrated the newest innovations in typographic design and implemented a practical printing shop which served the printing needs of Dessau businesses.[6] This service afforded both practical experience and financial remuneration for students. Bayer was instrumental in changing the look of every pictorial and written graphic of the school, even designing the "bauhaus" signage on the new, now famous building. Sans serif fonts were used almost exclusively and in 1925 Bayer convinced Gropius to adopt the use of only lower case letters for all official Bauhaus needs. Additionally, Bayer introduced DIN standards (German Industrial Standards) and began the inclusion of photographs in Bauhaus printed materials.

At first Bayer printed a four-line explanation at the bottom of the Bauhaus stationery, clarifying his decision to use only lower case letters.[7] In addition to citing the advantages of increased legibility and economy and the practicability of limiting one sound to one written letter, he referred to the work of the Berlin engineer Walter Porstmann who, beginning in 1917, had argued for standardization of spoken and written language, simplification, and the use of only lower case letters.[8] Porstmann is also mentioned by Bayer in his essay on the "basic alfabet" of 1958–60.[9] Porstmann's ideas were known at the Bauhaus through a lecture given there by the German advertising expert Weidenmueller, who had himself worked for the systematizing of advertising principles and a simplification of language and script. Weidenmueller's writings also were influential in the formation of Bayer's advertising principles.[10]

The year 1925 saw Bayer conceptualizing his "universal type" (fig. 61), envisioning it as a means "toward a new alfabet." Bayer's universal type consisted of a machine age alphabet whose simplified geometric form was more legible and appeared stylistically more cohesive than those derived from handwriting. Bayer's universal type included only one alphabet, of lower case, because, Bayer reasoned, since in speech there is no difference between a capital and small letter sound, there was no need for two written symbols. Bayer also thought that one alphabet would be more efficient to produce and would provide economic advantages.

Typographic innovation remained a lasting concern for Bayer. Although the practical consideration of client preference sometimes prevented him from designing typography exactly as he wished, he continued to theorize, to write about the written language, and to give his ideas practical application

Figure 61. Herbert Bayer, "universal type," narrow version, 1925

at every opportunity. As late as 1958–60, in the United States, Bayer designed a new, more efficient alphabet, expanding his early visions and creating his "basic alfabet" for improved visual communication; he continued to lobby for changes in the written language.

Following Bayer's departure from the Bauhaus in 1928, the artist was able to put into practice the concepts he had developed within the academic sector. By 1928 he was well respected among professionals and producing substantial work. One of his most gratifying experiences was the production of his "bayer type" by the Berthold Type Foundry in 1933.

After ten years of design production in Berlin, Bayer left for America as one of the world's most knowledgeable graphic designers. Although he initially came to the United States to create an exhibition design for the Museum of Modern Art, his graphic work had always been his financial mainstay in Europe. Twice, in 1931 and 1938, the respected journal *Gebrauchsgraphik* published comprehensive articles on him;[11] and he had been represented at important exhibitions of advertising art and typography, including two in 1929, one in Magdeburg and another at the Berlin Art Library.[12] Although the exodus of major artists and designers from Europe brought America some other great modern designers, we shall see that Bayer's role was particularly special in America because, in addition to his expertise as a first-rate designer, Bayer also demonstrated his abilities as an important spokesman and educator.

Prior to the 1930s, American graphic design had remained unaffected by the international modernist language. American regionalist painters had rejected the introduction to abstract art presented to them at the landmark 1913 Armory Show in New York. American designers were even less apt to be influenced by modernism, especially because their work required client acceptance. It was not until the 1930s, with the arrival of avant-garde designers themselves, that American design received the vital boost it required to catch up with Europe. The 1938 Bayer-designed exhibition "Bauhaus 1919–1928" at the Museum of Modern Art, which traveled to many locations across the country, was an important early introduction of modernist design here. It is fitting that Bayer's own exhibition design was able to assist in making known another of his fields, graphic/typographic design. Comparing the illustrative, traditional poster style in America prior to the European modernist migration with posters made after it, one sees the tremendous influence these designers had. A 1939 comment by Bayer, with regard to American commercial graphics of the day, sums up the issue. He said, "Why is it difficult to be simple?"[13]

There were many internationally acclaimed designers who came to the United States. Bayer certainly was among those who effected the change,

but because there were many, it is difficult to assess the impact of any one designer. One of the earliest was Erté, who worked under exclusive contract to design covers and fashion illustrations for *Harper's Bazaar* between 1924 and 1937. Agha moved to New York to become *Vogue*'s art director (he had previously met Bayer in Berlin when he turned over his position to Bayer at *Vogue*). Agha also undertook design responsibilities for *Vanity Fair* and *House and Garden*. Martin Munkacsi, influenced by Moholy-Nagy and Man Ray, brought innovations in advertising photography to *Harper's Bazaar* which soon brought designer Alexey Brodovich from Paris to be *Harper's* art director. Joseph Binder, the creator of the geometric, planar poster for the 1939 New York World's Fair, received attention with his pictorial style relying on Cubist precedents.

By the late 1930s, the Bauhäusler Gropius, Breuer, Moholy-Nagy, Mies van der Rohe, and Bayer all were settled in the United States. Herbert Matter, Jean Carlu, Ladislav Sutnar, and Will Burtin had all made important design contributions as well. With this tremendous influx of talent, it would be impossible to declare that one or two individuals changed the face of American design. Certainly the entire climate had changed and forward-thinking Americans finally began to sponsor the work of these modern designers. Herbert Bayer was among the designers effecting change in American design; but where his greatest influence lay, because in this aspect he was unusual, was in educating the public broadly about the new design.

In Europe, Bayer already had demonstrated an interest in design education. The most obvious position in which he instructed was as Bauhaus master. David Gebhard recalled that Bayer never lectured or taught formally in the Bauhaus workshop but preferred to supervise and guide student work.[14] But if Bayer was not inclined to lecture, he was seemingly tireless at systematizing theories and then committing them to paper.[15] For example, in a paper Bayer wrote and published in 1926, he described seven elements of design—lettering, drawing, image, color, merchandise, light, and movement.[16] Also in 1926, he wrote an essay "on stationery," as a guide to designing paper on which letters would be typed. The following year he wrote a paper, "werbefoto" (advertising photograph) which explored means of reproducing an advertised item.[17]

In the first issue of the journal *Bauhaus*, 1928, for which he also produced the award-winning photographic cover, Bayer published an essay on typography and advertising design. Magdalena Droste points out that his outline for systematizing training for advertising work, based on five general areas (general foundations of design, technical knowledge, systematics of advertising, psychological considerations, and designing of the individual advertising item) relied heavily on Weidenmueller, who, according to Droste,

provided the terminology used in the field.[18] It was Bayer, once again, who deemed it important to systematize the information and to commit theories to print for the edification of many.

When Bayer collaborated on exhibition designs with his former Bauhaus colleagues Breuer, Gropius, and Moholy-Nagy in 1930 and 1931, it was Bayer who formulated diagrams to explain the dynamics of exhibition techniques to the public. And in 1936 he wrote his well-known "ein beitrag zur buchtypografie" ("a contribution to book typography") which was later translated and published in Italian and English in 1959 and 1960.[19] Clearly Bayer's talents and interest lay not only in designing, but also in informing others of the techniques and value of good design.

When Bayer arrived in New York in 1938, his self-styled mission to educate about design faced an entire country untrained in these matters. In a sense, Bayer's design of the Bauhaus exhibition at the Museum of Modern Art was the first of many educational projects for the artist. Not only the exhibition itself, but also the catalog, co-authored with Ise and Walter Gropius but prepared almost exclusively by Bayer, was highly educational. It provided many people with their first glimpse of what avant-garde design looked like, along with an explanation of what it was about.

Indications of just how far behind America remained, and how intensely Bayer perceived this gap, are evidenced by the statement he wrote about the "Fifty Books Show" which he juried in 1939:

> my appointment as a juror gave me an opportunity to examine america's 800 books on the basis of their typographical qualities. this was of great interest to me since there is little known about american book production in europe. I was able to establish the fact in my own mind that the book of today follows traditional tendencies and that experiments on a new form are somewhat isolated I found that there is no attempt to design or use new type-faces, nor efforts to break the wild monotony of book jackets to use new materials, no outspoken tendency toward a cheap, good book with greater contents, smaller size, less weight. there is little effort to make the text look more interesting by other optic means type-face, [*sic*] in order to support the contents. in short, the books are designed more in a formalistic than in a functional way. I could discover little clear understanding of the "new book."[20]

Bayer took his self-appointed position as spokesperson for the movement seriously and with energy. Compared with other European designers who had come to speak this new language of visual communication, Bayer's persistence in educating was unusual. By 1940 he was teaching a design class in New York, sponsored by the American Advertising Guild, which created enough interest to have an exhibition of student work at the A-D Gallery as well as an article written about the class in the June-July 1941 issue of

A-D.[21] Bayer based the course on exercises involving contrast, proportion, balance, action, harmony, space, texture, etc., and he encouraged unusual and new means such as montage, obviously drawing on his rich Bauhaus experience.[22] He postulated problems, presented tools for exploring them, and let students develop solutions independently. He included considerations of psychology in advertising (the human experience) as part of each design solution. In his 1940 "plan for twelve courses at the advertising guild," presumably used as part of his application to teach the course, Bayer listed some areas for consideration including communication and presentation (display); lettering and writing; standardization of format, colors, sizes, measures, etc.; the idea of montage as new perspective; layout of full and half-page advertisements; billboard posters; book layout; surface treatment; structure; and packaging.[23]

The other widely read advertising journal, *P.M.*, published an entire issue of three articles by Bayer in 1939. In addition to one about exhibition design, Bayer published "contribution toward rules of advertising design" in which he emphasized the need for dynamic compositions rather than traditional, axially symmetrical ones,[24] and "towards a universal type," based on his Bauhaus proposals for a new alphabet.[25] Bayer's own original dates for these articles are 1937 and 1935, respectively, indicating that these were ideas formed in Europe and brought to the United States.

Bayer also lectured about new design standards; in 1940, for instance, he presented a talk at the Philadelphia Art Directors Club and in 1939 (or 1940) he spoke at the A-D Gallery.[26] In these lectures he sought to convince design professionals of the need for change. Clearly Bayer felt the road to change would come through education.

Bayer was far ahead of his time in attempting to convince the Museum of Modern Art of the need for a "department of visual communication." He was, of course, familiar with the museum because of the large exhibitions he had designed there. In October 1943 he wrote to Monroe Wheeler at the museum with an outline of such a proposed department whose aim would be to display, preserve, and educate about advertising art.[27] The museum apparently saw no need for the department in 1943. In more recent times, however, it has been an important proponent of modern design.

Bayer sought a wide target of people for his educational goals: design professionals, business people, and the public. Of other graphic designers interested in education, Moholy-Nagy immediately comes to mind.[28] With his New Bauhaus at Chicago, where Bayer had been invited to teach, and the subsequent Institute of Design, Moholy-Nagy was a forceful spokesman. His books have been read ever since their publication, and still are read to-

day as important treatises about those advanced design theories. Unfortunately, Moholy-Nagy died young, in 1946, over forty years ago, forty years during which Bayer actively promoted these principles. Even had his death not come prematurely, Moholy-Nagy's personal demeanor was such that he offended many businessmen and therefore could not attract support and interest as successfully as Bayer, who with his gentlemanly manner always found respectful admirers and close associates within the business sector.[29] Had he lived, Moholy-Nagy undoubtedly would have continued to influence future artists, but he lacked the facility for educating beyond the artists (many of whom themselves had trouble getting along with him), for educating within the business community, and for reaching out into the public sector. Bayer began to educate broadly in New York City and continued in association with Walter Paepcke within Chicago's Container Corporation. Especially at Aspen, Bayer was highly successful in getting the message to important centers of influence in America.

What Bayer advocated was a means of visual communication in tune with the modern era. He argued that antiquated means of communication should give way to new forms. In typography these forms would be geometrically conceived, machine-oriented, and sans serif (no need for the anachronistic "tails," mere remnants of handwritten letters). And he advocated the use of only one set of alphabetic letters, lower case, doing away with duplicate symbols for the same spoken sound. Bayer sought not only to *eliminate* symbols, but also to introduce a number of new alphabetic symbols as well. He proposed new symbols for such repeated letter groups as ph, ch, th, and ing. One symbol, he reasoned, would be more efficient for each of these recurring combinations.[30] (Up to his last days, in his personal writing, Bayer replaced ph with f, as in "alfabet" and "foto.") Bayer advocated the development of a new alphabet, such as his "basic alfabet" which emphasized phonics and considered the kinetics of vision, how our eyes perceive letter shapes. A new alphabet would be easier to read as well as more efficient to produce mechanically, thus taking its form from function rather than aesthetics. In addition to the letters themselves, Bayer also suggested specific new formats for paragraphs, pages, and even some which pointed "towards the book of the future," a phrase which he used for the title of an article (February 1951). He considered narrow columns and short square blocks of type to be more easily read than lengthy lines across the page. Once changes in type format were adopted, the shape of books also might be altered to fit the new type arrangement. He practiced the use of color highlighting for emphasis; and he advocated a natural rather than a justified right margin so that uniform spacing of type throughout lines would

prevail. Realistically, Bayer knew that most of these changes, especially with regard to the alphabet, would never materialize. But he believed that a gradual change could be effected over a period of years, much in the way that the metric system is being introduced. In defense of his conviction, Bayer cited George Bernard Shaw's bequest for a proposed British alphabet, in which it is stated:

> in the year MCMLIX, no sane individual would dream of opposing the more compact, comprehensible and economical form of the arabic 1959. yet for many centuries the introduction of the new numerical system in place of the roman system was strenuously opposed.[31]

In calling for clarity and conciseness, Bayer designed advertisements and posters with a similar economy of design. He sought to pare every composition to its essential, with a strong, unified image replacing any overstated narrative, no matter how informative it might be. Bayer was an innovator in America in the practice of eliminating lengthy prose in advertising so that the short written text was instantaneously discernible. He advocated the use of dynamic symmetry which carried the eye throughout a composition, rather than a static, axially balanced symmetry; he was always mindful of the psychology of approaching an advertisement or poster and of the physiology of actual vision. He listed the attributes of a successful poster: "attention-getting . . . awakening interest, . . . persuasion and conviction."[32]

It was not always easy for Bayer to maintain his principles and at the same time to make a living in design. Especially during his first years in the United States, Bayer found few clients who understood his ideas. Even in Europe these principles of modern design had met considerable misunderstanding and resistance. Detractors found the new language threatening, sometimes labeling it "bolshevik." At the Bauhaus the local post office refused to handle mail that used only lower case letters.[33] And many, like Stanley Morison, for example, the famous English typographer, were contemptuous of Bayer and the Bauhäusler. When Herbert Read demanded that Bayer be hired to lay out his *Art and Industry* being published by Faber & Faber, Morison wrote to a colleague:

> This Mr. Bayer, not content with being ignorant of the function of italics, deepens his ignorance by willfully shutting his eyes to the utility of capitals. Of course he did not invent. Like most of the modern tricks which the German Jews have elaborated into an intellectual theory tied on to contemporary architectural customs, it was invented in Paris. (By German Jews I really mean Jews in Germany.) The effect of it is to make typography a romantic thing instead of a rational thing.[34]

It is interesting that Morison associated Bayer with alleged "Jewish subversion." In fact, Bayer was not Jewish. But Morison, like many others, apparently associated the Bauhaus with what he and others perceived as a subversive Jewish intelligentsia. As late as 1938, while the Museum of Modern Art was exhibiting "Bauhaus 1919–1928," the question of Jewishness arose.[35]

Bayer's innovations never received widespread acceptance or implementation in Europe. He was forced to use capital letters in much of his commercial design work there, his lower case preference never gaining much favor. Obviously if many design professionals themselves opposed these kinds of changes, whether for professional or personal reasons, it would have been even more difficult to convince the public of the need for innovation. Because the nature of graphics and typography requires that it influence the man on the street in a positive manner, it is always difficult to effect changes and to please a client at the same time.

Nevertheless, it was in Europe that Bayer's ideas formed and solidified. Founded and systematized at the Bauhaus and then developed and practiced during the artist's ten-year design career in Berlin, Bayer's theories were well formulated, tested, and written about by the time he arrived in New York. If Bayer's proposals themselves were never altered much from their Bauhaus development, Bayer's sphere of influence was enlarged greatly over the years. Many ideas which earlier had been confined to the most limited circles of avant-garde designers were transmitted by Bayer to the public realm, where they exerted the greatest effect. It became Bayer's mission to educate a larger base of people which would enable change to occur at every level of American visual communication. Articles by and about Bayer appeared not only in art and design journals but also in popular American magazines which reached a broad population. Even though most of Bayer's ideas were formed early, in Europe, their influence was magnified through the distribution of pieces published in the fifties and early sixties in this country. And these ideas, which were already over three decades old, still appeared fresh and new.

By that time America was ripe for these ideas. In postwar America optimism and energy prevailed. New ideas were encouraged as liberal approaches to business and open thinking as a means of problem-solving flourished. Nowhere was the sense of excited anticipation and optimism more alive than at Aspen.

Like the Bauhaus, the Aspen Institute for Humanistic Studies provided a sheltered, liberal environment where ideas could be fostered and could grow. In this setting, Bayer's tenets regarding graphics and typography were im-

plemented without the necessity of public approval. And while Aspen provided opportunity for experimentation, in turn the use of innovative design there gave it sanction in larger circles as the "Aspen Idea" gained prominence. Bayer's position at the Aspen Institute, the International Design Conference, Aspen, and within two large and influential corporations afforded him a platform of influence from which to effect change.

Today, opening any "how to" book on graphic design and typography, one sees the assimilation of Bayer's modern precepts. Many of his ideas, such as efficiency of design, movement of the eye from a strong emphasis throughout a composition, and minimal use of text in advertisements, are today stated as "givens" for the creation of successful graphics. Sans serif fonts are reproduced in these pages, along with older type styles. Today, not only organizations as free-thinking as the Aspen Institute use all lower case letters in modern graphics. Many contemporary billboards, title pages, letterheads, and advertisements choose lower case sans serif lettering for a modern streamlined look. What Bayer accomplished in America was the introduction of new design principles into everyday use. If he was not able to actually transform our entire written language, at least he helped people to consider the mechanics of our system, and to enact some changes in our typography and graphic design for increased visual communication.

7

Exhibition Design

The great possibilities of exhibition design rest on the universal application of all known means of design. . . . It is the apex of all collective effects, of all powers of design.
 —Herbert Bayer, in Rudofsky, "Notes on Exhibition Design"

Exhibition design was one of Herbert Bayer's foremost interests after he left the Bauhaus. Considering that the exhibition hall is a finite, self-contained environment, Bayer's interest in shaping this space was in perfect accord with his aims in shaping other human spaces. Exhibition design combines the design of human spaces, for which Bayer is so celebrated in large environmental projects, with visual communication, the area in which he excelled in his graphic work. Exhibition design was then, for Bayer, the arranging of an ideal microcosm of a world which the artist seeks to unify through good design. It is a limited, defined environment in which a designer can exercise the complete control that usually eludes him in the public domain. Herbert Bayer became a master designer of display in Germany, and it was in the area of exhibition design that he received his first employment in the United States.

Within a very short time after Bayer's arrival in New York in 1938, he had designed three major exhibitions for the Museum of Modern Art: "Bauhaus 1919–1928" in 1938, "Road to Victory" in 1942, and "Airways to Peace" in 1943. In each of these highly visible presentations, Bayer introduced to a relatively provincial American public some of the most advanced principles of exhibition design, effects which had first been attempted by the European avant-garde only during the preceding decade.

At the time of his arrival in New York, Bayer was one of only a handful of artists experienced in these new exhibition techniques. Bayer used his expertise to introduce these display principles to the American art world and its public. A more direct transition from Europe to America can hardly be imagined: Bayer was transplanted not only to the United States, but directly to a major American museum exhibition, "Bauhaus 1919–1928."

The idea that a museum gallery could be more than a static cube against whose vertical walls flat images are attached was, at the time of Bayer's arrival in New York, still quite revolutionary, even in Europe. In the United States these new ideas were absolutely radical, and Bayer's unexpected designs surprised the public and the critics when they were introduced here. It is worthwhile to examine, briefly, Bayer's European experience in the field of exhibition design, and then to assess the significance of his first American assignment, the 1938 Bauhaus exhibition, which led to other American exhibition projects.

Bayer was in a particularly good position to assimilate the latest developments in European design. His experience at the Bauhaus, both as student and master, had introduced him not only to the ideas behind advanced design principles but also to the individuals who were their ardent innovators and supporters, some of whom were not affiliated with the Bauhaus, but were nevertheless in communication with those at the school.[1]

Well before Bayer came to the United States he had established himself as an innovative designer of exhibitions. What is noteworthy about his designs is their emphasis on the exhibition hall as a *total environment* including, in addition to vertical walls, the entire space, which functions as a dynamic environment for the interaction between people and what is exhibited. In 1930 Bayer synthesized the principle that would guide his future direction in exhibition design: the concept of a "field of vision" (fig. 62), which he diagrammed while collaborating with Gropius, Breuer, and Moholy-Nagy on the "Deustcher Werkbund" section of the 1930 "Exposition de la Société des Artistes Décorateurs," held at the Grand Palais, Paris.

Illustrated on a page of the exhibition catalog is Bayer's schematic drawing visualizing the idea that although the viewing direction in an exhibition is traditionally horizontal, new possibilities can be explored by extending the viewer's field of vision to utilize other than flat vertical areas, and to add interest with unexpected arrangements. His principle was demonstrated in the 1930 exhibition gallery, which displayed architecture and mass-produced furniture as part of the exhibition's statement on the integration of design and industrial production. Photopanels and furniture were angled out from the ceiling and wall in an exciting display (fig. 63). Of this arrangement Bayer stated, "I hung chairs from the ceiling in order to express their serial nature."[2] The logic for this arrangement clearly lies in Bayer's diagram.

By the next year, 1931, Bayer and his colleagues Gropius and Breuer had designed an even more daring display at the "Building Workers Unions Exhibition," Berlin. Some innovations of this second exhibition were described in Bayer's next diagram, of 1935, which presented further extensions of vision by raising the viewer to an elevated viewing level on a ramp or platform

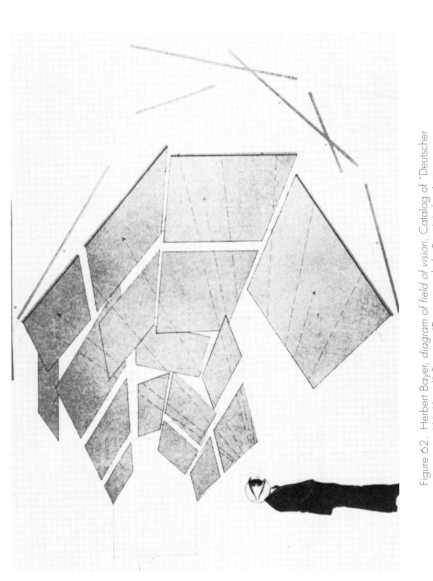

Figure 62. Herbert Bayer, *diagram of field of vision*, Catalog of "Deutscher Werkbund" Section, "Exposition de la Société des Artistes Décorateurs," Paris, 1930

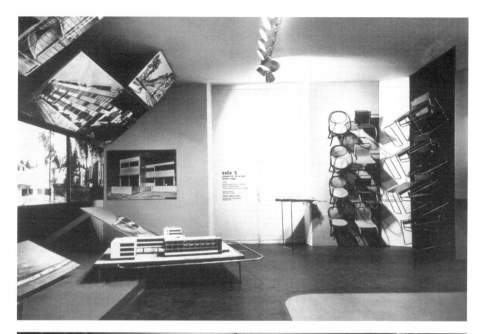

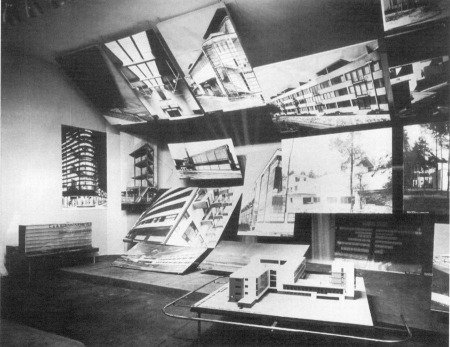

Figure 63. Herbert Bayer, Marcel Breuer, Walter Gropius, and László Moholy-Nagy "Deutscher Werkbund" Section, "Exposition de la Société des Artistes Décorateurs," Paris, 1930 *(photographs courtesy the Wolfsonian-Florida International University, Miami Beach, Florida)*

(fig. 64). In this arrangement added challenges for display present themselves and are met with materials simultaneously suspended at angles from the ceiling, tipped up from the floor, and hung on the wall, for a dynamic gallery environment. Not only is the material itself presented in a more lively manner, but the viewer must participate more actively as well, in order to experience all that is presented to him. Although a low ramp had been used at the 1930 "Werkbund" exhibition in a limited way, what Bayer diagrammed in 1935 was fully demonstrated by the 1931 "Building Workers Unions Exhibition" (fig. 65).

This exhibition included considerably elevated ramps along which viewers followed the exhibition.[3] Not only did these ramps elevate the viewer to positions which extended his field of vision for a birds-eye view of the entire hall, but by their placement, they led him through a complete series of planned experiences in space and time. The exhibition was designed for both panoramic views from ramps and for close-up views. Since the content of the exhibition was largely didactic and did not provide opportunity for particularly interesting pictorial treatment, other means of creating interest were applied. Animation, peepholes, and louvered walls which opened and closed were utilized, and viewer participation was encouraged by displays which viewers could manipulate by pressing buttons or moving parts. Giant photographs and montages were effective from distances; peepholes and manual gadgets required close-up attention. And some material was designed to be seen only by leaning over the ambulatory ramps.

An important consideration in both the "Werkbund" exhibition and that of the "Building Workers Unions" was the organization of displays for continuity of traffic flow and sequence of exhibits. Earlier interior organization of exhibition space had almost always been guided by the architecture of the building, rather than by the nature of the exhibit. But these new exhibitions demonstrated that careful planning could overcome problems of existing buildings. In the "Werkbund" exhibition, for example, a plan of circulation was difficult because the use of the space, cut up into several rooms, was conditioned by the old building in which it was housed, the stately Grand Palais. Ramps unified the area and directed the traffic smoothly. Added fluidity was achieved with a curved wall designed by Moholy-Nagy. Similar principles were applied in the "Building Workers Unions" exhibition where the use of ramps was expanded further, and their placement elevated.

Bayer's role in these two European exhibitions is well documented. What is less well known is that he also participated in the creation of an earlier exhibition directed by El Lissitzky, the "Pressa" exhibition of 1928, held at Cologne. This was one of two exhibitions by Lissitzky which became landmarks in the development of new dynamic techniques in European avant-garde exhibition design.

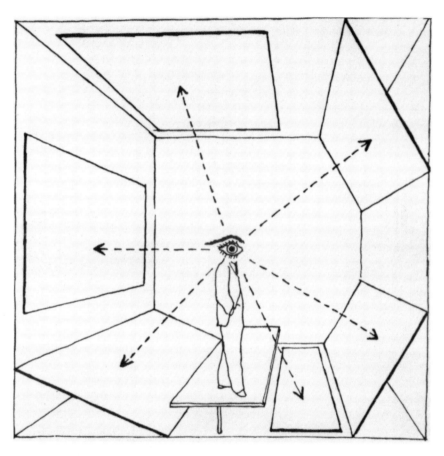

Figure 64. Herbert Bayer, *diagram of 360° field of vision,* 1935

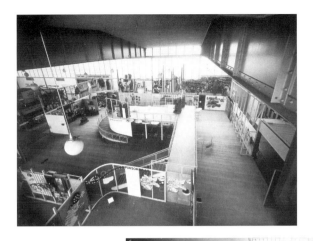

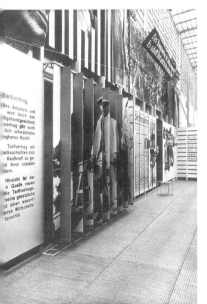

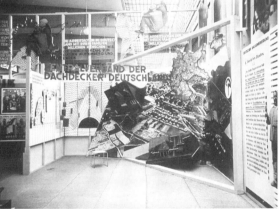

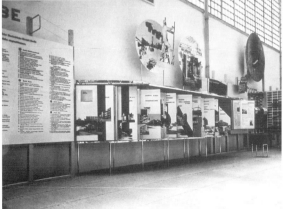

Figure 65. Herbert Bayer, Marcel Breuer, and Walter Gropius, "Baugewerkschafts" (Building Workers Unions) Exhibition, Berlin, 1931 *(photographs courtesy the Wolfsonian-Florida International University, Miami Beach, Florida)*

The experience of working on the ''Pressa'' exhibition opened Bayer's eyes to new possibilities of imaginative dynamic display.[4] Bayer had met Lissitzky briefly at the Bauhaus and Bayer had been interested in exhibition design while still at the school.[5] The opportunity to work with Lissitzky proved to be of immeasurable significance in shaping his own style of display, freed from the constraints of antiquated conventions that governed traditional exhibits.

In an unpublished interview Bayer recalled that he himself was assigned a small room of the exhibition in which he created a very pure, static display of German books with book pages neatly pinned on a series of orderly supporting slabs. He remembered his excitement at seeing Lissitzky's dynamic environment of books, pages, banners, and cellophane (fig. 66):

> when I saw Lissitzky's experimentation with large photomurals and the use of cellophane—it was just invented . . . he used that, and in general a mixture of techniques, of new techniques, but the overall impression was a rather chaotic one; it was not organized at all. It was just throwing in a lot of ideas, you know. But that made it interesting for me. . . . from there I started to think about exhibition design and I arrived at . . . a systematic approach, always thinking of the people who would look at it. So it was an influence, although I did not follow it except perhaps I then also used photoenlargements in exhibitions. . . . And color overlays . . . I used it more as . . . [a] division of spatial concepts, that you make spaces with the exhibition material.[6]

The importance of Lissitzky's dynamism to the creation of a new vocabulary of avant-garde display can hardly be overstated. Alexander Dorner, who was at the center of new exhibition activities in Europe as the forward-looking director of the Landesmuseum in Hannover,[7] explained the importance of Lissitzky's displays in two exhibitions, one in Leipzig (1927) and the other in Cologne (1928, on which Bayer worked):

> As far as I know, the Russian Constructivist El Lissitzky was the first artist to create this new, truly life-bearing milieu with remarkably inexpensive means. It was first in the Leipzig exhibition of 1927, and later in the Pressa at Cologne, 1928, that Lissitzky used large suspended photomontages and enlargements (they were held only by a thin and barely visible wire netting), as well as cellophane and multicolored paper in such complete relativity that the visitor was irresistibly drawn into the exhibition and forced to exercise his energies.[8]

Bayer himself has stated:

> A revolutionary turning point came when El Lissitzky applied new-contructivist ideas to a concrete project of communication at the ''Pressa'' Exhibition in Cologne in 1928. The innovation is in the use of a dynamic space design instead of unyielding symmetry, in the unconventional use of various materials (introduction of new materials such as

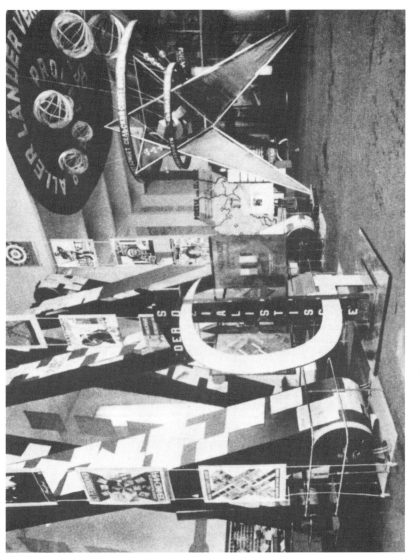

Figure 66. El Lissitzky, "Pressa" Exhibition, Cologne, 1928

cellophane for curved transparency), and in the application of a new scale, as in the use of giant photographs.[9]

Bayer's association with Lissitzky at the 1928 "Pressa" exhibition provides an important link between what the Russian artist had accomplished and the later exhibitions on which Bayer collaborated with his former Bauhaus associates. By the time of the "Deutscher Werkbund" exhibition, two years after the "Pressa," Bayer was already committed to the idea that a museum gallery did not have to be an inert repository against whose walls images must be fixed. It was precisely Bayer's introduction to the new ideas presented at the "Pressa" that enabled him to envision the gallery as a dynamic total environment in which the viewer became an important participant. Bayer's association with Lissitzky enabled him to see the unbridled possibilities of display. No longer confined to antiquated, rigid systems of order, Lissitzky's liberated, if chaotic, expression opened Bayer's eyes. For Bayer, the Russian artist's deconstruction of the laws of display led the way to a new order which embraced the dynamic freedom of materials, fluidity of design, and grandeur of scale, all of which he used to systematize a theory of exhibition design which provided the gallery visitor with a dynamic environment in which to interact with the display. To this free approach, Bayer added his own belief in the ability of the exhibition designer to communicate effectively to the viewer through a carefully planned system of visual design.

The year of the "Pressa" exhibition, 1928, was also the year that Bayer left the Bauhaus to live and work in Berlin. Surely his experience in the "Pressa" affected his subsequent work in Berlin. Over the next ten years, until his arrival in New York City, he was professionally active, in addition to exhibition design, in advertising, typography, painting, and photography. In addition to those exhibitions already cited, Bayer worked on the plans and technical installation of several other German exhibitions, including that of the German cork industry, 1931, on which he collaborated with Marcel Breuer; traveling exhibitions in Berlin and a municipal exhibition in Berlin, 1935; a traveling exhibition for the wallpaper industry in Hamburg, 1936; and a gas and water exhibit in Leipzig, 1937.[10]

The transition from Europe to America appears a logical one in Bayer's career. During the years 1928 to 1938 Bayer designed some ten exhibitions in Europe. On his 1937 visit to the United States, he traveled to Providence, Rhode Island to meet with Gropius, Breuer, Moholy-Nagy, Alexander Dorner, and John McAndrew, curator of architecture and industrial art at the Museum of Modern Art, New York.[11] Bayer was selected as the natural choice to organize and design the proposed Museum of Modern Art exhibition of Bauhaus art to be mounted in New York City early the following year. It

is easy to understand Bayer's appointment. He had been both student and master at the Bauhaus; he was thoroughly experienced in exhibition organization and display; he was a free agent without specific obligations to teaching and/or writing, which was not the case with other Bauhaus artists who had emigrated earlier (Gropius, Albers, and Moholy-Nagy all had substantial professional, academic commitments in the United States); and perhaps most important, Bayer was returning to Europe where he could secure much of the Bauhaus material still needed for the exhibition, no small consideration given the political climate abroad at that time.

Bayer first worked from Germany to organize the exhibition, to write the catalog text, and to cooperate with individuals in Europe to bring Bauhaus art out of Germany at this critical time in history. Letters and telegrams from the Museum of Modern Art archives between Bayer in Europe and museum officials and former Bauhaus masters in the United States reveal the realities not only of an artist designing a major exhibition, but of an individual grappling with the very real problems of customs officials, immigration visas, and cargo transport in an uncertain political climate.[12] Further, some artists and collectors were reluctant to lend objects for fear of political reprisal. After Bayer had amassed the works for the exhibition, finished the catalog text, and obtained extensions of deadlines from the museum including a delayed opening date,[13] he himself had difficulty exiting from Germany.[14] When he finally arrived in the summer of 1938, he continued his work in New York, gathering works from Bauhaus people in the United States, drawing plans for the gallery space, and making final revisions on the catalog text, which also had to be translated.

Without doubt, the Bauhaus exhibition in New York presented the American public with the most comprehensive view ever seen on this side of the Atlantic of that extraordinary European art school. Of no less importance, this exhibition demonstrated some of the latest principles of European avant-garde display. Bayer created a gallery space that caused a sensation among the critics and public alike. Reaction to the exhibition was intense, and much of it was unfavorable.[15] But among the exhibition's strongest and most eloquent allies in print was Lewis Mumford, writing in *The New Yorker*.[16]

The Bauhaus exhibition utilized many display innovations Bayer had brought from Europe (fig. 67). Peepholes and movable exhibits encouraged the viewer to participate in the show. Directional shapes were painted in white on the floor to assist visitors' circulation through an otherwise choppy arrangement of rooms provided for the exhibition (fig. 68). And throughout the exhibition examples of Bauhaus work and didactic labels which explained

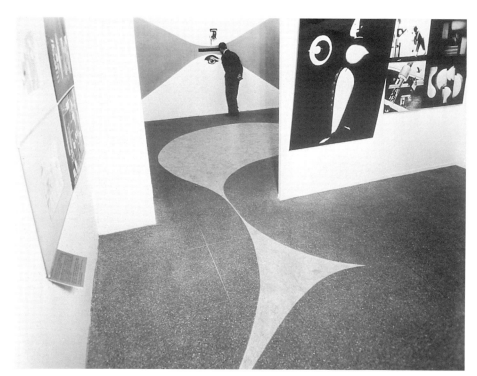

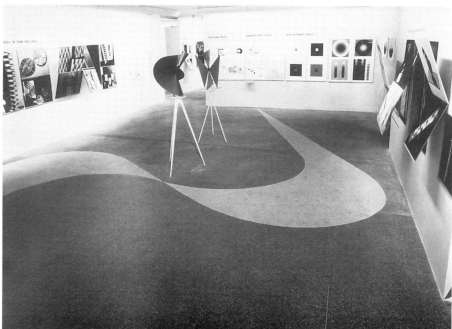

Figure 67. Herbert Bayer, "Bauhaus 1919–1928" Exhibition, The Museum of Modern Art, New York City, 1938
(photographs courtesy the Wolfsonian-Florida International University, Miami Beach, Florida)

Figure 68. Herbert Bayer, "Bauhaus 1919–1928" Exhibition, The Museum of Modern Art, New York City, 1938 (photographs courtesy the Wolfsonian-Florida International University, Miami Beach, Florida)

them were tipped out at angles from the ceiling and walls, rather than placed flush against surfaces.

After the exhibition had ended, there was considerable discussion among supporters of the exhibition (museum officials and former Bauhaus artists) about response to the exhibition.[17] Although Gropius was inclined to dismiss the poor critical reception, blaming it on a lack of American sophistication, Alfred Barr took the responses more seriously.[18] At its conclusion, Barr appears to have viewed the exhibition as one of life's experiences that one is glad to have undertaken, but is relieved when completed. The exhibition was considerably over budget, costing far more than other exhibitions presented by the museum; it had been delayed because of the logistics of bringing material from Europe; no doubt it had been exhausting dealing with so many former Bauhaus masters in setting up an exhibition which would express the spirit and breadth of the school; and finally when the exhibition was complete, major critical success was lacking. Only in retrospect has the Bauhaus exhibition become a great landmark exhibition and the show's catalog (on which they then envisioned losing much money) gone into successive printings as an acclaimed source on the Bauhaus.

Unlike the Bauhaus exhibition, Bayer's next installation at the Museum of Modern Art, the "Road to Victory," met with all around enthusiastic praise.[19] The subject matter of the "Road to Victory" was the growth of America and her philosophical war against Fascism.[20] Looking back, the difference in the contemporaneous receptions of these two exhibitions may be attributed to the fact that the Bauhaus show was an American exhibition of German art in a tense 1938 while the "Road to Victory" was an inspirational show meant to boost national morale during wartime. (The United States entered the war during the time that the exhibition was being planned; the title was changed from earlier versions to appropriately express hopes for a speedy victory.)[21]

Further, the "Road to Victory" exhibition was directed by none other than Edward Steichen, then Commodore Steichen, and the accompanying text was written by his brother-in-law, the poet Carl Sandburg, a collaboration of two beloved Americans which in itself assured a warm reception. Nevertheless, many of the favorable comments did focus on the extraordinary means of display created by Bayer, and his name, although less prominent in newspaper articles than those of the two illustrious brothers-in-law, was mentioned often in the press for the exciting installation.

Bayer worked closely with Steichen, constructing a three-dimensional model incorporating the ideas they discussed (see fig. 69).[22] Steichen selected the photographs (none of his own were in the show) and from a

vast number pared his choices to those which would create the strongest statement about America.[23] Bayer stated of Steichen, "He constantly asked me for my opinions. We always spread photographs on the floor and he always became sentimental about American things."[24]

Bayer's first task in preparing the exhibition galleries was to remove all interior walls, so that spatial divisions could be made with exhibition materials themselves rather than by arbitrary architectural features. In this case, large photopanels formed the divisions, so that Bayer's plan itself helped elucidate the exhibition's narrative and message (figs. 70, 71, 72, and 73). With walls, ceiling, and floor painted white, nothing in the exhibition hall distracted from the powerful images. The great wall-sized photographs stirred viewers' emotions and caused more than a few eyes to fill.[25] Christopher Phillips, in an article about "Road to Victory," described Bayer's dynamic design, which applied his "extension of vision" principle:

> To furnish an air of dynamism to the enlargements many were made free-standing or free-floating, thin wires supporting them at a variety of angles from floor to ceiling. At the exhibition's critical juncture, a dramatic juxtaposition of the Pearl Harbor explosion and a hard-bitten "Texas Farmer," Bayer underlined the effect by calling into play his "principle of extended vision." The spectator was led up a raised ramp which afforded a dramatic vista, and the ramp, itself, as it wound through the series of military images which followed, became the literal embodiment of the "road" to which the exhibition's title referred. The concluding enlargements grew progressively bigger, culminating in a gently curving 40-foot mural presenting row upon row of marching American troops. Over the larger mural were superimposed a number of smaller images depicting proud fathers and beaming American mothers. As remarked by Alexander Dorner in his very interesting study of Bayer's work: "The visitor was led from one such reaction to another, and finally to the climactic reaction of intense sympathy with the life of the USA and an ardent wish to help it and share its aims."[26]

"Road to Victory" traveled across the country, and Bayer designed floorplans for the exhibit in other cities in addition to New York.[27] The exhibition then traveled to England under the title "America Marches." Unfortunately the show had to be reconstructed after the original exhibition was sunk at sea by an enemy submarine. But despite difficulties, the London version victoriously opened in March 1943.[28]

While the "Road to Victory" was still traveling, Bayer designed another exhibition for the Museum of Modern Art, "Airways to Peace," directed by Monroe Wheeler. Opening at the museum in 1943, the year after "Road to Victory," and traveling to New York, Washington, D.C., and Pittsburgh, "Airways to Peace" emphasized the importance of air travel and how it effectively had shrunk the earth to bring the world's people closer, both for

Figure 69. Herbert Bayer, Model for "Road to Victory" Exhibition, The Museum of Modern Art, New York City, 1942

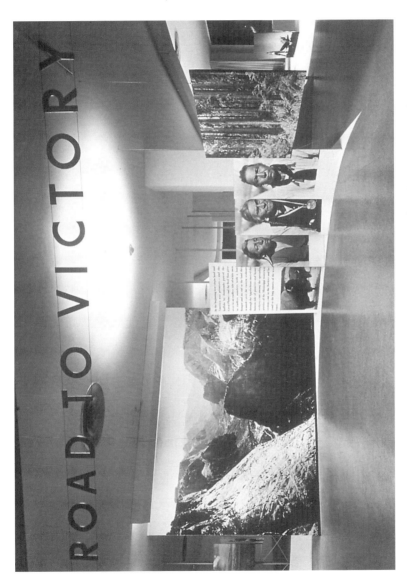

Figure 70. Herbert Bayer, "Road to Victory" Exhibition, The Museum of Modern Art, New York City, 1942 (photograph courtesy the Wolfsonian-Florida International University, Miami Beach, Florida)

Figure 71. Herbert Bayer, "Road to Victory" Exhibition, The Museum of Modern Art, New York City, 1942
(photograph courtesy the Wolfsonian-Florida International University, Miami Beach, Florida)

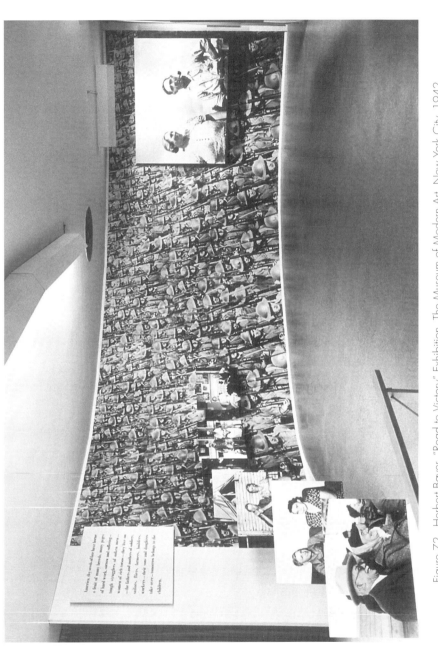

Figure 72. Herbert Bayer, "Road to Victory" Exhibition, The Museum of Modern Art, New York City, 1942 (photograph courtesy the Wolfsonian-Florida International University, Miami Beach, Florida)

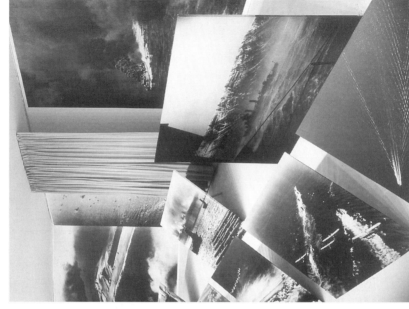

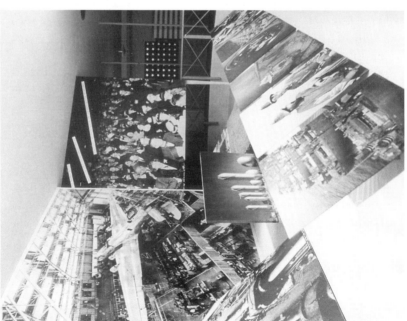

Figure 73. Herbert Bayer, "Road to Victory" Exhibition, The Museum of Modern Art, New York City, 1942 (photographs courtesy the Wolfsonian-Florida International University, Miami Beach, Florida)

peace and for war.[29] "Airways to Peace" included a collection of some fifty maps and globes, and many charts, diagrams, and photographs to explain some principles of aeronautics, weather, and geography to a lay public. In addition to graphics, Bayer provided some paintings related to the subject of atmospheric conditions. And he designed the layout of the galleries and many didactic panels.[30]

In "Airways to Peace" Bayer was somewhat more inventive in applying the concept of an "extension of vision." As part of the exhibition, he constructed a large, suspended walk-in globe, creating an environment surrounding the viewer (fig. 74). Although traditionally globes had been used to avoid the inherent distortions of flat maps, Bayer noted that when the viewer looks at a conventional globe it curves away from him, limiting his vision to a small geographical area at one time. By creating an outside-in globe, Bayer enabled the globe to encircle the viewer, extending his field of vision to include more data, while allowing him to experience the spherical physicality of the earth. Bayer used lengths of cord to physically separate one area from another and to mark off areas meant for the viewer from those closed to him; once again he manipulated the viewer through a planned experience and allowed the exhibition materials themselves to articulate the exhibition space (figs. 75 and 76).

It is interesting that only the year before, in 1942, Duchamp's exhibition design for the "First Papers of Surrealism" was also installed in New York City and was composed of a maze of string, strung across the exhibition space (fig. 77). Although their intentions were certainly at odds with each other (one was meant to confound, the other, to explicate), the similarity in form, so close in time and location by artists who knew each other, is provocative.[31] (Bayer also used heavy string, in more of a weblike formation, in the entrance display for the 1945 "Modern Art in Advertising" exhibition (fig. 78). Again he departed from Duchamp in intention. Rather than serving to confound, the string in Bayer's design served as a means to visually draw the visitor into the exhibition. And as late as 1967 he envisioned the use of string for the entrance to the "Fifty Years Bauhaus" exhibition (fig. 79).)

"Airways to Peace" generated tremendous critical excitement, both for its information and for its manner of display. By far the greatest attraction was the walk-in globe, for which offers to purchase were tendered. The globe eventually found its way to the Department of Commerce, Washington, D.C.[32]

During the five-year period 1938 to 1943, Bayer synthesized what he had learned from his experience in European display and developed a visual language of exhibition design well suited to its American public. These three

landmark exhibitions presented the most advanced principles of display in the world, and they were important early examples for American designers to see firsthand. Because these exhibitions were presented by a major American museum and because they traveled to other cities after their introduction in New York, Bayer's examples were seen by large numbers of people across the nation who otherwise would not have been introduced to these new ideas.

By the 1940s Bayer was well known in America as a master exhibition designer and several exhibitions followed, applying many of the same concepts. By 1945, Bayer, here only seven years, had designed about a dozen American exhibitions.[33] One exhibition from 1945 was a traveling show created for Container Corporation of America, with whom Bayer soon would begin a long and important association. The exhibition, entitled "Modern Art in Advertising," opened at the Art Institute of Chicago. It consisted of a demountable, self-supporting structure of standardized one-inch by two-inch wooden members which, bolted together, could be erected independent of any particular wall space (fig. 80). This system, designed for easy traveling, owed much to De Stijl and Constructivist examples in Europe such as Frederick Kiesler's Austrian Theater Exhibition in Paris, 1925, which had defined space by a structural framework supporting exhibits and text on panels. Again Bayer relied on his knowledge of European display concepts in designing American exhibitions.

In 1959 Bayer was selected to design the Air Force Museum at Dayton, Ohio.[34] In this unrealized project he continued to apply his earlier principles of exhibition design, making extensive use of ramps to elevate spectators to good viewing positions and to extend their fields of vision (fig. 81). Ramps were strategically placed so that none of the valuable displays would be within arm's reach. The ramps led the viewer through a planned series of chronological displays. The height of the ramps varied throughout, bringing the visitor to optimum viewing levels. Floor areas not to be walked on were to be painted white.

After 1960 Bayer's exhibition activity was almost nonexistent. One might say that he gave up exhibition design in favor of designing other human spaces, primarily those of corporations. In addition to Bayer's virtual full-time commitment to Container Corporation and to the development of Aspen, Colorado, the fact that he had moved to the mountain town also must have played a part in his lack of urban exhibition projects.

For Bayer, exhibition design was part of the larger concept of creating a unified environment. By 1960 he must have felt that he had carried his principles of exhibition design to fruition; however, exhibition design remained

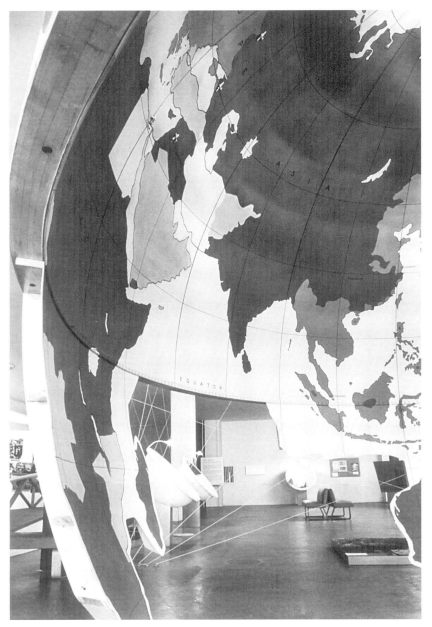

Figure 74. Herbert Bayer, "Airways to Peace" Exhibition, The Museum of Modern Art,
New York City, 1943
(photograph courtesy the Wolfsonian-Florida International University,
Miami Beach, Florida)

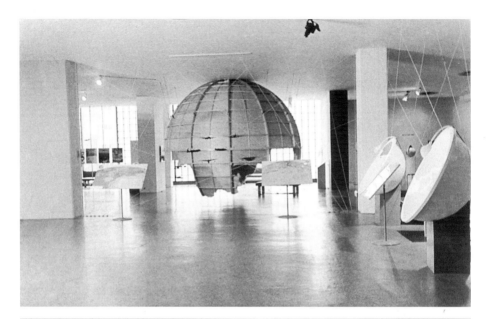

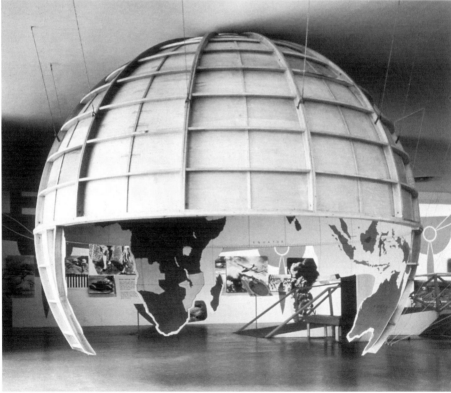

Figure 75. Herbert Bayer, "Airways to Peace" Exhibition, The Museum of Modern Art, New York City, 1943
(photographs courtesy the Wolfsonian-Florida International University, Miami Beach, Florida)

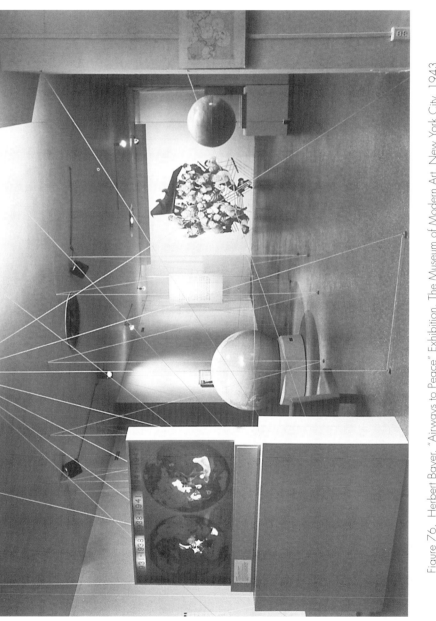

Figure 76. Herbert Bayer, "Airways to Peace" Exhibition, The Museum of Modern Art, New York City, 1943 (photograph courtesy the Wolfsonian-Florida International University, Miami Beach, Florida)

Figure 77. Marcel Duchamp, "First Papers of Surrealism" Exhibition, New York City, 1942

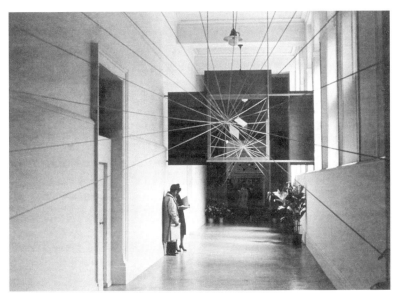

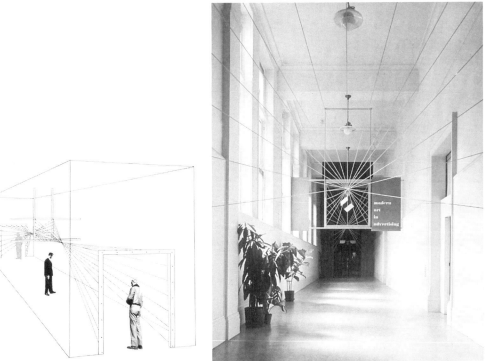

Figure 78. Herbert Bayer, Entrance to "Modern Art in Advertising" Exhibition,
The Art Institute of Chicago, 1945
(photographs courtesy the Wolfsonian-Florida International University, Miami Beach, Florida)

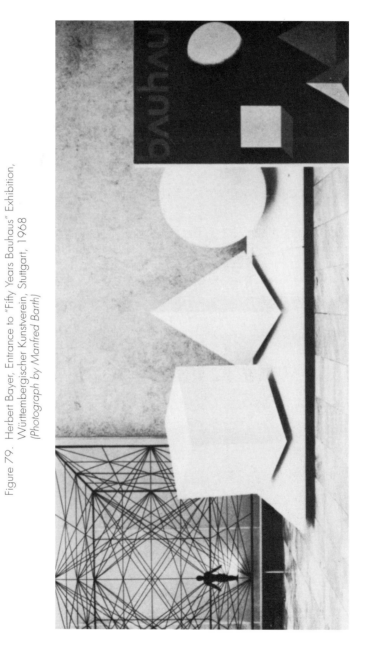

Figure 79. Herbert Bayer, Entrance to "Fifty Years Bauhaus" Exhibition, Württembergischer Kunstverein, Stuttgart, 1968 (Photograph by Manfred Barth)

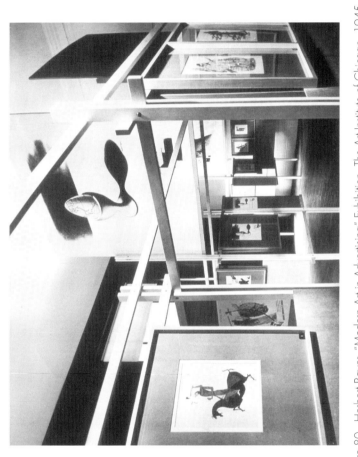

Figure 80. Herbert Bayer, "Modern Art in Advertising" Exhibition, The Art Institute of Chicago, 1945 (photograph courtesy the Wolfsonian-Florida International University, Miami Beach, Florida)

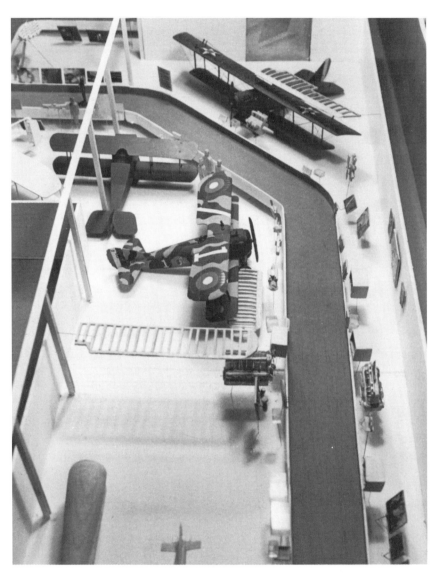

Figure 81. Herbert Bayer, Model for United States Air Force Museum (Project),
Dayton, Ohio, 1959
(Photograph by Ted Dutton)

an important interest for the artist, and periodically Bayer returned to this discipline for the short duration of an exhibition, such as the "Fifty Years Bauhaus" worldwide exhibition which he designed in 1967.

Exhibition design, for Bayer, was the culmination of all that a designer could achieve, bringing together every consideration for which he worked in other areas of design. He stated:

> The total application of all plastic and psychological means . . . makes exhibition design an intensified and new language. It becomes integrated use of graphics with architectural structure, of advertising psychology with space concepts, of light and color with motion and sound. To play successfully with this modern instrument of possibilities is the task of the exhibition designer.[35]

Clearly, the designing of exhibitions is directly related to two areas which were Bayer's lifelong concern: visual communication and environmental design. His goal in exhibitions was to create a planned environment that communicates to the visitor.

As we have seen, exhibition design was the area of expertise which enabled Herbert Bayer to find his first American work. But no less importantly, Herbert Bayer's *example* on American soil provided important precedents which helped advance the state of American exhibition design. Both by his actual exhibitions and through his writing, Bayer quickly transmitted advanced principles of display and sparked new interest in exhibition design in America, a field which had been lacking both in originality and direction. Bayer also served as a visible role model for a new generation of designers who, for the first time in America, would be considered as creative artists, not merely as technicians.[36] By mid-century, exhibition design in America already reflected the advances brought by Bayer and other modern European-educated designers.

Bayer's exhibition activity was given immediate sanction here, if only by virtue of the fact that his first American designs were done for the reputable Museum of Modern Art in New York. Designing the large Bauhaus exhibition was the single most important factor in Bayer's transition to the United States. On a practical level it provided him with some immediate financial remuneration and with important letters of support for his immigration.[37] Professionally, the job provided affiliation with a major American museum and immediate national exposure. Certainly his designs for the subsequent Museum of Modern Art exhibitions "Road to Victory" and "Airways to Peace" followed because of his earlier Museum of Modern Art experience. These exhibitions added to his reputation in this country and, because they traveled, to the visibility of his exhibition techniques nationwide.

Several articles about Bayer's exhibition design appeared in professional journals and popular magazines. Written by the artist and by others, major pieces on Bayer's exhibition work were published between 1939, when his article "fundamentals of exhibition design" appeared in *P.M.*[38] and 1961 when *Curator* presented his "Aspects of Design of Exhibitions and Museums."[39]

It is clear that even in Europe, as early as the beginning of the decade of the 1930s, Bayer deemed it important to synthesize a theory of exhibition design and to present it in a clearly stated manner. His two diagrams of the "field of vision" and "extension of vision," done in 1930 and 1935, serve as examples of Bayer's predilection for clearly stated principles. Further, the fact that his diagram was placed in the actual printed "Werkbund" catalog indicates that his interest went beyond informing those within the art community; clearly Bayer was also concerned with educating members of the public who ventured into the exhibition.[40]

In the United States, Bayer continued his interest in educating broad segments of society. Through his writing he sought to explain the importance of good design in the world, and particularly of good exhibition design for the successful communication of an exhibition theme. Bayer's lesson was that without adhering to certain guidelines, an exhibition becomes disorganized, lacking the unity and power to successfully address its audience. Within Bayer's directives are a number of principles which he considered mandatory to a successful design.

First, the total experience of an exhibition requires careful orchestration from the earliest introductory material at the entrance to the final experience with which the viewer exits. Bayer contended that the design of an exhibition is so bound up with theme and content that it must be integrated into the planning of an exhibition from its conception, through every stage of its development. The theme itself must be well defined at the outset; from the theme, the order of sequence and actual design will develop logically. Thus the design cannot be a last minute arranging of material, but must be an integrated part of the exhibition's statement. In order for an exhibition to emphasize and highlight a theme, the design must maximize and clarify its message throughout the entire spatial sequence. The result is an integrated, powerful statement, well communicated to an audience. According to Bayer, a successfully designed exhibition provides "unity, mobility, aesthetic pleasure, forcefulness, and economy."[41] It is toward this goal that the designer works.

Bayer always used a meticulously constructed three-dimensional model, eliminating all last minute guesswork. All parts of the design were reconciled

within the preliminary model, which was then used to construct the final exhibition space. In preparing this model he ordered the sequence of views for a logical progression in time through the exhibition. He advocated using only one entrance and one exit, with the viewer unobtrusively guided through a planned, logical sequence of parts which not only elucidated the theme, but also provided a smooth, unambiguous flow of traffic through the gallery.[42]

Bayer found that neither rigid, axial symmetry (which *looks* orderly from a birds-eye view, but does not aid in traffic organization) nor asymmetry without careful orientation and direction (which is too confusing) can be effective in laying out the floorplan of an exhibition.[43] One must always plan an orderly, directed flow deriving from and guided by the exhibition material itself, rather than by arbitrary architectural features of the particular building which houses it. One solution used to aid traffic flow in the "Deutscher Werkbund" exhibition was the addition of a curved interior wall which directed the audience comfortably. Whenever possible, Bayer let the actual exhibition materials themselves create the gallery divisions, as with his arrangement of photopanels placed to create spatial definition in the "Road to Victory." Because we read from left to right, Bayer preferred the orientation of exhibitions likewise to proceed from left to right in order to comply with our subconscious left to right predilection.[44] This principle is especially important when the exhibition materials include writing; the viewer is inclined to walk in the direction of his reading.

The principle of an extended field of vision enables exhibition designers to create dynamic spaces which are efficiently utilized, allowing more display materials to be included within the full range of sight. By not limiting himself only to flat walls, Bayer improved the gallery experience for his audience. Antiquated museum practices of stacking rows of pictures vertically on a flat wall always meant that the highest objects could not be seen. But Bayer's method considered the viewer's scope of vision, tilting upper displays down and lower displays up toward the viewer's line of sight.

Ramps for audience passage also aided in maximizing the viewer's field of vision. And uneven lighting, with spotlights emphasizing specific areas and objects, added interest beyond that of a uniform overall lighting. New interesting materials also added excitement. Interest in a variety of materials with diverse physical and psychological effects was fostered at the Bauhaus and Bayer continued to realize the value of utilizing unexpected materials. It was, as previously stated, an exciting discovery for Bayer when he first saw Lissitzky's dramatic use of the new material, cellophane. In his own exhibitions, Bayer continued to substitute lightweight replacements for traditional

wood and plaster, making spatial divisions with photographs and lengths of cord, for example.

Just as in graphic design, where the bold symbol is more effective than a cluttered surface, exhibition design benefits from a pared down presentation. Directness, simplicity, and brevity enable materials to be more easily perceived and messages to be more effectively communicated. In the past, exhibition displays were often created as independent decorative structures which, although sometimes beautiful, did nothing to augment the perception of the objects displayed, often actually detracting from the objects.

Bayer's new exhibition techniques called only for presentational devices amplifying the subject, letting the exhibition material stand alone as much as possible, without unnecessary architectural adornment. He cited the 1920s as a turning point away from the pompous decorativeness and historical eclecticism of the nineteenth century. The new modern style of display found precedents in the Russian Constructivist exhibition of 1921 and subsequent developments of the later 1920s in Germany, and then in Italy, Switzerland, and Sweden.[45] Among his native Austrians, Bayer cited Kiesler as providing an important precedent for movable exhibition structures, with his 1925 "Austrian Theater Exhibition" at the Paris "Exposition Internationale des Arts Décoratifs."[46]

Bayer built upon the early modernist developments in Europe to arrive at his own standard of exhibition design. Based on these early European avant-garde developments, Bayer's designs in America brought to this country the newest forms of display. His exciting example aroused much interest on this side of the Atlantic, and his influence here cannot be missed if one but pages through the literature of American exhibition design in the twentieth century.[47]

Prior to the time of the European modernist exodus to the United States, American exhibition design was not even a serious discipline. Although exhibitions themselves were given serious consideration, methods of display were outmoded and uninspired, although often including much surface embellishment. By the early 1930s, the most intelligent and weighty studies of museum installation were just beginning to question how current installations affected the public, by analyzing the public profile and by observing individual reactions to specific exhibits, types of wall labels, and lighting conditions, and by recording data such as the length of time a "typical" viewer spent in particular exhibits.[48] Although these studies were on the right track, they were quite subjective and also far from effecting any dramatic change in American exhibition design. They did, however, create a climate ready to receive what European modernists such as Bayer brought here.[49]

It is clear from the critical response to Bayer's Museum of Modern Art exhibition designs of 1938, 1942, and 1943 that the type of display he introduced here was a revolutionary discovery for Americans. Not in one instance known to this author did a critic relate Bayer's designs to any other previous American phenomenon.[50] What is especially noteworthy is that by the late 1940s, and particularly in the 1950s and 1960s, a new style of literature about exhibitions evolved. Although the literature on exhibition design, even today, is hardly scholarly or historically documented, by the 1960s books were beginning to explore the possibilities present in new exhibition design. For the first time, discussion centered on the very precepts by which Bayer had structured his exhibitions. Finally, Americans demonstrated concern for intelligent planning of exhibitions, considering ease of perception, traffic flow, and above all what Bayer called "visual communication." Many illustrations in the exhibition literature after the late 1940s show Bayer's influence, with oversized photopanels angled out toward the viewer, minimal architectural supports, etc. And Bayer's examples themselves appear over and over in the reproductions accompanying the texts, as examples of innovative exhibition design. One designer/author, George Nelson, devoted a full dozen pages to Bayer in his book *Display*, stating that

> Bayer, perhaps more than any other designer, has developed, synthesized and expounded new ways of visual communication, and in his work in the field of exhibition and display, he has brought together a remarkable variety of techniques and media.[51]

Bayer's example provided important precedents in America for a new breed of designer who is more than just a technician installing exhibitions, one who is a creative, integral part of the museum team designing an exhibition, from its first inception through every stage of its realization. For Bayer, exhibition design was inextricably linked to two areas which had been his lifelong concern: visual communication and environmental design, and his goal was to create a planned, finite *environment* that *communicates* to the visitor.

There is little doubt that the modern installations by Bayer and some of his contemporaries in America influenced the display methods of later American exhibitions and trade fairs. The photographs which follow document only a few examples of later exhibitions which seem to rely on Bayer's method (see figs. 82, 83, 84, and 85). Even further, Bayer's example of the exhibition hall as a dynamic, participative environment may also have served as a precursor to some later twentieth-century modern installations where the designed space *is* the exhibition, not merely a bland space in which to display autonomous objects. Gallery spaces by people such as Alan Kaprow

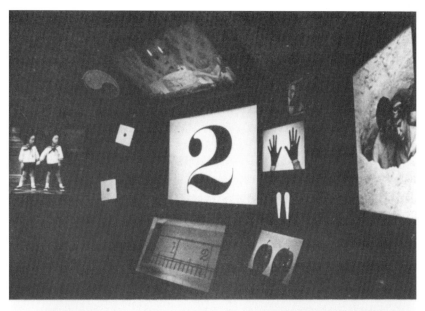

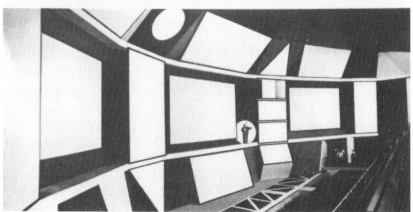

Figure 82. Charles Eames, Interior of Ovoid Theater of IBM Exhibit,
New York World's Fair, 1964–65

Figure 83. Warnett Kennedy and Associates, Display at "New Health Service" Exhibit, 1948

Figure 84. Map Exhibit, Joslyn Museum, Omaha, Nebraska, 1948

Figure 85. Peter G. Harnden and Lanfranco Bombelli, "United States Food and Agriculture" Exhibit, R.A.I. Building, Amsterdam, 1963

and Dan Flavin seem a logical continuation of Bayer's theories. Although Bayer probably would have denied that he had had a hand in the development of these kinds of contemporary installations, he may have provided a point of departure for the kind of thinking required of those creating total gallery environments.

More than forty years ago, Herbert Bayer's ideas and design of the exhibition hall as a dynamic environment provided an early example on American soil of the most advanced principles of exhibition design. This example encouraged the creative direction of American artists and designers who assimilated and used it in formulating future American exhibitions. Certainly Bayer was not the only new designer of avant-garde display in America. But because of his association with the Museum of Modern Art, his designs were in the limelight, receiving considerable attention in the press.[52] And his energetic efforts to write about the field also made his ideas well known. Bayer's example was a major factor in changing the character of American exhibition design in the second half of the twentieth century.

8

Environmental Design

*i am not so much concerned with the individual work of art, as
with the total shape and content of the human scene.*
—Herbert Bayer, *herbert bayer, painter, designer, architect*

The concept of environmental design is not new. During ancient times entire monumental complexes were shaped at places such as Giza and Athens. Later, Michelangelo and Bernini were responsible for creating wondrous large-scale environments. But the nineteenth and early twentieth centuries saw changes resulting in specialization of the artist, separation of disciplines, and a dearth of integrated programs of total design. The ideological and practical separation between the artist and craftsman augmented the problem, leaving a schism in the arts and a shortage of people qualified to integrate art into the realm of the general population. During its short existence, the Bauhaus strove to overcome the causes of this specialization and separation within the fields of art and design. Herbert Bayer's belief in this Bauhaus goal led him to spend his life spreading the word and example of the Bauhaus. Especially in the United States, Bayer almost single handedly purveyed the Bauhaus method of integrating the arts; his example demonstrated the positive results of carefully shaping integrated environments unified by design which is both visually pleasing and functional.

Bayer himself identified some concern involved in shaping well-designed modern environments, stating that architects and planners need to coordinate an entire fleet of specialists including, but not limited to structural and mechanical engineers, acoustical experts, real estate experts, demographers, and plastic artists.[1] He reiterated the need for the artist to become a primary and influential member of a planning team:

> art, integrated from the very inception of the urban plan, is of fundamental importance. this suggests that artistic work will expand from the picture frame to the large outdoor spaces where it will eventually assume terrestrial, even cosmic dimension. it will again assume meaning for the majority.[2]

Of the Bauhaus, Bayer stated:

> the bauhaus already saw the function of the artist not only in the shaping of particular objects and issues, but in the totality of all design for an all inclusive environment. I was personally interested in the esthetic incorporation of communication media, especially lettering, into the city-scape. I refer to my ideas for newspaper kiosks, trolley car waiting stations, outdoor advertising, exhibition structures.[3]

After his immigration to the United States, the urban environment of New York City became an exciting catalyst for new thoughts about environment:

> in the late '30s I watched the light and motion environment of times square in new york, its outdoor advertising signs, with great interest and excitement. it was like an art gallery where one could see designs and word-messages light up, change, and disappear rhythmically. although most of these light posters were of bad taste and the messages were banal, it was the conglomeration of many signs, different in kind and size which produced an incoherent but brilliant night environment and bathed times square in luminosity.[4]

Of course mechanical investigations of light and motion had already begun much earlier in Bauhaus experiments by Moholy-Nagy, Schlemmer, and others. In New York Bayer became fascinated with possibilities of large environments of light and motion:

> at the time [in the late 1930s] I intended to enlarge the light posters of times square into truly gigantic sizes by using entire skyscrapers. since all interior light sources appear through the grid pattern of the windows, each illuminated window would then become one dot of a large light screen: as many dots of the grid as there are windows in one facade. letters and other images would light up in color and in very large dimensions. or if the individual window lights would be keyed to an electronically controlled time system, the lights would turn on and off according to a previously designed pattern and produce sequences of changing designs. . . . much later a similar method occurred to me as applied to the project "festive illumination of a city." in this project all light sources of one building would be covered by a clip-on device or by plastic sheets placed over the windows. red, blue, yellow illuminated towers would stand out gay and festive at night if one color for each skyscraper would be used.[5]

These early large-scale ideas were the antecedents of later works which by now have come to be grouped under the heading of "environmental sculpture and design." Bayer's early ideas for skyscraper illumination projects, conceived half a century ago, are still exciting today, no less innovative or ambitious than the current projects of an artist like Christo, for example. In Bayer's actualized environmental projects he became drawn more to the human environmental experience than to either the process of creation which

interests Christo so much or the autonomous sculptural effects of his own earlier ideas for large illuminated skyscraper designs.

It is this involvement with the human experience that also separates Bayer's early earthworks from those of later artists known for earth projects such as Robert Morris, Michael Heizer, or Robert Smithson, whose works do not invite active participation from within as much as aesthetic contemplation from outside of the work. Bayer considered function to be central to his environmental work in any media, including earth art, whether its function is as humble as offering a site for relaxation[6] or as grandiose as providing flood control in a large land reclamation project.[7] Even in the latter, Bayer ensured that his project would provide a site for positive human experiences at times other than the infrequent periods when flood control concerns predominate.

Bayer's sculptured gardens with berms and recesses recall those of Noguchi, to which they sometimes relate formally. Yet again the comparison falls short. The closest iconographic definitions one might be able to pin to Bayer's land art are those of geology, vis-à-vis his involvement with related issues contained in his *world geo-graphic atlas.* His grass mounds and other sunken and raised landscapes are not linked to any cerebral or mythic meaning; they are tied to the human function of experiencing them. Bayer knew Noguchi for many years, but despite tremendous mutual respect of the two artists,[8] Bayer's environmental work is devoid of the mythic, surreal, or ceremonial references which have imbued Noguchi's designs. And while Noguchi has created some "contained" gardens not to be walked on, as Japanese gardens, this concept is inconceivable in Bayer's oeuvre where the human physical experience is primary. Perhaps it is with Noguchi's playground designs that the two artists come closest together, both men's projects designed for human involvement.

Certainly Bayer's interest in environment was related to the Bauhaus education and method. Bauhaus precedents always guided Bayer in his large-scale designs, whether he was creating a corporate identity by unifying company design, arranging an integrated, logical exhibition environment, or providing functional and liveable architectural and landscape complexes. In all, Bayer pursued an organic integration of elements which would be unified both visually and functionally. Above all, his concern with the *human* environment prevailed.

During Bauhaus times the term "environmental design" had not yet come into being. But the ideal of the school, to integrate good design into all phases of modern life including the structures of man, of modern industry, and of technology, surely have led to and fostered the new contemporary concern

with environmental design: the thoughtful shaping of our world. The Bauhaus philosophy and practice of mastering more than one discipline led to an outlook on design as a totality and to an engagement with the total environment. Bayer's comprehensive design programs demonstrated and expanded upon the Bauhaus method. Working in a wide range of media, Bayer created systems of total design throughout architectural complexes, outdoor landscapes, and even within multinational corporations (the focus of the next chapter).

In the present discussion, we shall consider Bayer's environmental design, the large-scale public projects in which he was able to implement systems of unified design into human spaces. Whether they be projects for parklike rural settings, designs for projects along highways, or designs for business, recreational, and residential complexes, all of Bayer's large-scale environments involve both functional and aesthetic considerations, with the human issues always at the forefront.

In considering Herbert Bayer's contributions to the field of environmental design, one is drawn to Aspen, Colorado which, if only by the sheer number of Bayer projects, would be the logical place to begin any discussion of Bayer's impact on environmental design. But beyond the outstanding *number* of design projects completed by Bayer at Aspen, a discussion must focus on Aspen because of the concerted attempt made there, not simply to do projects, but consciously to shape a total environment. Bayer created large-scale projects all over the world, but nowhere did he, or perhaps anyone, have as much impact on creating an entire unified environment as he had at Aspen. For Bayer, Aspen was a kind of testing ground of Bauhaus ideas. It provided the stage upon which he could enact the lessons of his education.

Bayer's first contact with Aspen was through Walter Paepcke, whom Bayer met in 1945 while designing Container Corporation's exhibition, "Modern Art in Advertising." Although the Paepckes' principle residence was in the Chicago area, from 1936 on they also had a large ranch at Larkspur, Colorado (Perry Park), between Denver and Colorado Springs. Aspen was discovered on an excursion.[9] According to Bayer,

walter, influenced by his wife's love for the victorian (they had previously built a victorian house in sandwich, illinois) was attracted to the quaint architecture and beautiful surroundings of the sleepy town of aspen and bought quite a few houses.

he first dreamed of aspen as a retreat for a small group of cultivated friends. . . . mr. paepcke knew of my background in the mountains of austria, my attachment to nature, the outdoors, mountaineering and skiing. he repeatedly urged me to visit aspen. by november 1945 his plans had already gone beyond his first enthusiasm for this old mining town, and he was considering making aspen into a new, more balanced community where livelihood, sports, culture, and art could be pursued amidst the beauty of nature.

by that time i was contemplating a move away from new york and accepted the paepckes' invitation. having never previously ventured further west than chicago, i came with them to aspen between christmas and new year, at which time i bought an old house originally owned by colorado's governor waite. the following april 1946, i moved here permanently.[10]

A more lively and detailed accounting of Paepcke's introduction to Aspen has recently been provided by James Sloan Allen, through interviews with Elizabeth Paepcke, in *The Romance of Commerce and Culture*. In this account Paepcke's early relationship with Aspen is explained as having been anything but accidental or haphazard; his approach to it was as to any carefully considered investment opportunity. Even before he had stepped foot in the town, the businessman had thoroughly researched every aspect and had calculated plans for development. These plans included Bayer, whom he invited to associate with him on the project.[11]

Bayer accepted the position of consultant to Container Corporation and to the development of Aspen. In addition to being an astute businessman, Paepcke was a well-read, cultured man of German descent who believed in the inherent value of cultural education. Among other things he was an enthusiast of the "Great Books"; he envisioned Aspen as a utopian retreat where one could be refreshed and stimulated in association with nature and with ideas. Said Bayer,

it may be considered an unusual and far-sighted move for a businessman to feel the need for the assistance of an artist at the outset of an enterprise of this nature. It was not accident which made me accept and move to aspen. the opportunity came as an answer to my wish for a well rounded and more complete life.[12]

Although Aspen presented many hardships and none of the glamour that now is associated with its name, Bayer found in this almost deserted place an opportunity to implement the cherished tenets of the Bauhaus while personally recapturing a mountain lifestyle.[13] He recalled:

at the time, this was a doubtful venture. the place that lay before paepcke and bayer was truly a ghost town. the town was dormant from the time of its decline at the turn of the century—empty quiet streets, overgrown with grass; mostly older people, ex-miners living on pensions; few young people as there was no opportunity for work; few cars, few of the conveniences of civilization. even fresh fruit and vegetables were hard to come by.[14]

What Aspen offered Bayer was the opportunity to shape an environment, to deal with social problems in building a community. Bayer began

by restoring the quasi-Victorian buildings that were the miners' legacy to the future ski resort; he devised color schemes which he hoped would unify the town's appearance. In addition to the individual old houses, the Wheeler Opera House, damaged by two fires in 1913, was restored elegantly. (Bayer's restoration remained until the building was again refurbished in 1984.) Although Bayer believed in accurately restoring these historic buildings from Aspen's past, he could not justify constructing new buildings in an old style. For Aspen's redevelopment he envisioned a harmonious new plan which would be unified within itself and with nature by a pervasive system of good design.

It was fortunate that the Bauhaus had encouraged its progeny to excel in more than one discipline to create unified systems of design; Bayer quickly found that in order to accomplish his task in Aspen, he needed to venture into areas which were previously unfamiliar. For example, although he had never been trained as an architect, he found that Aspen's development required him to enter the field of architecture.[15] Bayer stated, "it was my intimate involvement in the aims and physical needs of the city as an organism and of the ideas for the humanities which first encouraged me as a designer to assume architectural responsibilities."[16]

Already in 1946 Bayer's sundeck warming hut and lunch restaurant for skiers at the top of Ajax Mountain was built. At an elevation of 11,300 feet, its construction was an adventurous project. In keeping with his interest in creating an integrated total environment, Bayer was concerned not only with function but also with appearance on the mountain, and with framed views from the structure. He lowered outer areas of the building to maintain clear vistas from within the innermost part. Its shape, an octagon, must have been planned for maximum panoramas from within.

Bayer approached the development of Aspen as a unified project. Whether he was designing outdoor structures, creating posters to advertise new skiing opportunities (fig. 86), or designing promotional literature for the town, Bayer worked towards the same goal: to define a character for the town in transition.[17]

In the early years Bayer was able to exert considerable influence upon Aspen's character, but as the town grew his efforts to define a town plan were not always accepted by the community at large. The town council repeatedly failed to implement Bayer's proposed zoning regulations, which today are recognized as common safeguards but then were innovative ideas that were largely misunderstood. Because of his inability to effect controls, it became impossible to prevent overdevelopment or self-serving business practices of land speculators and absentee owners.[18] Thus Bayer con-

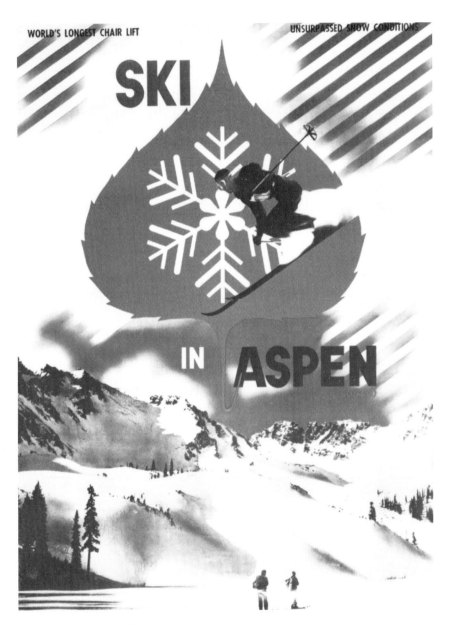

Figure 86. Herbert Bayer, Aspen Ski Poster, 1946
 (Herbert Bayer Collection and Archive, Denver Art Museum;
 Gift of the Estate of Herbert Bayer)

sidered the town of Aspen, even with its special character, to have failed somewhat as a unified planned environment.

If Bayer's results were not wholly successful in town, his influence was more pervasive at the Aspen Institute for Humanistic Studies, a site on the outskirts of the city where, as a designer, he had tremendous autonomy in development. It is the Aspen Institute site which provided Bayer a place to implement his concept of a unified total environment. Here Bayer's architecture, sculpture, murals, and earthworks all merge into a cohesive whole. Bayer's well-known statement, "I am not so much concerned with the individual work of art, as with the total shape and content of the human scene,"[19] is nowhere more in evidence than here. The interrelationships at the Aspen Institute create an environment greater than the sum of its parts. By necessity we shall examine separately the components of this carefully designed space, but its impact lies in experiencing the whole. Although some individual elements of Bayer's design appear to be visually related to those of other artists such as Noguchi or the later earthwork artists, it is clear that Bayer used individual forms as solutions to a greater problem, the design of a functional, liveable environmental space.

The year 1949 was a key year in the development of Aspen. In that year, through Paepcke's efforts and influence, Aspen hosted the Goethe Bicentennial Festival, from which grew the Aspen Institute for Humanistic Studies and the annual music festival and music school. To accommodate the activities which followed these beginnings, a building program commenced. During the decades of the 1950s, 1960s, and 1970s, Bayer shaped the working environment of the Aspen Institute, providing housing, meeting space, and recreational facilities for program participants. Foremost in Bayer's plan was the maintenance of a sensitive relationship between manmade structures and the natural beauty which is so prominent all around this site. It is fitting that one of the final large projects Bayer designed for the Aspen Institute is Anderson Park, a large, green expanse of berms and recesses, literally an earthwork park for play and meditation, a soft, low-lying, manmade foil for the glacier-molded majesty of the surrounding Rockies (fig. 87).

Today the Aspen Institute is an autonomous total environment providing visitors not only complete practical facilities within its perimeters, but also a site unified by a system of integrated design. Surely the continuity of having had one thoughtful and involved designer from its beginning over the course of thirty years has encouraged a sensitive, unified system to emerge even after a building program of that duration: "what the future of aspen promised . . . was participation in shaping an environment."[20]

Figure 87. Herbert Bayer, Anderson Park, Aspen Institute for Humanistic Studies, 1973 (Photograph by Ferenc Berko)

In speaking about the Bauhaus, Bayer stated, "the idea of the artist embracing more than one discipline led to an outlook upon design as a totality and to the engagement with a total environment."[21] He speaks of an

> art of the future . . . [which] would go beyond art for the tombs of the museums, out into the street, to the people, into the environment. it would penetrate daily life in all its aspects and would again become one with it. . . . we must envision a "realized" art. that is, all arts are to abandon a separate existence and come to life as part of the newly ordered surroundings.[22]

Aspen provided the site to realize these goals.

> for me . . . there are two kinds of bauhaus: the one of the past which I like to remember because of the group spirit which unified our feeling and work . . . but my sympathies and interests are with the bauhaus of the present, as I am living and working along timeless and flexible principles as evolved in the old bauhaus.[23]

Bayer's contributions at Aspen not only created a unique mountain community, but also demonstrated, on American soil, the positive results of applying and expanding upon Bauhaus ideals. Bayer's example showed the following generation what could be achieved through planning and implementing a unified system of total design. His pioneering American project has been continually studied as a model for future environmental design in this country.[24] Closer examination enables us to identify the characteristics which comprise this intangible value of "unity" within Aspen's system of environmental design.

Looking at the man-made structures at the Aspen Institute, we are first impressed by the fact that they seem at one with the natural landscape. Rather than standing as a separate, developed cluster in opposition to the natural terrain, as is often the case in other mountain developments, the structures of the Aspen Institute were designed to defer to and to be enhanced by the natural beauty all around (in fact, placed on the flat plains, these buildings would appear rather lifeless). They are diminutive in scale, with no building reaching more than a few stories in height, and most remaining on one level. Materials also are understated, with wood, cinder block, and concrete predominating. Financial restrictions often influenced architectural choice, but nonetheless, preference for understated forms prevailed. The conference buildings themselves are simple, composed of planar, geometric shapes; the Seminar Building, for example, is a double starlike formation which includes two radially oriented seminar rooms of hexagonal shape, each organized around a central table for free exchange of ideas without a fixed lecturer-

audience format (fig. 88). Speaking of the important relationship between form and function in these hexagonal meeting rooms, Mortimer J. Adler stated:

> The phrase "round table" must be given physical reality if its intellectual significance is to be realized. For a group of persons to be able to talk with, not just at, each other, they must somehow confront one another in as nearly a face-to-face manner as possible.[25]

The Paepcke Memorial Building echoes the sculptural configuration of the Seminar Building, with a faceted exterior of planar geometric elements. The separate building which houses the Physics Division is also planar, a low-slung horizontal series of rectangles with cinderblock and redwood predominating.

In each of these buildings a continuity of style pervades which is modest, never competing with the landscape. Rather than finding integration with the landscape through an "earthy" style of logs and stone as is often seen in mountain towns,[26] the low planar architecture has its source in the understated Bauhaus aesthetic. Function is primary in determining shape. All unessential ornamentation is eliminated; materials such as cinderblock are not covered but are open to "honest" view; the simple flat architectural parts echo one against another to yield a sensed unity without any slavish imitation from building to building. And the restful simplicity of design never attempts to compete with the splendor of the natural environment.

The surrounding mountain environment is echoed in a monochromatic sgraffito mural (fig. 89) scratched into a layer of plaster across an exterior wall of the Seminar Building. (Recall that Bayer had learned sgraffito technique in Kandinsky's wallpainting workshop.) Following the style of Bayer's two-dimensional series entitled convolutions, the sgraffito mural explores the movement undulating within the interior of mountains; a sense of movement is also experienced as one walks alongside its series of wavelike stratifications. The sgraffito mural helps to bridge the jump between large mountains looming above and low architecture below by echoing the natural site in both subject and material. The mural was a communal nocturnal project accomplished by Bayer and some Aspen friends on a summer evening in 1953.

When color is introduced to architecture at the Aspen Institute, Bayer chooses, as might be expected, the three primary colors. These he employs for emphasis in both the Health Center, on which the initials "H C" are colorfully incorporated into a large mural (fig. 90), and at the Aspen Meadows hotel complex, a small grouping of three horizontally oriented buildings of hotel rooms with balcony dividers of blue, red, and yellow (fig. 91).

Figure 88. Herbert Bayer, Seminar Building, Aspen Institute for Humanistic Studies, 1953 (Photograph by Jonathan Bayer)

Figure 89. Herbert Bayer, Sgraffito Mural, Seminar Building, Aspen Institute for Humanistic Studies, 1953
Sgraffito, 10′ × 26′

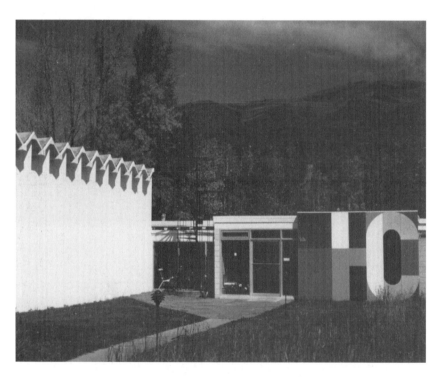

Figure 90. Herbert Bayer, Health Center, Aspen Institute for Humanistic Studies, 1955

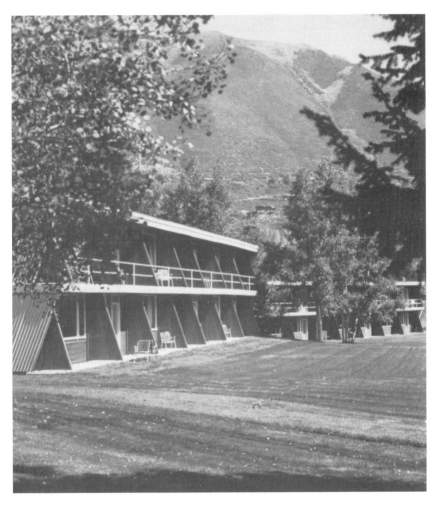

Figure 91. Herbert Bayer, Aspen Meadows Hotel Complex,
Aspen Institute for Humanistic Studies, 1964
(no longer extant)

Figure 92. Herbert Bayer, Model for Music Tent, Aspen Institute for Humanistic Studies, 1964

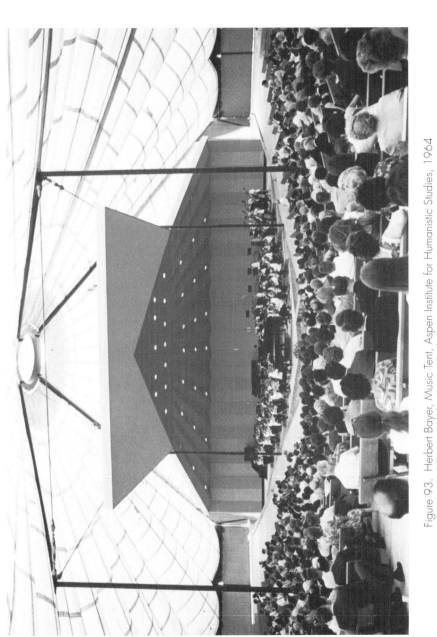

Figure 93. Herbert Bayer, Music Tent, Aspen Institute for Humanistic Studies, 1964
(Photograph by Ferenc Berko)
(no longer extant)

Bayer's music tent, designed for the internationally acclaimed concerts of the Music Associates of Aspen, lies somewhere between the realms of architecture and sculpture. Built in 1964 to replace the original 1949 Saarinen tent constructed for the Goethe celebration, Bayer's structure is defined by a rigid suspension system of steel columns and cables to which a sliding canvas ceiling system is fastened for relative ease in erection and dismantlement (figs. 92 and 93). Again, simplicity of materials (steel, canvas, concrete, and pleated plywood) and simplicity of design elements is followed. Seating 1400, the canvas tent itself is white, with red and blue canvas walls.

When Bayer turned to freestanding sculpture at the Aspen Institute he continued his involvement with simple, unadorned shapes and with human issues. The *marble garden* (1955, fig. 94) is Bayer's sculptured arrangement of discarded marble remnants collected from a nearby quarry at Marble, Colorado, a quarry once used extensively for important architectural monuments including Washington, D.C.'s Lincoln Memorial. *Marble garden* is in a sense a "found object" park which owes much of its fascination to Bayer's fine-tuned ability to balance elements of chance with thoughtful arrangement. Interesting interplays of light, shadow, site, and scale are created between disparate parts with unpolished surfaces and roughhewn markings, these pieces discarded from some earlier, now anonymous ambitions. The ever-changing angles and views and the contrasts between solid and void reward those who experience the site. Additionally, the exchange between the white stone and the tall peaks all around adds to its power. *Marble garden* is a favorite spot at Aspen. On any given day one sees people relaxing here, many with book in hand, sprawled on the surrounding grass.

While the *marble garden* provides a human space for leisure, the *kaleidoscreen* (1957, fig. 95) is even more closely tied to the human function. Sited near the edge of a swimming pool, over which is a Buckminster Fuller geodesic dome, the work is made of movable aluminum louvers. Closed, the planar surface displays on one side a frieze of multicolored pattern which emphasizes primary colors, and on the other a heat-reflecting textured aluminum surface. The louvers can be rotated almost 180° by a cranking mechanism; as the louvers turn, the visual patterns change. At least as important, the work reflects sunlight at different angles and filters or blocks wind (which can be considerable coming across from the mountain), depending upon its position. With the *kaleidoscreen* Bayer created a functional design which not only is satisfying visually but also enhances the human experience by redirecting wind and sun.[27] Although one is likely to label the *kaleidoscreen* "sculpture," in fact it operates aesthetically between the realms of painting and sculpture, while functionally approaching architecture. Bayer

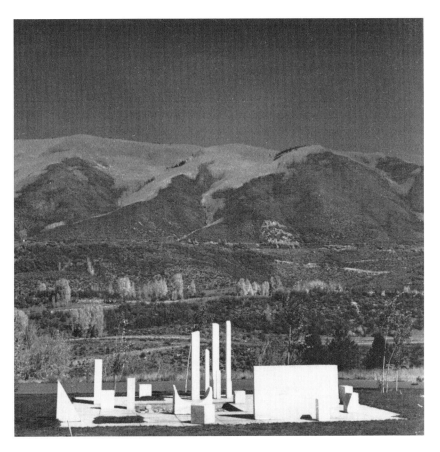

Figure 94. Herbert Bayer, *marble garden*, Aspen Institute for
Humanistic Studies, 1955
12' × 36' × 36'
(Photograph by Jonathan Bayer)

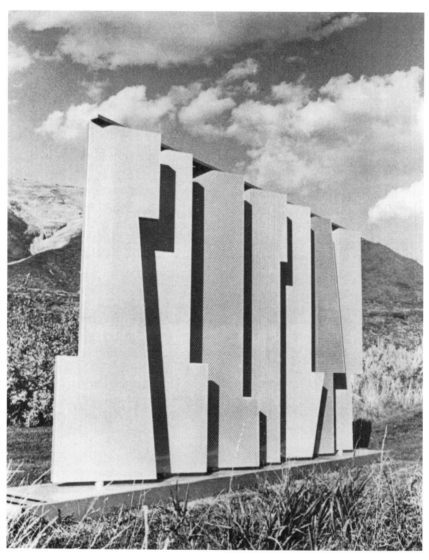

Figure 95. Herbert Bayer, *kaleidoscreen*, Aspen Institute for
Humanistic Studies, 1957
Aluminum and paint, 7' × 12'

describes it and other related works as "environmental design";[28] by his ter-minology, we realize that it is the issue of site which provides definition.

The structures created by Bayer at Aspen display a visual integration among themselves and with the natural landscape.[29] Two more projects at Aspen further bridge the gap between his work and the natural environment. These structures of molded earth provide engaging sites for human experience and, quite appropriately, complete the union of manmade and natural elements at the Institute site.

In 1955 Bayer created a *grass mound,* forty feet in diameter, at the Aspen Meadows (fig. 96), adjacent to the site of the *marble garden* of the same year. This monument of molded land was created fully a decade before anyone had even heard the term "earthwork." Bayer became involved with this large-scale environmental piece as an answer to his ongoing search for solutions to the dual problem of relating structures to the physical landscape and to the people who inhabit them. Although Bayer preferred not to be designated an "earthwork sculptor," surely he was a pioneer in the explora-tion of ideas now associated with site-specific sculpture. This phenomenon in his oeuvre, at such an early date, was one more expression of his desire to integrate the arts and to bridge the gap between art and everyday life.[30] In 1956 Bayer was asked about the function of the grass mound. He replied, "it may be used to sit on."[31] In response to a question about his relation-ship to later earth artists such as Heizer and Smithson, Bayer modestly replied:

> i am in a predicament with an answer. i am being credited with being the first "earth artist" in our time. ancient cultures have used earth for environmental edifices, usually of a religious nature. mine came about as a landscape feature embellishing a garden. it was natural to me to shape earth and cover it with grass to become integral with the landscape. the group of heizer, etc., explain their work in highly philosophical terms which i have never properly studied because of the extreme intellectual jargon.[32]

By 1973–74 Bayer had completed a large earthwork site, literally an earthwork park, Anderson Park. Not only is this park the physical link be-tween the conference buildings and the residences of the Aspen Institute, it also provides the unifying link between all of the structures and the natural landscape of the Institute. Nature and man are in harmony at Anderson Park, from whose hills and recesses one views Bayer's other structures, the con-ference buildings, music tent, and residences, and the sublime mountains soar-ing high above, for which the manmade park serves as a foil. It is this unity of corresponding parts at the Aspen Institute that makes the total environ-ment much greater than its individual parts.

As Aspen became a well-known cultural center, Bayer's name was associated with innovative environmental projects. At Aspen his work matured,

Figure 96. Herbert Bayer, *grass mound*, Aspen Institute for Humanistic Studies, 1955
40' diameter
(Photograph by James O. Milmoe)

he gained assurance in shaping large spaces, and he earned an important reputation as a leader in the field. And what better location to implement his designs than at the site which annually hosted the International Design Conference. Aspen has been visited by international design leaders, political figures, and corporate executives who have seen Bayer as a leading innovator in American environmental design. If Bayer decided to place himself in a quiet, removed environment, he was instrumental in making that environment a place where, as he said, "People came to us, they didn't have to go to Europe to see somebody."[33] The International Design Conference at Aspen has been perhaps the single most influential forum for American design over the past thirty years. Surely Bayer's influence in American design has made its mark, to a large extent, because of this forum (at which he was a prominent figure and from which he could explain his views) and because of his permanent "exhibition" at Aspen.

Although no other environmental project has been as extensive as Aspen, which provided not only a raw site on which to create an entire new community but also the opportunity for Bayer to exert several decades of influence over it, Bayer nonetheless did create some important monumental projects outside of Aspen. Leaving the subject of corporate projects for further discussion, we note that Bayer created other designs ranging from highway and surf sculpture to land reclamation as sculpture to outdoor plazas, murals, and walk-through sculpture, all to improve the human domain.

By now, Bayer's ideas for environmental design have reached far beyond Aspen, although no doubt Aspen's success initially enabled him to make his mark elsewhere. Even just a few years before his death, at an age when he professed a preference for concentrating on private studio work, monumental projects were brought to him regularly in hopes that he would be excited by the challenge; and often this was the case. Even so, detractors thwarted some of his most exciting and innovative proposals, such as those he envisioned for surf and highway works which by their nature require public and municipal sanction.

Projects that Bayer completed outside of Aspen after his settlement there in 1946 include the remodeling of Orchestra Hall, Chicago (1950); two murals for the New Commons Building of the Graduate Center, Harvard University (architect: Walter Gropius, 1950); Fort Worth Art Center, Fort Worth, Texas (1954); brick wall mural for elementary school, West Bridgewater, Massachusetts (1955); two historical map murals for Colonial Williamsburg, Virginia (1957); metal space divider for Lackritz House, Palm Springs, California (1957); private chapel for Robert O. Anderson, Hondo Valley, New Mexico (1962); sculpture, *articulated wall*, Mexico City Route of Friendship (1968); tile mural, *beyond the wall* and minipark, Philadelphia

College of Art (1977); *organ fountain* sculpture, Linz, Austria (1977); design of landscape for floodwater control, City of Kent, Washington (1979); *articulated wall* (twice the size of the 1968 Mexican wall), Denver, Colorado (1985).

In all of Bayer's environmental designs, the human experience and involvement is primary. His 1955 *grass mound,* for example, although often cited as a precursor to contemporary earthworks, was created as a human space to be experienced. The emphasis here is the *human* aspect rather than the *earth* aspect, which is secondary. In planning and shaping that human space at Aspen, Bayer simply was inventive and resourceful enough to have thought of molding the land. It is inconceivable that he ever could have created earth sculpture in a remote part of the country where object and site supersede the involvement of object and site with people and their use.[34] For Bayer the human function was essential and his aim was to design spaces for people, regardless of the materials used to fabricate them. This one purpose guided Bayer's environmental works, and in this goal the Bauhaus influence is evidenced.

We remember that at the Bauhaus Bayer was trained in wallpainting, a discipline which was firmly integrated into Gropius's idea of uniting all the arts within architecture. If we expand this concept beyond the confines of traditional walled architecture, we arrive at Bayer's enlarged concept of designing human spaces, and once again, it is clear that Bayer's Bauhaus experience was the formative and generative factor guiding his growth and maturation as an artist. His environmental work at Harvard, Fort Worth, West Bridgewater, and Williamsburg all could have been conceivable Bauhaus projects. Yet even though Bayer continued to design architecture, architectural sculpture, and murals, he carried Bauhaus ideas even farther. During the late 1960s, perhaps in response to expansive thinking fostered at Aspen, he began to envision environmental projects in a larger sense, an orientation that had also been foreshadowed in his Bauhaus ideas for future urban-sited newspaper kiosks, trolley car waiting stations, and outdoor advertising. Beginning with a highway sculpture created in Mexico City for the 1968 Olympics (*articulated wall*, fig. 97), Bayer's work demonstrated a broader public emphasis than he had displayed previously.

Bayer was invited to participate, along with other internationally recognized sculptors, in producing a monumental work in concrete as part of a permanent exhibition of sculpture along an eleven-mile strip of highway leading to the Olympic Village and Azteca Stadium.[35] In accepting the challenge of creating art for this highway route, Bayer emphasized his continuing interest in correlating project to site: "all my previous three dimen-

Figure 97. Herbert Bayer, *articulated wall*, Mexico City, 1968
Prefabricated concrete and paint, 53'6" high.
(Photograph by Garay)

sional art works have been designed for their specific surroundings and particular functions and I have, therefore, seen them as environmental designs.''[36]

The idea of creating sculpture to be seen from the highway interested Bayer who, as early as 1932, had created an innovative outdoor roadside advertising poster for the German periodical *Die neue Linie.* At the Bauhaus he also had envisioned designs for well-planned environments with ideas for the ''esthetic incorporation of communication media . . . into the cityscape.''[37] The Mexico City project related to these ideas.

> i have long considered the highway an issue worth the attention of the artist beyond the immediate necessity for planners, engineers, communication and traffic experts, landscape architects to study its problems towards more satisfactory and more functional solutions. to place eighteen sculptures in distances from one-half to two kilometers along a traffic artery is a new and interesting attempt to enhance a drive of approximately eleven miles. i see it as an experiment which had to be made sooner or later. up to this point we have only known how to disgrace a highway with advertising. although most of the works are placed so that one can stop and see them at close range, the major viewing point is from a distance from a car driving at a speed of 25 to 40 miles.[38]

In another statement he continued:

> sculptural treatment towards ''beautification'' of the highway is a task for the contemporary artist and a necessity. areas of ugly industrial or slum development and roads leading monotonously through uninteresting landscapes need first attention. visual interest of sculptures placed in such areas would also ease the driving and would, on long monotonous stretches, help keep the driver on the alert.[39]

Bayer looked on the Mexico City project much more as a ''design'' problem than as a ''sculptural'' creation. This means that rather than creating an autonomous three-dimensional work to be displayed, he designed a work whose form would be an integral part of its surroundings, and whose form also was determined by considerations of site. Additionally, because this work was to be erected in Mexico, within a short period of time by a team of workmen with whom the artist was unfamiliar, he designed his piece for ease in construction:

> ''articulated wall'' consists of thirty-three concrete forms, each eight meter by one meter by 0.50 meter. they were prefabricated at the site. . . . it took little time to erect the wall. it is placed in a north-south position perpendicular to the road for maximum effect of light and shadows and for the greatest variety of views . . . because of its character, i prefer to call my work not sculpture, but construction. concrete, at least as it was used on my project, is not a handsome finished material. however much it was against my feeling

for the truthfulness of a material, i painted the entire structure in yellow. . . . i decided on a color, largely because . . . of the rare opportunity to use bright color. mexican people love color and the face of the contractor lit up when i told him that it will be yellow. i would like the form of the construction to dissolve through its bright coloring and to be defined only by its light and shadow effects, the "articulated wall" should stand as a symbol on the highway.[40]

Central to Bayer's design was the fact that the work would be seen primarily from vehicles traveling along the highway, often at high speed. His plan maximized the effects created by quickly changing viewpoints. By creating a work whose form would be enriched by its site, he capitalized on the fact that the shape of the *articulated wall* appears to change as it is seen by one driving past it.

it should be understood that a sculpture placed along a highway must be of a different concept from a sculpture statically situated on a plaza. the fact that one will see such a sculpture from far away and approaches it with relatively high speed and then passes it preconditions a highway sculpture to new concepts. . . . the dimensions of the highway itself, the grandeur of a landscape, and distant view of such sculptures condition them to monumental sizes. the question has been raised that any visual interest beyond paying attention to the road when driving may impair the safety of the driver. this question, however, has been answered a long time ago by the many billboards along roads which not only expect to be looked at but expect to be read. i am convinced that any problem of safety can be solved by placing sculptural structures in a manner by which safety is controlled or even improved.[41]

Realizing that "the new environment . . . must be planned to a large extent for the man in a moving vehicle, while environments of the past were exclusively related to the pedestrian,"[42] Bayer directed his energies towards fulfilling that challenge within the modern environment. By the end of the 1960s and especially in the 1970s, Bayer envisioned innovative projects for highways such as his *highway gate in three parts* (1971), *undulating grass mounds* (for the side of a highway, 1971), *road of the leaning pyramids* (1972), *highway with positive and negative hemispheres* (1971), and *road in deep embankments* (1972).[43] As their titles suggest, these plans included redeveloping the actual site, going much further than simply placing congruent works along highway borders.

Similar in scope to Bayer's highway projects are those he envisioned for some areas of surf along the coast of southern California. Just as his works for highways consider not only the aesthetics of their placement but also the function of their placement, his designs for surf sculpture take into account ecological considerations, seeking to ameliorate some problems of the ocean shoreline environment.

A 1982 large-scale work was developed as an ecological conservation solution for its environment, in this case, the control of a troublesome flood-water plain. Bayer was one of eight artists commissioned by the King County Arts Commission (City of Kent, Washington, near Seattle) to develop proposals and models for the redesigning and reclamation of specific county sites. These sites had been turned into wastelands, mostly gravel pits, through industrial misuse. Of the eight projects, two were chosen to be implemented, those of Robert Morris and Herbert Bayer.[44] Bayer's project reclaims a two-and-a-half acre site, a portion of Mill Creek Canyon Park which Bayer restructured into a high-usage recreational park (fig. 98). Again the difference between Bayer's so-called "earthworks" and those of more "classic" earth artists is seen. While Morris's project is not intended for prolonged human activity (except to drive out and walk through it in order to see it) Bayer's is meant to be lived in and experienced. Pathways and a bridge invite one to spend leisure time enjoying the land and its rechanneled creek. Additionally, during flood conditions it is capable of holding 460,000 cubic feet of water,[45] in effect doubling as a system of natural dams which form an integral part of the landscape.[46]

In another series of environmental designs, Bayer created what he called *walk in space paintings*. Although the only constructed example in the series could be considered within the category of "corporate art," since it is sited at the Breakers, ARCO's executive training center at Santa Barbara (fig. 99), this group will be discussed here. Its place in Bayer's oeuvre is not confined to the corporate sector, nor were these designs conceived specifically for a corporate setting. The artist envisioned this series over a period of years beginning in 1962, and it is only by circumstances of patronage that the opportunity to see its development from model to full-scale realization finally came at a corporate site.[47]

The *walk in space* projects are especially interesting as environmental designs because, like other Bayer projects, notably the earlier *kaleidoscreen,* they operate in the gap between more traditionally described forms. These works are architectural, sculptural, and painterly; yet they cannot be fully defined as any one of these. Expanding upon ideas which had emerged with *kaleidoscreens* and *space dividers,* Bayer created paintings (actually tile murals in the Santa Barbara piece) which are three-dimensional, which form a sculptural group, and which can be walked through and experienced in space and time, as architecture. Appearances change with the movement of the viewer/participant, affording a multiplicity of experiences. In this respect they are related to the highway works whose forms also change with varying viewing positions. Once again Bayer envisioned art for human experience,

Figure 98. Herbert Bayer, Mill Creek Canyon Park, Kent, Washington, 1982
 (Photograph by Don Smith)

Figure 99. Herbert Bayer, *walk in space painting,* Santa Barbara,
California, 1981
Concrete faced with glazed brick, maximum height, 10';
pool, 40' diameter.

to be explored by people in daily activity within their surroundings. As environmental design, this series enriches human experience.

In assessing Bayer's role in American environmental design one recognizes a well-delineated orientation from the Bauhaus, where the artist was trained not only in the use of form, materials, and technique, but also in his role as benefactor to society. His vision for the world around him was rooted in the Bauhaus desire to integrate good design into all of modern life. At Aspen, Bayer was able to experiment and to mature as a designer of environments. On a practical level, he was able not only to participate in the newest conferences on modern design, but to make personal and corporate associations that enabled him to take his designs into the public realm. Only relatively recently are his humane environmental designs finally becoming known in larger circles.[48]

9

Corporate Projects

By following a consistent policy of good design, corporations can encourage good taste and profit.
—Herbert Bayer, in *Atlantic Richfield: Art and Design*

Bayer's corporate projects represent a special group of works which could be individually categorized by medium but which, as a whole, may best be considered as unified total designs. Through thoughtfully planned visual communication each defines a finite environment: the particular corporation. With graphics, advertising, typography, and the design of offices, plazas, exhibits, and meeting rooms, the visual character of a company is molded to an individual unified image. Bayer's corporate work sought an immediate and recognizable company identity while bringing the highest level of art and design to every sector of the corporate structure.

The collaboration of art and industry had long been a goal for Bayer. Certainly this was not a new concept for him in America; but application here took new form. Within the postwar American era of the burgeoning giant corporation, new and exciting possibilities presented themselves. As we have seen, in Europe Bayer's involvement with art and industry began with his early apprenticeships in studios devoted to commercial graphics and architecture. Soon the practical application of the young artist's talents was more sharply focused.

At the Bauhaus, Bayer became even more involved with the idea that talented artists could serve the world of modern commerce. Rather than providing a mere romantic respite from the pressures of daily life, the artist was encouraged to become involved with commercial issues, to embrace the machine as a useful modern tool, and to infuse the business sector with the human aesthetic viewpoint. The Bauhaus taught that when good design guides industry, everyone benefits. (It eventually became a favorite dictum among enlightened American businessmen that it costs no more to produce a well-designed item than a mediocre one.)

Bauhaus tenets were influenced greatly by Gropius's own mentor, Peter Behrens, in his pioneering designs for AEG, Germany's nationwide electric company which began as a producer of electric light bulbs and became a huge conglomerate. It is interesting with respect to Bayer's career that the precedents for his American corporate work lay in Germany, where he was taught by Behrens's own disciple. Yet for Bayer, America provided the practical proving ground.

The Bauhaus stressed the value of learning many disciplines in order to relate works of diverse media in unified programs of design. By shaping a total design, an enhanced environment was achieved. What more appropriate assignment could a Bauhaus artist wish for than the designing of a large, unified corporate system? This is the task which Bayer undertook in a comprehensive manner, first for Container Corporation of America and later for the Atlantic Richfield Company. In fulfilling these assignments, Bayer's influence extended far beyond any that he had had in Europe.

It is no accident that Bayer considered Kandinsky his most important mentor. In assignments for Kandinsky's wallpainting workshop, Bayer first became involved with enhancing human spaces. His murals for the Bauhaus stairwell and his entrance poster for the building were precursors of his later designs for corporate spaces. In the Bauhaus spirit, Bayer continued, until the end of his life, to create programs of design which were consistent within themselves and which reflected consideration for their audience and function.

The ten years Bayer spent in Berlin after the Bauhaus found him collaborating with industry as an independent agent, providing graphic designs, letterheads, advertisements, information folders, and prospecti for business use. At least as significant to his later corporate work were the exhibitions he designed during this period. The experience of creating these carefully planned, functional human spaces surely contributed to his later expertise in designing functional, livable corporate spaces. And his work with huge trade fairs and national exhibits such as "Das Wunder des Lebens" ensured that he would never feel overwhelmed by the sheer size and magnitude of the corporate structure. He had already been trained to see the large picture and then to focus on details.

Bayer always believed strongly in the value of the artist to society and to business. He decried those who felt, however altruistically, only a charitable obligation to support the "poor" artist. He stated, "design is a fundamental outlook at the service of the visual improvement of life; it is not merely detached self-expression. the artist is not a luxury."[1]

Society needs the artist as much as the artist needs society. Industry needs the artist today as much as the artist needs industry. Industry has found out that they have to give the con-

sumer aesthetically valuable things. They have to use the artist for their corporate image. . . . I believe that artists should be drawn more into the forces of life. They should be just as important as the banker or businessman. An artist should be taking part in all the big issues because he is the one person who is capable of adding the value of aesthetics. Nobody else can do that.[2]

Therefore Bayer rejected the notion of art "patronage" in the sense of benefaction or sheer material support. A new *mutual* relationship enabled collaboration and interdependency of equal partners. In Bayer's estimation, this collaboration had to take place at the highest level of management in order to be unified, supported, and continually renewed and affirmed.[3]

It was Container Corporation of America that first offered Bayer an opportunity to participate in such a collaborative venture. Bayer's first contact with Container Corporation came while he was in Europe, about to emigrate. Egbert Jacobson, first director of design for Container Corporation, approached him with the idea of designing some advertising pages for the company. Jacobson, a nationally recognized art director and color consultant, had been hired in 1936 to develop Container Corporation's corporate design program.[4] He initiated a pioneering design program that over the years revamped the company's entire look, earning the company tremendous stature within international design circles. Container Corporation itself was only ten years old when Jacobson was brought in. At Container Corporation's inception,

the cracker barrel at the corner grocery was a part of everyday life, not just a bit of nostalgia. The grocer wrapped meat in a newspaper. Flour came in 100-pound sacks—and you baked your own bread and cake. . . . wooden barrels, crates and boxes, along with burlap sacks, were the most common containers in use, and consumer packaging was rare for all but the most expensive luxury products.[5]

During its first ten years the company had already proven its economic vitality, with annual sales reaching $22.5 million in 1936. Its founder Walter Paepcke had ambitious plans for Container Corporation and he pursued his vision energetically.

We have seen that Paepcke was not only a man with substantial business acumen but was also well read, culturally oriented, and a visionary who felt no obstacle to be insurmountable.[6] Paepcke was a believer in the importance of music, the arts, and the classics of literature, some of which were at that time being compiled into the "Great Books of the Western World" series. His wife Elizabeth encouraged him in these areas. According to John Massey, Container Corporation's recent director of visual communication (a newer name for the design department), Paepcke looked to the Italian Olivetti

Company's early example of corporate design, and he modeled Container Corporation in part on the positive qualities he perceived at Olivetti.[7]

Paepcke recognized that paperboard containers, no matter how well designed and useful, would never be particularly alluring. But if his product itself could never be acclaimed as exceptional compared with that of the competition, Paepcke saw that the way to distinguish Container Corporation was through innovative advertising and corporate image.

Beginning in 1937 Container Corporation commissioned internationally notable artists and designers to create images which highlighted the company. A. M. Cassandre was the first to create a series of Container Corporation advertisements. The Russian-born French artist's series of black and white designs were well-received boosters for the company. Over the next few years Cassandre's designs were joined by those of a larger group of distinguished international artists such as Jean Carlu, Gyorgi Kepes, Fernand Léger, Man Ray, and Herbert Matter. Herbert Bayer was part of this group commissioned by Container Corporation.[8] Each advertisement made a simple, brief statement about Container Corporation, its operations, or its contributions to the national economy.

> CCA wanted to get its name before the public: to illustrate that it is an industry leader; to exemplify its integrated resource capability; and to portray the company as a dynamic, humanistic, resourceful enterprise, . . . to communicate CCA's and packaging's role as catalysts in the world economy, and in the distribution of the world's resources.[9]

In response to Jacobson's request, in 1938 Bayer produced a series of eight pages for Container Corporation, the first jobs he did for American industry (fig. 100). By this time Container Corporation was already beginning to think in terms of a new type of advertising. A limit of fifteen words of copy was specified so that each ad would be predominantly visual; Bayer continually maintained this value, concluding that people simply do not read lengthy text. While Bayer's first contact with Container Corporation was that of a commissioned artist like many others, his relationship with the company eventually became quite special.

We recall that Bayer first met Walter Paepcke in 1945 when the artist was commissioned to design the installation of the ''Modern Art in Advertising'' exhibition for Container Corporation, which opened at the Chicago Art Institute before traveling across country.[10] Daniel Catton Rich, director of the Art Institute, had been so impressed by Container Corporation's advertising campaign using firstrate modern artists rather than merely copying modernist devices that he requested an exhibit of designs from its national advertising. It was this exhibition of eighty-nine designs that brought Paepcke and

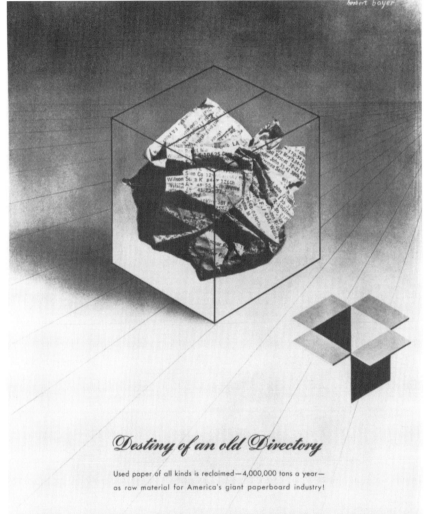

Figure 100. Herbert Bayer, Container Corporation of America Advertisement, 1938
(Herbert Bayer Collection and Archive, Denver Art Museum;
Gift of the Estate of Herbert Bayer)

Bayer together for the first time; soon their lives would mesh in a close business and personal relationship terminated only by Paepcke's death fifteen years later.

In his introduction to the exhibition catalog, which he entitled "Art in Industry," Paepcke wrote,

> it should be made easy, remunerative and agreeable for the artist to "function in society not as a decorator but as a vital participant." The artist and the business man should cultivate every opportunity to teach and supplement one another, to cooperate with one another, just as the nations of the world must do. Only in such a fusion of talents, abilities, and philosophies can there be even a modest hope for the future, a partial alleviation of the chaos and misunderstandings of today, and a first small step toward a Golden Age of Tomorrow.[11]

The ideas expressed here are so close to those of Bayer that they conceivably could have been written by the Bauhaus artist himself. No wonder that by 1946 they were both eager to begin a venture together.

By the time Bayer designed the "Modern Art in Advertising" exhibition, Paepcke and Container Corporation were already committed to a comprehensive corporate design program. The hiring of Egbert Jacobson in 1936 attested to the chief executive's enlightened viewpoint. Together Jacobson and Paepcke established the visual and aesthetic direction which would guide the company's future development. A new trademark was created and a consistent typographic style introduced. Since tan was the predominant color of the company's paper and fiber products, tan and dark brown were selected as the basic color scheme. A continuity of style, geared to human factors, was carried throughout the design of new factories, offices, laboratories, cafeterias, and even the painted signage on their trucks. A program of architecture and interiors was implemented by Container's design department in collaboration with outside designers and architects (including Walter Gropius, who designed a carton plant in Greensboro, North Carolina in 1947–48, during Bayer's tenure as design consultant).[12]

In advertising, the company recognized early that it did not sell its products to individual consumers; instead the company needed to reach and influence management executives. They reasoned that among this audience they could not expect to make sales through the typical "hard sell" advertisement. Instead, Container Corporation looked to advertising as a public relations service which made the aims and purposes of their industry and product known and which served as a good introduction for the salesman who approached potential customers in person. Additionally, the advertisements provided a distinctive background and gave the salesman a sense of pride in the company, which was reflected in his work.

In some of Bayer's early advertisements for Container Corporation he made use of montage, collage, photomontage, and airbrush. Paper recycling was an important theme, especially as part of the wartime effort. Public information and patriotic pleas are evident in works such as his April 1942 advertisement, "paper that goes to war is paper that wasn't burned" (fig. 101), depicting a bundle of stacked paper transformed into packages of bombs dropped by an airplane which is depicted photographically; and his depiction of the world in an eggcup, with the text, "billions of powdered eggs and other dehydrated foods, in paper containers, feed our armies and allies around the world" (October 1943); and the November 1943 image of a telescopic sighting of a military target with the words, "AIM HIGH! Military production sights are set high—because quantities of metals, plastics, wood are released by new packaging in paper" (fig. 102). Bayer's works and those of other commissioned international artists such as Cassandre, Carlu, and Matter were directed towards the war effort using montage effects, often using photography for objective depiction with dramatic intensity.

By 1944 a special series was developed by Container Corporation to salute the many nations allied in the common war effort. Until the campaign ended in 1946, artists native to each country created images highlighting the importance of packaging in the Allied efforts worldwide. Called the "United Nations" series, this group included twenty-eight countries represented by twenty-eight native painters. In a later, similar campaign, the forty-eight states were recognized in full-page designs, again by artists indigenous to each state. These civically oriented, nontraditional designs, which departed from any usual kind of sales technique, set the stage for two extremely well-known projects behind which Bayer was a central force in his new position at Container Corporation. The first was the "Great Ideas of Western Man" series for which Bayer was art director and the second was the acclaimed Container Corporation publication, the *world geo-graphic atlas,* completely designed and edited by Bayer.

In 1946 Paepcke hired Bayer as consultant to Container Corporation and to the development of Aspen as a cultural haven.[13] Paepcke greatly respected Bayer's artistic abilities and the principles of the Bauhaus. He also knew of Bayer's attachment to the mountain life he had left behind in his native Austria. Over the next two decades Bayer's mark on both Container Corporation and Aspen was profound.

In 1956 Bayer assumed the title of chairman of Container's Department of Design (later to be renamed Department of Visual Communication, a term coined by Bayer), a position of considerable influence in which he was much more than an art *director.* He contributed at the highest level of management to every visual aspect of the company, including "all of their major

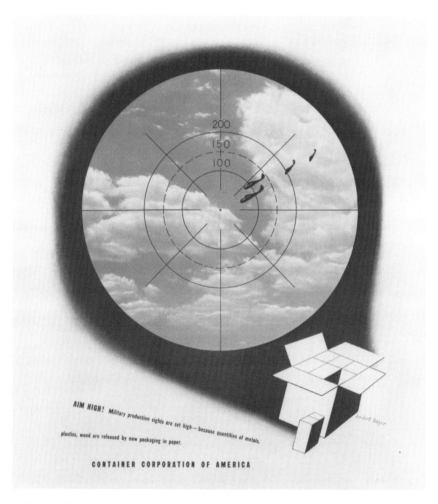

Figure 101. Herbert Bayer, Container Corporation of America Advertisement, 1942
(Herbert Bayer Collection and Archive, Denver Art Museum;
Gift of the Estate of Herbert Bayer)

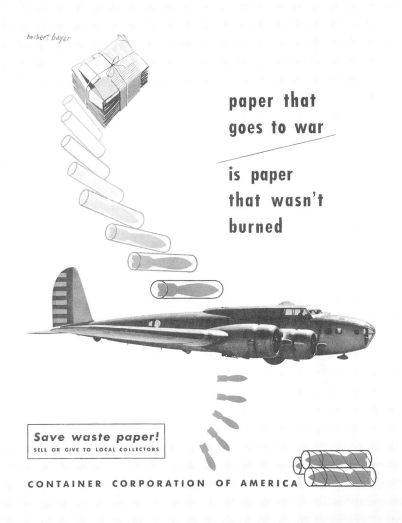

Figure 102. Herbert Bayer, Container Corporation of America Advertisement, 1943
(Herbert Bayer Collection and Archive, Denver Art Museum;
Gift of the Estate of Herbert Bayer)

buildings—factories, interiors—including paper mills here and abroad, folding carton plants, corrugated plants; a research center."[14] From 1955 to 1957 alone, Bayer designed paper mills in Santa Clara, California; Brewton, Alabama; Hoya, Germany; and folding carton plants in Seattle, Washington; Muskogee, Oklahoma; Dolton, Illinois; and Fort Worth, Texas.

The "Great Ideas of Western Man" series, for which Bayer was art director, was one of the most famous ad campaigns of the 1950s. (It began in 1950 and continued on and off for more than two decades.)[15] Although it was devoid of any sales message, people identified Container Corporation with the high standards of this campaign. The "Great Ideas" concept was an outgrowth of philosophic discussions at the Aspen Institute for Humanistic Studies. According to Bayer,

> one of the objectives of this institute [is] . . . to develop man's understanding of his role in our society and the goals toward which he can direct his life. it was one step further for walter paepcke, founder of the aspen institute, to avail himself of cca's advertising as a deeper stimulus to the minds of millions of magazine readers by devoting paid space to "great ideas of western man."[16]

At first it was proposed that, for popular appeal, current leaders in the fields of education, government, religion, the arts, and business should be asked to make individual statements. But problems were anticipated in publishing statements which might be too controversial to endorse. At that same time the *Encyclopedia Britannica* was in the final stages of publishing their set of "Great Books of the Western World" and its index to great ideas, the *Syntopicon.* Bayer stated that "in these books were many great statements of the ideas that are the very foundation of the Western tradition."[17] They decided to make use of this resource.

Choosing ideas which centered around moral, philosophical, or political issues was accomplished by a small committee which received prospective statements from Dr. Mortimer Adler, founder of the "Great Books" concept, who agreed to do the research. The committee included both Container Corporation personnel and outside people.[18] A small art committee determined to which artist each particular statement would be submitted for interpretation in any of a variety of media.[19] Usually the artist was requested to prepare a preliminary sketch; as it turned out, in many cases the sketch itself was accepted as the final work. As art director for the series, Bayer's mark was felt throughout, and he also served as the artist for several of the individual pages (figs. 103 and 104).

One significant difference between this ongoing project and other graphic campaigns was that each commission represented the creation of an original

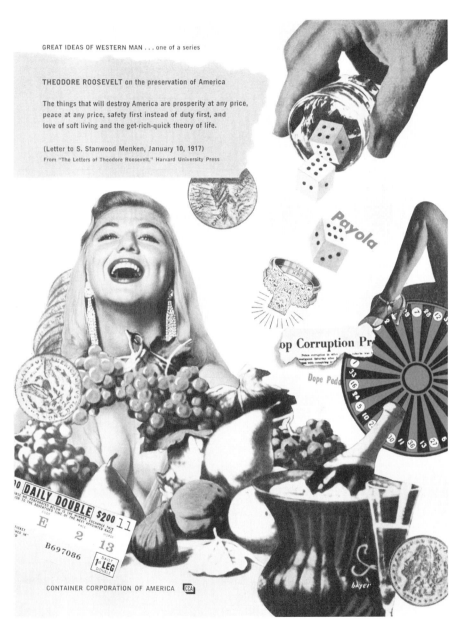

GREAT IDEAS OF WESTERN MAN . . . one of a series

THEODORE ROOSEVELT on the preservation of America

The things that will destroy America are prosperity at any price, peace at any price, safety first instead of duty first, and love of soft living and the get-rich-quick theory of life.

(Letter to S. Stanwood Menken, January 10, 1917)
From "The Letters of Theodore Roosevelt," Harvard University Press

CONTAINER CORPORATION OF AMERICA [CCA]

Figure 103. Herbert Bayer, *great ideas of western man*, 1960
(Herbert Bayer Collection and Archive, Denver Art Museum;
Gift of the Estate of Herbert Bayer)

The art of progress is to preserve order amid change and to preserve change amid order

Alfred North Whitehead, 1861-1947 artist: herbert bayer

Great Ideas of Western Man one of a series Container Corporation of America

Figure 104. Herbert Bayer, *great ideas of western man*, 1964
 *(Herbert Bayer Collection and Archive, Denver Art Museum;
 Gift of the Estate of Herbert Bayer)*

work of art. The only stipulation was that the work somehow relate to the quotation provided. Interpretations took many forms, including portraits of authors, pure graphic/typographic solutions, and interpretations of the content of the idea. One of the valuable byproducts of this campaign was the formation of a large and significant corporate art collection comprising works commissioned for the "Great Ideas" series.[20] For Bayer, at least, this collection was always secondary to the primary public project, which reached large segments of the population through popular periodicals.

Container Corporation's innovative advertisements testified to the possibilities of reaching an audience through nontraditional means. The merits of this approach were not just recognized by designers and artists. The Starch Survey of readership volume and company identification, at the time of these advertisements, indicated a high level of performance.[21] In speaking about the "Great Ideas" series in 1958, Paepcke remarked that they

> have made people talk about the company; have given the organization a tone of quality; opened doors for salespeople; interested college students in pursuing a CCA career; and perhaps even induced investors to study the company's stock.[22]

Bayer himself became closely identified with this visible and successful series and it gave him additional national recognition. So did another project which he created for Container Corporation, the design and editing of the *world geo-graphic atlas*, a corporate-produced publication whose fame reached far beyond its original audience.

Bayer had long been interested in geology, weather, cosmology, and astronomy. Volcanos, for example, were of tremendous interest to him (he visited the erupting Mt. Etna, Mt. Vesuvius, and Popocatepetl in Mexico); this meteorological/geological interest was manifest in his pictorial imagery, especially in his European works of the 1930s. We have seen that Bayer's 1943 exhibition, "Airways to Peace," made extensive use of maps and globes in highlighting the extent to which air travel had made the earth shrink. Bayer was inventive in creating some unusual types of globes, most notably his walk-in, outside-in globe of the earth. By 1944 his interest in the earth's movement was reflected in his series, convolutions. With this predilection towards the natural forces of earth and sky, Bayer welcomed the great challenge of designing and editing Container's new atlas.[23] Although the company had published an atlas in 1936, changes resulting from World War II necessitated an updating. Bayer worked on the project for five years and the result was literally the creation of a new formula and standard of excellence for books of this nature.

Bayer's title for the atlas is, in itself, indicative of its format. He entitled it the *world geo-graphic atlas*, separating "geo" and "graphic" with a hyphen to emphasize that the book contained both *geo*-graphic informational maps and *graphic* illustrations of subjects closely related to modern geography (fig. 105). Bayer, who himself was never trained as a cartographer, meteorologist, or geologist, related to the lay reader by providing clear graphic charts and symbols to decipher otherwise complicated data. Seeking to produce a readable reference book that would present the physical facts of the earth in an understandable manner, Bayer expressed salient points simply and directly by visual rather than textual means. This maximizing of graphic potential distinguished Bayer's atlas from previous ones and drew acclaim from reviewers, educators, and the general public.

The atlas was never for sale, published for private distribution by Container Corporation as a goodwill gift to business friends. Still it received considerable attention in larger circles. A contemporary review summarized its unusual nature:

> In a branch of publishing not known for its attention to design, what Bayer produced should chart a course toward more direct visual communication. It should also stand as a testament to the breadth of one designer's interest and learning, for Bayer, though not a scientist, organized from scratch all the material in the book. Working with some hundred reference volumes, he wrote for statistics to all parts of the world, devised his own pictorial methods, and decided ultimately what information was worth including. He personally designed a 13-page visual introduction to the earth's place in the universe . . . and even wrote most of the text because he wanted the wording to be concise and vivid.[24]

Bayer's atlas, by and for a general reader, was never intended to further any scientific ends, but rather to transmit information easily. Bayer himself acknowledged his nonscientific viewpoint in his essay, "my position as a non scientist":

> it was at the beginning my plan to ask scientists . . . to contribute the facts. the first attempt in this direction taught me that it could not be done this way. i did not get the information in a usable form, nor did i get those facts which i thought were the most important ones within the frame of the book, nor were the illustrations usable as they were. i realize that i as a designer had a different vision of this project, that my ideas, after i had made the first dummy book, were clear, that the selection of material had to follow this outline, that it had to be selected, written and designed for the particular purpose. the first experience told me, that, even if i would get scientific contributors to give me what i wanted, it still had to be checked and crosschecked with information coming from other sources as not to contradict other parts of the book. (and as it may be known, no facts or figures ever match.) in short, the information was not available in the form in which i needed it. therefore, i had to do most of the research myself. . . . the fact that such a book has, i believe, never been made, seems to tell that a scientist would not think in terms in which

Figure 105. Herbert Bayer, Page on Clouds, *world geo-graphic atlas*, 1953

i worked. this atlas is the concept of a "visualist," based on the urge to make accessible and palatable such knowledge as otherwise can only be obtained by tedious research from unimaginative textbooks, specialized papers and journals. publishers of atlases have perhaps not attempted such a book, because they foresaw the difficulties and obstacles. only the enthusiasm and also innocence of a non professional would begin such a project.[25]

One must attribute some of Bayer's success with the atlas and other Container Corporation projects to the remarkable amount of freedom and support he was given to create his work. Because he operated at a high level, conferring directly with Paepcke, Bayer always maintained authority in executing projects, received additional manpower when necessary, and was given the time and financial support to concentrate fully on producing his best work.

In addition to securing what might be considered an ideal position within the corporation, Bayer also maintained an important role within the Aspen Institute, enabling him to bring his corporate expertise to a position of influence even beyond Container Corporation. The conference format at Aspen, which brought influential American businessmen together with intellectuals and artists, encouraged considerable discussion about the ideal future of the country. With his position at Container Corporation and with the remarkable transformation he had already accomplished at Aspen, Bayer was given an unusual measure of acceptance and respect. The artistic community admired his accomplishments and principles, and the businessmen had found an artist with whom they could comfortably discuss their companies' future. Bayer was not the only designer working for corporate America, nor was he the first to envision Container Corporation's design potential, but he accomplished a great deal. Container Corporation gave him valuable experience translating Bauhaus principles into a large American company, effecting nationally visible innovations. It also provided him with credentials for presenting his ideas to other American businessmen. Aspen provided the all-important forum for these discussions, attended at first primarily by businessmen who later were joined by larger numbers of artists and designers.

The Aspen conferences provided Bayer opportunity to meet many top management executives on an equal footing in an idyllic, relaxed setting conducive to optimistic planning. Many saw the potential for Bayer's concepts within their own companies. Over the years the exchange of ideas at Aspen brought about changes in many companies. Bayer himself did limited freelance design for other businesses whose executives he had met at Aspen.[26] It was at Aspen in 1953 that Bayer first met Robert O. Anderson, who later became chairman of the board of Atlantic Richfield and transformed

it into a major energy company, and who also became Paepcke's successor as chairman of the board of the Aspen Institute in 1960. Six years after Paepcke's death Bayer entered into his second important corporate relationship, this time at the side of Robert O. Anderson at Atlantic Richfield.

By the 1960s, Bayer was no longer a young, idealistic artist starting out. And the United States' corporate climate, as well, was mature. In 1966 Bayer became art and design consultant to Atlantic Richfield "for all design and aesthetics including graphics, corporate image, architecture, acquisition of art collection and design of offices."[27] He had already become well acquainted with Anderson at Aspen so that this business arrangement cemented a close personal friendship as well.

Anderson, like Paepcke, had a special enthusiasm for art and culture and a belief in its importance for the business world. He had had virtually his entire formal education at one of America's great liberal institutions, the University of Chicago, which he attended beginning with kindergarten, continuing through the acclaimed laboratory school, and finally entering the university. He had been a painter before turning to business and he brought a similar creative spirit to his business life. In providing information for an article on Anderson, Bayer compared his two corporate experiences: "container corporation's statement of the relation of business and art was carried on within a relatively small framework. r. o. anderson went far beyond in scope."[28]

When Bayer joined Anderson at Atlantic Richfield, he was appointed to head a team which would develop a corporate image. In 1968 ARCO introduced a companywide identification program to unify and enhance its image and that of its subsidiaries around the world. Logotype, stationeries, and graphics were developed first.[29] In 1979, when several divisions of the company were designated individual companies under the one "corporate umbrella," each company was given a separate *color* identity while maintaining the same unified corporate design image.[30]

Along with uniform signage, advertising, packaging, etc. came company architecture and interior design. Bayer oversaw the design of offices in New York, Washington, Chicago, Philadelphia, Anchorage, Houston, Dallas, and Los Angeles, the company's relocated headquarters where he executed a large outdoor sculpture in the ARCO Plaza (fig. 106). The amassing of a large corporate art collection and the sponsoring of performing arts, television programs, and the ARCO Center for the Visual Arts, a nonprofit art gallery, all followed.[31] Bayer had a hand in all facets of this transformation of ARCO's visual image. From designing tapestries and carpets for executive offices to personally selecting fine art for the collection, Bayer accomplished at ARCO what one writer has called "a Bauhaus dream . . . because he

Figure 106. Herbert Bayer, *double ascension*, Los Angeles,
California, 1972–73
Painted aluminum, 14'3" high, maximum length, 33';
pool, 60' diameter.

has been given virtually free reign over all visual matters, he has been able to create a sense of totality."[32]

Notwithstanding Bayer's unusual position within the corporation, he had some disappointments. With a company as large as ARCO, there are bound to be board decisions which cannot be circumvented. One of his pet projects for ARCO, a visionary proposal for the beautification of its oil refinery at Philadelphia, was never approved for implementation, much to Bayer's regret.

Bayer's project, which was to have served as a model for future visual improvement of all ARCO refineries, included unifying the area by color-coding large tanks according to their contents with fifteen-foot-wide color bands at the top of the tank, most of which would be painted in a dominant aluminum paint. (Some tanks would be painted black, because of their susceptibility to stains and spills.) The yards would contain a green belt, fifty feet deep wherever possible, landscaped with trees, bushes, and ground cover. A decorative screen of vertical colored panels, ten feet high, would screen unsightly views from cars driving on the adjacent highway, which serves as the main route between the airport and the city. All buildings would be painted silver-grey with blue. The addition of monumental colored sculpture would distract attention from nearby unsightly land and would become distinctive ARCO landmarks, designed for changing appearances from the viewpoints of cars driving along the highway.[33]

In developing this unified plan for the ARCO refinery, Bayer expanded upon Bauhaus concepts to unify and improve some of our industrial society's most banal property. It may be precisely because of the site's mundane nature that the ARCO board did not elect to use Bayer's plan. Of course many would argue, as did Bayer, that an oil refinery adjacent to a well-traveled road is a worthy site for visual improvement.

Bayer's most visible ARCO successes have been his designs integrated into corporate architectural complexes. The ARCO Tower in Los Angeles, the company's headquarters, is a masterful arrangement of spaces, all functional and unified by a continuity of design which carries from the public groundfloor entrance to the secure inner sanctum of the fifty-first floor. (There is also a lower level of shops.) The fifty-first floor is an elegantly appointed, opulent 25,000-square-foot space which houses the offices of ARCO's six chief executives and was designed "to be the best anywhere."[34]

Artwork is abundant throughout the complex, not only as is evidenced by the extensive collection of painting and sculpture (many chosen by Bayer and all at least approved by him), but also by Bayer-designed tapestries, custom rugs, and murals. He even designed a special window treatment of

motorized louvered blinds for the executive board room with grey on one side and a vibrant color range on the other for a changeable mural effect (fig. 107).

> Bayer participated every inch along the way as a consultant, both on the design of this building, on the exterior, looking over the shoulder of the architect, and then in the interior design of the offices. . . . the design approach was either his or he approved it.[35]

In terms of sheer magnitude, Bayer's accomplishments at ARCO's corporate headquarters are astonishing. But another project, the Breakers, along Channel Drive at Santa Barbara, may represent an even more unified total design and without doubt is more a personal Bayer statement, though the building itself is not new, but a renovation. There are some advantages to this complex that are immediately apparent. One is its human scale; another is its spacious oceanfront setting, where Bayer designed the outdoor landscaping complete with Japanese garden and full size, three-dimensional *walk in space painting;* finally there is the fact that here Bayer could operate with considerably more freedom, creating a retreat center free of many of the practical limitations of a high-density downtown office complex.

The Breakers is literally a private Herbert Bayer museum. Except for one outdoor portrait head of Anderson, all of the art at the Breakers is by Bayer, representing his work from 1928 to 1980. In addition to creating the works themselves, Bayer designed their setting. The interiors are a rich grey, providing an understated, elegant neutral ground against which the paintings fairly sing. The individual rooms which function as seminar rooms, dining rooms, and offices serve as galleries whose works are often related by style or theme.

Outside the grounds are beautifully arranged. Bayer's Japanese garden was designed for contemplation, and nearby he installed his *walk in space painting,* an environmental work of prefabricated elements over a pool. This work mediates between the realms of painting, sculpture, and architecture for a multifaceted experience. Bayer had created models for *walk in space paintings* as early as 1962, but the example at the Breakers, brilliantly colored in shiny tile, was the first to be executed.

A unity extends throughout the Breakers, so that one continually draws parallels and connections between the various painted and sculpted elements. Its carefully planned and executed cohesion in a sense mirrors, in smaller context, the kind of unified statement which the company seeks on a grand scale. Yet it is interesting that the Breakers, like the fifty-first floor of ARCO's headquarters, is not open to public view. Obviously there is more to ARCO's design policy than *public* image. Another fact worth considering is that the Breakers,

Figure 107. Herbert Bayer, ARCO Board Room, Los Angeles, California, ca. 1972 (no longer extant)

with its private oceanfront setting and its use as an executive retreat, relates more to Bayer's Aspen work than to anything else he has done for corporations.

In commenting about his position at ARCO, Bayer stated:

> my ideas are now generally understood and appreciated at arco by the board and by the employees. I am considered an equal with the top businessman. this is a position which I have long sought for the designer to attain in order to be useful and effective within the structure of our society.[36]

What Bayer achieved within corporate structures not only helped to obtain a standard of excellence in corporate design, but also to raise the relative position of both the design product and the designer/artist. Admittedly Bayer was not the only designer to gain prominence within American corporations. Eliot Noyes, for example, acted as design consultant for IBM products and buildings starting in 1946 under the direction of IBM president Thomas Watson, Jr., who, like Paepcke, was impressed by the Olivetti style. Paul Rand joined Noyes in developing the IBM style in graphics. Yet if there were others with influence in the corporate marketplace, Bayer was unique because of his position at Aspen. He was able, through the Aspen conferences, to pass along ideas and principles to nationally prominent corporate executives who respected his influential position at Container Corporation, his close ties with Paepcke, and his visible example at Aspen. His influence on American corporate design must be attributed at least as much to his presence at Aspen as to what he accomplished at Container Corporation and Atlantic Richfield.[37] One might argue that Bayer's work within Container Corporation was really an effective continuation of design policies begun earlier and that his work at ARCO was an expansion upon similar lines. But there can be little doubt that his work at Aspen was truly revolutionary and visionary.

We may never be able to unequivocally state that specific corporate projects accomplished by Bayer or others have changed the future of American corporate design. But Bayer's participation at Aspen guided an educational forum which absolutely revolutionized the future thinking of American executives. They were introduced firsthand to Bayer's high standards and to his concept of creating a unified whole, expressive of the corporation, through extended cooperation between art and industry. This, in itself, is quite remarkable and unprecedented.

10

The Anthologies

as in writing, where the essence is often to be found between the words, the meaning in these paintings is found beyond the images.
 —Herbert Bayer, "statement on anthologies paintings"

If Bayer had ceased painting early, or even by 1970, when he was seventy years old, critics might have stated that he was a good painter but that his greatest gifts lay in other areas. However, Bayer's last series, the anthologies, invites new analysis. An evaluation from the reference point of the anthologies provides justification for a far higher assessment of Bayer's abilities as a painter, and helps us to understand his entire oeuvre more fully. Not only are the anthologies exceedingly rich formally, but conceptually they serve as a summary of Bayer's imagery. We have seen that Bayer's early work in graphics incorporated elements drawn from a variety of disciplines. In Bayer's last series of paintings he reaches not only across disciplines but also back into his own previous work for sources which enrich his painting and explicate his personal iconography. This series expresses a mature vision and presents a creative reconsideration of elements the artist explored in graphics, exhibitions, environments, and earlier painting. The anthologies series requires careful analysis in terms of Bayer's entire oeuvre in order to understand its synthesis. This series reaffirms the fact that Bayer never forgot the lessons of the Bauhaus, whose early formal problems served as points of departure for new creative expressions. It also affords new appreciation of this individual whom we realize, in retrospect, had been building phase upon phase, never abandoning problems he had set for himself, but instead reserving issues to reexamine in future dialectics. Bayer's anthologies are an individual iconographic compendium of ideas and motifs that the artist had examined over a lifetime. In retrospect, it is as if all his previous work had been studies, vocabulary-building exercises, destined to be part of this rich mature idiom.

The anthologies began in 1976, with the intense colors and hard edges of the chromatics giving way to richly articulated surface treatment marked by subtle coloration. The anthologies depart from all earlier Bayer paintings not only in style but also in intent.[1] These works demonstrate a new preference for loose brushwork and delicate color, for a handmade look which is the antithesis of the formula-generated chromatics; they also offer a reexamination of virtually every facet of the artist's earlier visual vocabulary. The result is that more than art concerned with nature, this art is also about art. It reevaluates within a new context Bayer's previous treatment of geometry, dating back to his early studies of descriptive (solid) geometry in school, and of themes like geologic and atmospheric forces, and symbols such as letters, celestial bodies, gates, etc. Geometric forms, for example, reappear in the anthologies, but they have lost all solidity, seeming to float mysteriously in a world of spatial ambiguity, as do the forms of letters apparently signifying nothing, and gates leading to nowhere. Within the new, richly articulated surfaces the poetic and the scientific find themselves in fruitful juxtaposition as Bayer explores nature and the cosmos, themes to which he was drawn throughout his life, assimilating issues and imagery from a personal vocabulary developed over decades.

Weightless forms immobilized within a universe of rich, immersive color and texture at times seem to refer to sun, moon, stars, and continents. In some examples diagrammatic, maplike forms are read across the picture plane, emphasizing the flat surface while other forms, seen simultaneously, reach deep into space to create an ambiguous and absorbing spatial dialectic. A significant difference in this series is that Bayer no longer worked directly from original sources, but instead appears to have worked through past exercises, reinvestigating his previous formal language within the new context. With this fresh approach to both style and subject, Bayer created what surely will be assessed as the most important paintings of his oeuvre, and which, in the end, may give special credence to the earlier paintings as the germinal vocabulary for the late works.

In a sense the period following 1976 parallels the years following 1928 when, after intense Bauhaus commitments were lifted from Bayer's schedule, the artist was able to devote more time to studio work and burst forth with new, important works. Again in the mid-1970s Bayer's situation enabled him to increase his studio time after releasing himself from some corporate responsibilities. The anthologies were born of this renewed commitment to private artmaking, a commitment which had always been foremost in Bayer's mental list of priorities but was difficult to fulfill because of other responsibilities.[2]

In 1975, the year preceding the birth of the anthologies, Bayer left Aspen for all but the summer season, moving to southern California, where doctors

hoped the low altitude and mild climate would improve his declining health. By the next year Bayer had embarked upon the new painting style. One might like to explain the new style in terms of a fresh environment, perhaps attributing the change from hard-edged, crisp surfaces to soft, mottled ones to a change from the crisp mountain air of Aspen to the hazy, moist ocean atmosphere. But drawing parallels such as these are rarely defensible or confirmable by solid methodological means.

Perhaps the change in climate and environment had a subtle effect on the artist,[3] but even more significant, after a severe heart attack and the abrupt change in his life, Bayer must have felt the need to direct his paintings toward a new, more personal style. The fact that Bayer labeled his series "anthologies" itself indicates his intention to create works of a summarizing nature; most probably he wanted to reexamine his life's work at what he must have felt was the end of his life.

It will prove fruitful to consider some imagery from this new series, and to attempt to trace origins within the context of Bayer's earlier work. One important kind of imagery used by Bayer in the anthologies refers to particular styles of his past works on canvas. As if creating "sample swatches" of previous painting styles, the artist sectioned off small, usually slim, rectangular areas within larger canvases and within them created reduced compositions in his earlier styles. Many of these quote Bayer's color studies. Were it not for the fact that Bayer took color as his subject for so many years, one might argue that the anthologies' source is, indeed, color charts themselves. But close examination confirms that Bayer referred to his own earlier canvases. In *iconograph of a day* (1978, fig. 108), for example, he recreated a miniature Fibonacci progression at the upper right, using values of brown extending to white, in a configuration identical to his earlier *curve from two progressions* of 1974. At the right in the same canvas is another small series of blue, green, and yellow bands which lie within a triangular shape extending off the page, inviting the eye to complete a progression echoing the former one. Reference to his monochrome series is made in the same painting in a vertical section of black and white bands, at left, gradating to grey in their interstices. A similar vertical section of black and white bands gradating to greys is found in *maroon painting II,* 1980, where the colors fairly glisten with the look of tubular metal, similar to the effect of earlier Bayer paintings such as *suspended,* 1965.

Another painting style which Bayer incorporated into the anthologies is that of the linear structures, his best known series of the 1950s, whose long, overlapping members have been compared with sets of pick-up sticks. In *nocturnal with "7"* (fig. 109) of 1981 and *blue anthology* of 1982, the artist

Figure 108. Herbert Bayer, *iconograph of a day*, 1978/47
Acrylic, 80″ × 80″
*(Herbert Bayer Collection and Archive, Denver Art Museum;
Gift of Joella Bayer)*

Figure 109. Herbert Bayer, *nocturnal with "7"*, 1981/30
Acrylic, 60" × 60"
(Collection Barry Berkus)

quoted directly from earlier works such as *on the way to order* of 1954, a painting he also chose to include in his 1967 text.[4]

Bayer's paintings which deal with geological, meteorological, and astronomical changes also serve as references. Anthologies such as *amphora, blue* (1981, fig. 110) look like diagrams of imagined universes of continents and celestial bodies. Forms in *seasonal reflections III* (1980), for example, seem to be equated with amorphous continents situated within an all-pervasive sea of murky, reddish-brown color. Gridlike patterning and intersecting lines (meridians?) add to the maplike quality of the image. *Nocturnal with "n"* (1979, fig. 111) seems to be a celestial depiction of stars, meteors, planets, or satellites in orbit within a dark universe. *Radiation II* (1981) continues this celestial exploration with phosphorescentlike lines radiating outward from some central energy points.

In *shadow of a line* (1981, fig. 112) the background surface seems to depict a sea and continents with a sunlike ring of flames passing over it. *Anthology graph III* (1981, fig. 113) also resembles an ocean, this time invaded by the tip of a large continent. Superimposed, as in an atlas with transparent overlays, are forms resembling celestial bodies and lines of charts and graphs. This combination is not surprising to find in Bayer's work, given his long interest in geological and meteorological data, which culminated in the *world geo-graphic atlas.*[5] The atlas, which, as we have seen, maximized the power of graphics to describe scientific data, had combined maps and charts throughout its pages. Further, Bayer's work with corporations, especially in producing corporate annual reports, often required precise diagramming. Bayer-designed charts were also visible in some of the earliest graphics done by the artist in this country, for such publications as *Fortune* and *Life,* describing statistics for wartime commercial and agricultural production and for accurate descriptions of such things as aircraft capabilities.

In addition to quoting styles used in previous canvases, Bayer also repeated some earlier symbols. Just as individual letters and numbers derived from Bayer's typographic experience were included in earlier paintings, single letters and numbers found their way into anthologies such as *nocturnal with "n", nocturnal with "7",* and *shadow of a line,* which includes an "O" tipped on its side.[6] It is difficult to determine whether the direct impetus for these symbols came from typographic sources themselves, or, more likely, from the earlier paintings which were themselves indebted to Bayer's typography.

The gate is another image that Bayer developed over many years, including it in his *gates over pools* series and his *walk in space paintings.* Although most were never executed beyond the model, these environmental works were only held back by financial limitations.[7] Gatelike forms appeared earlier in some paintings of the 1950s such as *moon and structure*

Figure 110. Herbert Bayer, *amphora, blue*, 1981/20
Acrylic, 40″ × 40″
(Collection Jonathan Bayer)

Figure 111. Herbert Bayer, *nocturnal with "n"*, 1979/13c
Acrylic, 60" × 60"
(Collection Mr. and Mrs. Gary Borman)

Figure 112. Herbert Bayer, *shadow of a line*, 1981/13
Acrylic, 60" × 60"
(Private Collection)

Figure 113. Herbert Bayer, *anthology graph III*, 1981/36
Acrylic, 80" × 80"
*(Herbert Bayer Collection and Archive, Denver Art Museum;
Gift of Joella Bayer)*

of 1959 and in the 1960s and 1970s in others like *chromatic gate* (1969) and *egress with appendix* (1973). In a 1972 project proposal for highway sculpture, *drive in roadside interest,* Bayer again used the gate as a principle form. Bayer acknowledged that his gate forms were inspired by forms he saw in Morocco. About gates he stated:

> I see a gate's function alone in the experience of "walking through" a form or forms, in the perception of its plastic forms and colors by passing through them. an example may be a narrow walkway through "arched forms" . . . all placed over a large pool of water. the views would be reversed when returning on the walkway. the purpose . . . is the act of walking through, thereby bringing it to life as a gate. the aim is not to go somewhere.[8]

Gates appear in the anthologies devoid of all function, seeming to float aimlessly within the painted surface, as in *two gates* (1981, fig. 114) and (upside down—totally nonfunctional) in *nocturnal with "7".* Apparently, as with numbers and letters, the gate form is more important than what it may signify.

A pleated, circular form was used by Bayer in several variations, from the roof of the Aspen Music Tent (1964) to a small, tabletop, polished aluminum sculpture called *circular stairs* (1968) and the large sculpture *double ascension,* 1973 (which is essentially a circular stairway) at the ARCO Plaza, Los Angeles. Similar circular forms are presented in the anthology paintings *two gates, interspace III* (1981), *nocturnal with "n",* and *nocturnal with "7".*

Geometry as a subject captivated Bayer throughout his life. His early interest in descriptive geometry, fired by the geometric emphasis at the Bauhaus, was carried into virtually every phase of his creative output.[9] If the anthologies' soft, handmade, and personal nature seems to be the antithesis of this geometric predilection, they too have retained aspects of the geometric, especially as a means of mapping out their underlying structure, which often may be found in lines and forms superimposed on Bayer's mottled surfaces. Some canvases include small forms resembling geometric crystals or starlike prisms, as in *nocturnal with "n", nocturnal with "7",* and *proportion as harmony* (1980), which includes a flattened, two-dimensional, drawn version of what is diagrammed to represent the three-dimensional in the other preceding examples. Almost every anthology painting is structured by an overall geometric plan, sometimes superimposed with fine lines across the canvas, as seen in *proportion as harmony, triangular progressions* (1981), *four radiations III* (1981), and *geometry homework II* (1981, fig. 115). The title of this last painting indicates Bayer's recognition of the importance of geometry to his particular visual language and probably refers specifically to his own schooling in that subject.[10]

Figure 114. Herbert Bayer, *two gates*, 1981/23
Acrylic, 40″ × 40″
(Herbert Bayer Collection and Archive, Denver Art Museum;
Gift of Joella Bayer)

Figure 115. Herbert Bayer, *geometry homework II*, 1981/2
Acrylic, 70" × 70"
(Herbert Bayer Collection and Archive, Denver Art Museum;
Gift of Joella Bayer)

Shadow of a line, of 1981, appears to refer to Bayer's geometric wall-painting for the Bauhaus stairwell of almost sixty years earlier.[11] The painting's examination of a triangle and a sphere and the almost rectangular dark shadow casting off from them recalls the 1923 study of triangle, sphere, and cube. Like the 1927 photographic cover for the magazine *Bauhaus* and the 1934 gouache *shadow over cone, shadow of a line* indicates how significant Bayer's Bauhaus lessons were to him. They sustained his creative life, even into old age.

As a group, the anthologies provide an eloquent recapitulation of Bayer's entire oeuvre, using as sources the artist's work in all media and from every phase of his full career. These canvases are entirely capable of standing alone; they are surely the best paintings of his career in the sense that they are Bayer-original, that they engage the viewer with their sensual paint quality and personal symbolism, and they invite repeated attention which rewards the viewer with new discoveries. But apart from providing worthwhile viewing experiences, the anthologies are significant as summaries in paint of Bayer's oeuvre. As early as 1956 Bayer had written in his sketchbook,

why separate character of painting so much from my design work? could more unity in my work be obtained by painting the "subjects" of my design work? ie: architectural plans, typography (calligraphy), plan and perspectives.[12]

The anthologies seem to answer this desire to incorporate design elements into his painting. Although this kind of insertion of design into painting had occurred earlier in Bayer's oeuvre (during the 1920s and 1930s), it had not been present in his more recent canvases.

It is not without significance that Bayer's method had long included working from a carefully maintained series of personal sketchbooks which he kept from the 1930s on. Unassuming, student-type looseleaf pages hold notes and sketches about ideas which the artist hoped to use at a future date, preliminary to larger current works, or methodical working through of solutions. On any given day Bayer may have worked not only with the current notebook but he also may have referred to notebooks and entries made in years long past.[13] What more tangible dictionary of personal vocabulary could exist for an artist? When Bayer stated that "painting is the continuous link connecting the various facets of my work,"[14] surely he must have included in his use of the term "painting" this entire process of notetaking and notebook referral. With this method he assured himself continual links with the past and with the future.

It is with his late series, the anthologies, that Bayer was finally able to synthesize all the diverse activities of his life. As a designer, Bayer could easily

unify his design work under the concept of ''visual communication'' for a ''unified total environment.'' Until the anthologies, Bayer's ''fine art'' was not capable of any kind of unifying or synthesizing power. The anthologies represent the artist's own final statement about his work in all media, but on his own terms, that of a painter, through the activity which he always considered primary in his artistic life.

Epilogue

When one thinks of the influence of European Modernism in New York during the thirties and early forties, one usually thinks of the well-known modernist *painters* in exile. However, the influence of European avant-garde *design* in America made changes which have been less studied but which are at least as profound. And the transformation of American design, affecting every kind of object, typeset specimen, exhibition, and graphic design, had an even greater impact on American society as a whole than the painters who effected change primarily within the museums. These lesser-known European modernists, the designers, were introducing Americans to other aspects of the European avant-garde. Because these innovations centered around human communication, they were brought to virtually every level of the American scene. Herbert Bayer played a key role in this transmission and dissemination of European modernist design principles in America.

The idea of visual communication is the unifying concept which binds all of Herbert Bayer's work. In graphics, typography, environmental design, and exhibition design, and in all of his efforts on behalf of corporations, Bayer's career centered around the enrichment of human experience through visual communication. He continually sought better means of human communication by designing for the modern world.

Bayer's career was enriched and his influence magnified by his involvement with two great institutions, the Bauhaus and the Aspen Institute for Humanistic Studies, and with two men and the important American corporations which they headed, Walter Paepcke of Container Corporation of America and Robert O. Anderson of the Atlantic Richfield Company. An examination of each helps to summarize Bayer's artistic substance and his influence in America.

The Bauhaus taught Bayer the important principles that guided his artistic life. Without the Bauhaus, Bayer's oeuvre could never have been the same. One can only guess what form the career of a romantic young man from rural Austria might have taken. In addition to becoming the catalyst for his

future direction, the Bauhaus also provided Bayer with opportunity to meet virtually all of the giants of European avant-garde design. This combination of receiving a superior education and of meeting influential people in the field opened many doors to Bayer. Not only as a young man in prewar Germany but also as a new immigrant in the United States, Bayer received immediate credibility because of his association with the Bauhaus and the people connected with its name. It was due to Bauhaus ties that he secured his first job in the United States, designing the Museum of Modern Art's ''Bauhaus 1919–1928'' exhibition. The experience gave him early exposure here, within the circle of one of America's most prestigious museums; and having his own works in the exhibition presented an extra bonus in terms of recognition. No other affiliation could have supplied as solid a foundation or could have promised as much recognition as did the Bauhaus.

The ideas for which Bayer labored for over sixty years all have their origin at the Bauhaus. Indeed, the experience of that institution guided the artist's every endeavor. But rather than stagnating within the structure of his early experience, Bayer took Bauhaus goals, amplifying and transposing them for application in this country. If it was difficult to begin anew in another country, America eventually offered Bayer some opportunities he had not had in Europe. The timing of Bayer's arrival here could not have been more opportune. The postwar climate of optimistic energy and the new wealth of American corporations provided a favorable setting for his ideas. Without this wealth and self-confidence, it is unlikely that American business would have been as receptive to Bayer's innovations. Bayer's timing was fortuitous. Forward-thinking United States corporations and the visionary Aspen Institute enabled Bayer to apply his by now broadened concepts to realize Bauhaus goals, at least within the perimeters of these institutions.

The idea of integrating the arts within contemporary society and of becoming master of several disciplines came directly from Bauhaus precepts. But Bayer's wholehearted personal application of these ideas surpassed any reasonable expectation. He provided, on American soil, a model of what can be accomplished when prejudices between and limitations of disciplines are ignored and when open thinking governs the artistic process.

Although virtually all of Bayer's American ideas had their origin at the Bauhaus, America provided a particularly receptive environment for implementing them. It was through large-scale application here that these ideas eventually became standards of excellence, rather than experiments. This result owes much to the fact that in addition to providing an example, Bayer also enlightened the United States through education, stressing the seemingly limitless possibilities of avant-garde design here. The first great institution in Bayer's experience, the Bauhaus, gave him the education and inspiration

to develop as a participative modern artist. The second, the Aspen Institute, enabled him to amplify and pass along these educational precepts to a larger, vital audience in America.

The Aspen Institute for Humanistic Studies with its affiliated International Design Conference provided Bayer a forum in which to discuss innovative ideas and disciples/colleagues to disseminate these ideas throughout the country.[1] Like the Bauhaus, the Aspen Institute thrived not only because of its excellent format but also because of the influential people who were associated with it. From the beginning, Aspen attracted top corporate executives, dignitaries, politicians, celebrities, and intellectuals. Albert Schweitzer, José Ortega y Gasset, Willy Brandt, Gary Cooper, Robert Hutchins, Thornton Wilder, and Arthur Rubinstein were among Aspen's early visitors, later to be joined by innumerable others as Aspen's reputation flowered. With the growth of the International Design Conference, the town became a center for creative thinking about the shaping of the world environment: "With its heady discussions in the music tent, on flowery meadows, along mountain walks, on riverside picnics and in the bar of the Jerome Hotel, the Conference has become an institution, a sort of Academy."[2]

Bayer's position as a founder of the Institute and Design Conference and as an influential resident member placed him at the center of these activities. While we may be sure that Bayer was responsible for much of the good planning which led to its success, in turn Aspen was indispensable to Bayer's increased prestige among a growing audience. Not only were Bayer's ideas becoming known through the material of the sessions themselves, but the conferences were held in facilities and environments created by Bayer. As the conference participants lived, worked, and played within Bayer's designs, surely his influence asserted itself on another level. Had the International Design Conference been a traveling meeting, one wonders if Bayer's influence might not have waned somewhat after the early, energetic planning years. Instead his influence has continued to work its effect on each successive group of participants and today Bayer is revered at these gatherings in the manner of a grand old master.

With the increased importance of Aspen as a center for exploring creative ideas, Bayer became more and more influential as America's design professionals and corporate executives made Aspen a summer mecca. It is on Aspen's ground that these two seemingly disparate factions of society have continued to meet to explore the world's future. Once again, Bayer's historical entrance in time and place appear to have been perfectly synchronized at Aspen. Of course one cannot attribute Bayer's success entirely to the fortuitous chance of relocating in early Aspen, because he was himself largely responsible for making Aspen the great center that it is. Nonetheless, the

Figure 116. Herbert and Joella Bayer, Aspen, Colorado, Mid-1960s
(Photograph by Ferenc Berko)

favorable timing and placement which allowed Bayer's visions to be realized are clear. With the development of Aspen, Bayer was placed in a position of influence, enabling him to chart the direction of design in this country. His Aspen affiliation gave him important credibility with both businessmen and designers. His influence on both has been far-reaching.

Finally, the two corporate leaders who placed their trust in Bayer's vision were vital to Bayer's role in America. Walter Paepcke met Bayer soon after the close of World War II. With a vision of making Container Corporation a humanistic, influential institution, and with the ideals of the "Great Books" foremost in his mind, he placed Bayer in a position of influence as his personal advisor and made him head of Container Corporation's department of design. Paepcke's ingenious arrangement of placing Bayer in Aspen to work for the Aspen Development Corporation while continuing to have him work for the Chicago-based Container Corporation allowed the executive full advantage of Bayer's expertise and creativity. And while Aspen allowed Bayer a measure of freedom in developing an idyllic retreat for free-thinking individuals along Bauhaus lines, his position with Container Corporation afforded him influence within a major American corporation. This position with a large corporation, the mainstay of American urban life, allowed his vision to be experienced in new ways. For Container Corporation he designed offices, industrial plants, corporate reports, and the *world geo-graphic atlas* and "Great Ideas of Western Man" series. These latter public relations-oriented works reached every segment of the American population. The "Great Ideas" series, for example, was highly acclaimed by people across the country. Bayer's position with Container Corporation gave the artist credibility within industry as well as with designers. Without question, the single most important person in terms of Bayer's recognition and influence in America was Walter Paepcke. He saw in Bayer the potential for great innovation and placed him in two important positions early, with Aspen and with Container Corporation. It was through Paepcke that Bayer was first able to bring artists and industry together to solve mutual concerns.

Later, Robert O. Anderson, chairman of the board of Atlantic Richfield and chairman of the board of the Aspen Institute, brought Bayer to a key role with Atlantic Richfield. No doubt due to the successful precedent of Bayer's relationship with Paepcke and Container Corporation and Anderson's close relationship with Bayer at Aspen, the oil executive saw exciting possibilities for Bayer at Atlantic Richfield. Because of ARCO's tremendous size and its worldwide extension, Bayer supervised even more ambitious projects at ARCO than at Container Corporation, and because of this Bayer's influence had a greater impact than ever.

Bayer's unusually close relationship with the top men in these corporations enabled him to exert unusual influence in corporate America, particularly for an artist. No doubt it was due to the structure and climate of the Aspen Institute, which brought him together on equal ground with important business leaders, that he was never regarded as a mere employee but rather as a collaborator among industry giants.

Bayer was not the only designer in America with far-reaching ideas for our society. But unlike others, he was a unique spokesman for new design issues and was able to bridge the gap between the artist and the business community. His position enabled him to promote the ideas to which he had devoted his life ever since his Bauhaus years. The changes in both design and in attitude which Bayer helped to effect in this country have been extraordinary. Just as European immigrant painters brought new approaches to the canvas, Bayer helped change the face of American design in the twentieth century. And just as the center of influence in painting transferred to this country, so did the center of design. By 1950 the United States, which only twenty years earlier had been provincial and derivative, had clearly become the center for the newest innovations in the design world.

Bayer survived beyond his Bauhaus colleagues and lived to see a resurgence of interest in design. In the past decade or two, design has finally been receiving serious critical consideration. Surely Bayer's lifelong commitment stimulated and forwarded that direction by providing visible examples of good design and by providing an American forum at Aspen for its discussion. Bayer was not the sole author of every design principle he championed; nonetheless he truly was remarkable in developing the means to transmit and adapt the European modernist vision to American design. It is because of his important role as purveyor of modernist design in America that Bayer must be seen as an indispensable figure in twentieth-century American art and design.

Notes

Prologue

1. The term "guru" was used by John Massey in describing Bayer's relationship with Walter Paepcke. (Gwen Chanzit, Interview with John Massey, Chicago, June 1983.)

2. After this study was completed in dissertation form, Arthur A. Cohen's book on Bayer was published, entitled *Herbert Bayer, the Complete Work* (MIT, 1984). Subsequently, the second of the Bauhaus-Archiv catalogs was published. (See *Herbert Bayer: Kunst und Design in Amerika 1938–1985* [Bauhaus-Archiv, 1986]. The first was *Herbert Bayer, Das künstlerische Werk 1919–1938* [Bauhaus-Archiv, 1982]).

3. Authors Alexander Dorner and Ida Rodríguez Prampolini knew Bayer well. (See Dorner, *The Way beyond Art* [Wittenborn, 1947] and Prampolini, *herbert bayer, un concepto total* [University of Mexico, 1975]). Bayer himself wrote the well-known *herbert bayer, painter, designer, architect* (Reinhold, 1967). And Bayer selected Arthur Cohen to author the MIT Press book cited above.

Chapter 1 Herbert Bayer and the Bauhaus

1. Herbert Bayer, *herbert bayer, painter, designer, architect* (New York: Reinhold, 1967), p. 9.

2. Ibid, p. 10.

3. Ibid.

4. Bayer's apprenticeship with the architect Margold began in either 1919 or 1920. The earlier date is cited in the text of Bayer, *herbert bayer, painter, designer, architect,* p. 9, while the biographical material provided by Mr. Bayer cites the later date. The later date also is cited in the biography of the same book, p. 14, which appears to have been taken from the identical biographical material that was provided to this author.

5. Wassily Kandinsky, *Concerning the Spiritual in Art,* translated and with an introduction by M. T. H. Sadler (New York: Dover, 1977), p. viii.

6. Bayer recalled Margold telling him that "during entrance examinations, the applicant is locked up in a dark room. thunder and lightning are let loose to get him into a state of agitation. his being admitted depends upon how well he expresses this experience by drawing or painting." Bayer, *herbert bayer,* p. 10.

7. Even while producing polished design programs for corporations and cool sculpture that often was not only aesthetic but also functional, Bayer continued to satisfy another, private, side of his personality. His Aspen *birdhouses* of 1953, although decorated with clean, crisp designs, are the kind of project one would expect more from a craftsman living in a rural mountain town than from a busy corporate designer. Bayer was also taken with owls and butterflies, and some of his works on these nature subjects seem out of step with his more polished pieces such as the *kaleidoscreen* of 1957, now on site by a pool at the Aspen Meadows complex. But it is interesting that these are the works he chose to keep close to him, to live with. An owl sculpture, for example, sat directly outside of his Aspen studio. Bayer himself, in conversation with the author (14 August 1982) said that his series of paintings of butterflies had not been seen widely, because he had always thought of them as "playful." Even though he had great feeling for them, it appears that he separated his private works, such as these, from those he felt were more for exhibition. During this same conversation, the artist explained that as a boy he had begun collecting butterflies and that this hobby continued into his adult life. This side of the artist, his interest in nature and in the spiritual, is less well known. It also helps to explain Bayer's attachment to Aspen, as he stated in his book: "i fully acknowledge that it is in urban concentrations where things happen. But my affinity to the smaller community, which still retains a more manageable scale and permits a constant contact with nature, attracted me to start a new and different life" (ibid., p. 11).

 It is interesting that a similar dichotomy existed at the Bauhaus. During the institution's early years it leaned towards a spiritual emphasis and less towards the practical functionalism that would later become its hallmark. For a full discussion of this subject, see Reyner Banham, *Theory and Design in the First Machine Age* (London: The Architectural Press, 1960) and Marcel Franciscono, *Walter Gropius and the Creation of the Bauhaus in Weimar: The Ideals and Artistic Theories of Its Founding Years* (Urbana: The Board of Trustees of the University of Illinois, 1971). Herbert Bayer's attendance at the Bauhaus coincided with these years of change in emphasis at the Bauhaus.

8. Kandinsky, pp. 54–55.

9. *A Tribute to Herbert Bayer* (multimedia production), Aspen, Colorado, 10 May 1979, transcript, p. 4.

10. Herbert Bayer, Unpublished address for opening of Herbert Bayer Archive, Denver Art Museum, November 1980, p. 3.

11. Kandinsky recognized that the hand was not the only factor in art. In a discussion of the poet Maeterlinck, he emphasized also the role of the mind and heart in the arts (Kandinsky, p. 15).

12. Herbert Bayer, Unpublished speech, "art in a modern world," 1974, p. 3.

13. Arthur A. Cohen, Interviews with Herbert Bayer, Oral History Program, Archives of American Art/Smithsonian Institution, San Francisco, 3–6 November 1981. Preliminary, unedited transcript, p. 157.

14. Kandinsky, p. 38.

15. Ibid., p. 47.

16. "if we are not free to work in any medium, be it wool or oil paint or stainless steel, then art will suffer. in the end, art cannot be judged on the basis of what material it is made

of or how it is made, but on its intrinsic value as art" (Unpublished letter of 13 October 1972, defending his work on display at Patricia Moore Gallery, Aspen, Colorado).

17. According to Bayer, his introduction to art history was through art books borrowed from an art historian friend in Linz, Gustav Guggenbaur. Although his friend's area of study was the Gothic, Bayer himself was most interested in Klimt, Schiele, and the Wiener Werkstätte (Cohen, Interviews with Herbert Bayer, p. 6).

18. Hans Wingler, *The Bauhaus. Weimar, Dessau, Berlin, Chicago* (Cambridge, Mass.: MIT Press, 1969), p. 280, and Herbert Bayer, Walter Gropius, and Ise Gropius, eds., *Bauhaus 1919–1928* (New York: Museum of Modern Art, 1938), p. 34.

19. Bayer used this word to describe himself in another context, but stated that he was even more "impressionable" earlier in life (Cohen, Interviews with Herbert Bayer, p. 114).

20. Ibid., p. 20. (Bayer also retold this story to the author in a conversation of March 1981.)

21. While certainly Bayer correctly recalled that he did not enroll in the preliminary course, sixty years have elapsed since he was a student and it is possible that he did observe more of the preliminary course sessions than he remembered. Plates 7 and 9 of a 1982 catalog illustrate two works from Itten's class of 1921. Since this one exhibition includes two works from the preliminary class, it would seem likely that more exist and that perhaps he attended more sessions than he remembered. For these two images, see *Herbert Bayer, Das Künstlerische Werk 1919–1938* (Berlin: Bauhaus-Archiv, 1982), pp. 23–24.

22. Cohen, Interviews with Herbert Bayer, p. 23.

23. Kandinsky was the "form" master of the wallpainting workshop, which also had a "technical" master (this was Gropius's solution to problems of hiring masters who could teach the well-rounded approach that he sought). In the early years he used two teachers (one artist and one craftsman), hoping that he would soon train masters who were capable of fusing the artistic with the technical. Later, at Dessau, only one master was needed (John Peter, "Heritage of the Bauhaus: A Conversation with Walter Gropius," *Print* 18 [May–June 1964]: 10). It is interesting that even with an egalitarian outlook regarding the "artist" and "craftsman," we rarely today see the names of "technical" masters in the literature, only the names of the "form" masters.

24. Herbert Bayer, Unpublished "statement on the wallpainting workshop at the bauhaus, weimar," p. 3.

25. Gropius titled the exhibition "Art and Technique, A New Unity" to emphasize the goals of the school (Peter, "Heritage of the Bauhaus," p. 12).
 Painting unrelated to architecture was not a part of the Bauhaus curriculum. The only exception was in the teaching of Paul Klee, whom Bayer admired very much. Klee taught a design course based on analysis of his own paintings. Bayer has said that he was particularly fond of his work, although he did not know Klee nearly as well as he knew Kandinsky (Cohen, Interviews with Herbert Bayer, pp. 24–25).

26. Ibid., p. 26.

27. Although for decades Bayer's Bauhaus murals were thought to be no longer extant, they were rediscovered recently under a layer (or more) of white paint and have undergone restoration. (Weimar now is a part of East Germany.) In a conversation with the author

(September 1982) Bayer stated that he was pleased that his murals were recovered and restored but that, unfortunately, the colors (particularly in the background) have been altered from the original.

28. Bayer, Unpublished "statement on the wallpainting workshop at the bauhaus, weimar," p. 2.

29. Cohen, Interviews with Herbert Bayer, pp. 46–50.

30. Bayer, *herbert bayer, painter, designer, architect*, p. 11.

31. Bayer's decision to join the Bauhaus faculty was complicated somewhat by the fact that the woman whom he was planning to marry (his first wife, Irene) wanted very much to emigrate with Bayer to America, where her father resided. Bayer questioned the state of the art of design in America at that time, however, wondering what he would be able to do there. He felt that he would be happier at the Bauhaus, and so he accepted Gropius's offer (Cohen, Interviews with Herbert Bayer, pp. 49–50). It is interesting to speculate what might have happened had Bayer come to the United States in 1925, at a time when American design was still quite provincial. If one places much importance on the value of proper timing for historical entrance, one is apt to wonder if Bayer might have had difficulty entering American life at a time when his ideas would have been too unusual for acceptance, especially in areas such as advertising which require public approval. It seems that the timing of Bayer's arrival in New York, some dozen years later, was optimal for the artist's acceptance. Enough former Bauhaus artists were becoming known in the United States already so that his association with the school itself was a bonus. Additionally, many of the school's teachers were already in influential positions which enabled them to introduce Bayer to the proper people and even to secure his first job, that of arranging a major exhibition at the Museum of Modern Art, New York, which would give him national exposure. It seems that, indeed, fortuitous timing was central to Bayer's good fortune in America.

32. Wingler, *The Bauhaus*, p. 80.

33. Unpublished letter to the author from Herbert Bayer, 5 January 1981.

34. Wingler, *The Bauhaus*, pp. 80–81.

35. Ibid., p. 81.

36. Ibid.

37. Ibid.

38. Bayer felt that the adage "form follows function" is questionable, since he believed that form and function are, or should be, one and the same.

39. *Herbert Bayer, Das künstlerische Werk 1919–1938*, p. 19. There is a discrepancy in dating. This work is dated 1918 in the above catalog, but the dates of his apprenticeship generally are given as beginning in 1919.

40. Bayer, *herbert bayer, painter, designer, architect*, p. 11.

41. Cohen, Interviews with Herbert Bayer, p. 45.

42. Ibid., p. 131.

43. Peter, "Heritage of the Bauhaus," p. 10.

44. *homage to gropius:* prose poem (1961)

he was in his office
at the van de velde-bauhaus building in weimar
when I first met him
presenting my work
to become a student at the bauhaus.

above his desk in the spacious high ceilinged room
hung a cubist léger.
there was also a medieval architectural drawing.

gropius wore black trousers, white shirt, slim black bow tie
and a short natural colored leather jacket
which squeaked with each movement.
his short mustache, trim figure and swift movements
gave him the air of a soldier
(which in fact he had been until recently).
gropius's manner of dress was in contrast
to the generally fantastic individualistic appearances
around the bauhaus.
it was a statement of his opinion
that the new artist need not oppose his society
by wearing dress which, to begin with,
would set him apart from the world he lives in,
that the first step toward common understanding
would be acceptance of such standards
as would not infringe on a free spirit.
when I recall those years
I first think of a community of highly eccentric individuals
some of them strange or just funny with vague notions
about their purpose for being there,
attracted mainly by the promise of the unknown,
bohemian, poor, defying weimar's bourgeoisie.
I also think of the scent of roses and lilac,
and of nightingales in goethe's moonflooded park.

my background lay in the viennese design tradition
of art nouveau and sezession.
dissatisfied with the role of the designer
as a mere beautifier,
I was drawn to the bauhaus by its first proclamation
with feininger's symbolic romantic woodcut—a revelation.
at the time I was deeply impressed by kandinsky's book
''about the spiritual in art,'' which I read by chance.

if even in retrospect I cannot express exactly
what brought us all together,
in gropius's mind it must have been clear,
as preceding the bauhaus he had already opened the doors
to new perspectives with his crystal clear buildings.

and he steadfastly guided us
through yet undefined concepts
to a distinct consummation.
outside currents and inside trends contributed
to an atmosphere of explosive evolution.
most of us were stricken with romantic expressionism.
dadaism paralleled our rejection of any sanctioned order.
the work of the stijl-group, attractive by its purity
had a short lived, formalistic influence.
constructivism added its share to the artistic turmoil
but the world of machine production
with its innate facts and functions
was already coloring the future.

more evident still becomes the greatness of his vision
if we understand the utter confusion of those times.

as a student of the bauhaus I honor gropius
for he was always drawn to youth—
and youth is always attracted to him.
a prerequisite for the great educator he is,
dedication to the younger generation
gave him strength in the face of hostility
to deal with unending personal, artistic, internal, financial issues.

(Herbert Bayer, *homage to gropius,* quoted in Arthur Cohen, *Herbert Bayer: The Complete Work* [Cambridge, Mass.: MIT, 1984], p. 337).

Chapter 2 Bayer's Post-Bauhaus Years in Europe, 1928–1938

1. Cohen, Interviews with Herbert Bayer, p. 42.

2. According to Arthur Cohen, "The advertising for French *Vogue* was handled by the Paris branch of Dorland, which was headed by Walter Maas. Through Maas, Bayer met Walther Matthews of German Dorland, who invited Bayer to manage all art for Dorland." See Arthur A. Cohen, *Herbert Bayer, The Complete Work* (Cambridge, Mass.: MIT, 1984), p. 409, fn. 24.

3. Cohen, Interviews with Herbert Bayer, p. 42.

4. Ibid. It is interesting that while three of Bayer's paintings were included in Hitler's exhibition of so-called "degenerate art" in Berlin during the time Bayer was living there, the Nazis apparently did not connect this work with his design practice, which was flourishing at the same time. See "Herbert Bayer Interview" in Paul Hill and Thomas Cooper, *Dialogue with Photography* (New York: Farrar, 1979), p. 124.

5. The monogram Y must have emerged from Bayer's signature, as the "Y" in Bayer is enlarged in many of the Dorland signatures. Subsequently, in other images, only the enlarged "Y" remains as Bayer's mark.

6. By the 1980s Bayer could not remember when he first saw a Cubist painting—and he attributed this lack of recall to the fact that it must not have impressed him very much (Cohen, Interviews with Herbert Bayer," pp. 75–78).

7. Wingler, *The Bauhaus,* p. 480.

8. Bayer's first wife, Irene, studied photography in Leipzig, near Dessau. They both were interested in photography for media communication ("Herbert Bayer Interview," in Hill and Cooper, *Dialogue with Photography,* p. 116).

 Even if Bayer had not come in contact with photography at the Bauhaus, he could scarcely have been unaware of the impact of the photographic image. By the mid-1920s and into the 1930s, photography was taking a tremendous role in the popular magazines of Germany. For a discussion of the important role of photography in journalism of the era, see Tim N. Gidal, *Modern Photojournalism: Origin and Evolution, 1910–1913,* trans. Maureen Oberli-Turner (New York: Macmillan, 1973).

 Bayer's use of the term *fotoplastik* requires explanation. Although this term had been invented by Moholy-Nagy, and originally involved reference to Neoplasticism, Bayer's use of the word meant only "to signify the plastic quality which dominates in these images" (Herbert Bayer, letter to Tim Gidal, 16 September 1977). For this reason, my use of this term throughout the book remains italicized, but also lower-cased, to refer to Bayer's sense of the term.

9. Bayer acknowledged his debt to Dada precedents: "we were familiar with some of the dadaist collages, with some works of kurt schwitters, who sometimes visited the bauhaus in weimar. for dance posters, invitations to festivals, and birthday greetings of a more private and playful nature we often used montage techniques" (unpublished lecture by Herbert Bayer on "typography and graphic design," given at Dartmouth College on 9 September 1976, p. 9).

10. Another Bayer image that relates to the Magritte is *geometry lost in an undulated landscape,* 1958/50, featuring cylinders, cubes, and cones in a parklike landscape. The close relationship between Bayer's photographs and surrealist imagery is also evidenced by his photomontage *monument* (fig. 26), which resembles Miró's *Poetic Object,* in the collection of the Museum of Modern Art, New York City.

11. Bayer only rarely returned to photography after the 1930s. And although he is well known among photographic historians for his work in this medium, late in life he considered this work almost as an aberration in his oeuvre, as an experimental diversion. Because the works are so appealing and so visually satisfying, it would be a mistake for the viewer to dismiss these works simply because they are confined to a relatively brief period in his career. For a more complete discussion of Bayer's photography, see Beaumont Newhall's introduction to the catalog by Beaumont Newhall and Leland Rice, *herbert bayer: photographic works* (Los Angeles: Atlantic Richfield Co., 1977).

12. For a more complete discussion of Bayer's exhibition design, see chapter 7.

13. Wingler, *The Bauhaus,* p. 569.

14. Alexander Dorner, *The Way beyond Art* (New York: Wittenborn, 1947), pp. 205 (note), 235. In 1939 Bayer also contributed to an exhibition for the House of the State of Pennsylvania at the World's Fair, an exhibition to which Gropius, Breuer, and Schawinsky also made contributions. (Dorner, p. 205, incorrectly dates this exhibition to 1937.)

Chapter 3 Early Painting

1. When asked, "In what order of importance would you place your various artistic activities?" Bayer responded, "I would put my independent, creative work first." "Herbert

Bayer Interview," in Paul Hill and Thomas Cooper, *Dialogue with Photography* (New York: Farrar, 1979), p. 131.

2. Speaking of his new life in America, Bayer stated, "My personal life was not so easy; and then this change of domicile. . . . And the contradiction of working as a designer/ architect and at the same time wanting to paint, because I thought the painting was the more important one" (Cohen, Interviews with Herbert Bayer, p. 131). It is interesting that Breuer, for example, did not want to be associated with the Bauhaus when he came to the United States, because he wanted to be known as an architect, not as a designer of furniture (ibid., pp. 64–65).

3. Jan van der Marck has recounted that Bayer "in 1963 . . . conceded to herbert lange, 'although i have been a painter all my life, i have only recently paid attention to show-ing it more consistently'" (Jan van der Marck, "exercise in polarities, the paintings and sculpture of herbert bayer," introduction to *herbert bayer, recent works* [New York: Marlborough Gallery, January–February 1971], p. 7). On the same page van der Marck notes that Bayer had no one-man New York exhibitions between 1965 and 1971.

4. For a discussion of Bayer's Bauhaus murals of 1923, see pp. 11, 13.

5. Alexander Dorner was the first to note these influences on Bayer's work (Dorner, *The Way beyond Art*, p. 133).

6. For a brief discussion of this time period, see chapter 2.

7. 1928 also provided a month of free time between his Bauhaus duties and those in Berlin, which he spent in Nice, actively working on fine art (Dorner, *The Way beyond Art*, p. 139).

8. Ibid.

9. Although Bayer was not well versed in Surrealist art, he did known the work of Magritte quite early; and he admired the paintings of de Chirico as well. Of course Dadaism was well known at the Bauhaus, with some of its leaders even making occasional visits.
 As early as 1947, Dorner discussed Bayer's affinity to de Chirico and the Surrealists (ibid., pp. 139–42).

10. Peter Roehl and Molnar were also influential at the Bauhaus (ibid., p. 133).

11. A notation in a sketchbook of 1940–41 includes a list of books including *Astronomie* and *History of Aeronautics* (Herbert Bayer, unpublished sketchbook, 1940–41, p. 22).

12. Vectors first appear in Bayer's sketchbook in 1942 drawings (Herbert Bayer, sketchbook, 1942, pp. 39–43).

13. Herbert Bayer, sketchbook, 1943, pp. 120–21.

14. Sgraffito was a technique that Bayer had learned at the Bauhaus. He explained, "sgraffito technique is many centuries old. in this case one dark underlayer of plaster was overlaid with light-colored plaster. while still wet the lines were scratched out of the light layer, exposing the dark one. the mural was produced with the help of aspen friends during one summer night while the plaster was wet and could be scratched" (Bayer, *herbert bayer, painter, designer, architect*, p. 176).

15. Herbert Bayer, *world geo-graphic atlas* (Chicago: Container Corporation of America, 1953).

16. Herbert Bayer, sketchbook, 1956 (section labeled "horizons," p. 1).

17. A Fibonacci progression is "based on the increase of each dimension by the addition of the two preceding dimensions: for instance, 1, 2, 3 (2+1), 5 (3+2), 8, 13, 21, etc." (Herbert Bayer, unpublished "statement on the fibonacci progressions," 1977). An article on "Mathematical Games, the Multiple Fascinations of the Fibonacci Sequence," by Martin Gardner, is pasted into Bayer's 1966 sketchbook, n.p.

18. Herbert Bayer, Unpublished statement "on the chromatics," 12 October 1970.

19. These works have been compared to those of Victor Vasarely, a comparison made, no doubt, because of the similar planned order and brilliant hues. Bayer himself has written about this identification (Herbert Bayer, Unpublished statement "on paintings by vasarely and bayer," 1970).

20. Bayer, Unpublished statement "on the chromatics," 12 October 1970.

21. Ibid.

Chapter 4 The Relationship between the Fine Arts and Commercial Work ...

1. In addition to Bayer, Albers and Breuer were among those who became masters after completing their Bauhaus studies.

2. The words "decorate" or "embellish" were discouraged by Gropius. He sought to unite all the arts under architecture so that the arts would be an integral part of the structure, not merely applied decoration.

3. Bayer's design for this cover received first prize in the Exhibition of International Advertising Photography at the Art Center, New York City, in 1931 (Dorner, *The Way beyond Art*, p. 137).

4. Certainly artists such as Kandinsky and Klee were aware of other European modernist developments. Yet even though they no doubt kept in contact with many artists outside of the Bauhaus, these did not frequent the Bauhaus as did van Doesburg and Lissitzky.

5. Clouds continued to be included in Bayer's pictorial vocabulary, entering his paintings throughout the decade of the 1940s, especially in those dealing with atmospheric and interstellar imagery.

6. *herbert bayer, a total concept* (Denver, Colo.: The Denver Art Museum, 1973), p. 18.

7. Dorner, *The Way beyond Art*, pp. 138–39. Although Dorner's discussion of Bayer's "common signs" as a "new language of public symbols" which "frees his visions from the aimless drifting of the Surrealist's private obsessions" is of questionable merit, his recognition of these signs deserves mention.

8. Cohen, Interviews with Herbert Bayer, p. 108, and Gwen Chanzit, Interview with Herbert Bayer, March 1982.

9. Cohen, Interviews with Herbert Bayer, p. 108, Chanzit, Interview with Herbert Bayer, August 1982, and Hill and Cooper, *Dialogue with Photography*, p. 123.

10. This comparison was brought to my attention by Jan van der Marck in November 1980.

Chapter 5 Bayer's Life in America

1. Bayer, sketchbook, 26 July 1937.

2. Cohen, Interviews with Herbert Bayer, p. 62.

3. Ibid., p. 63 and files of the Registrar, the Museum of Modern Art, New York.

4. Bayer's work could not have been altogether unknown here, because even prior to his arrival in the United States, his work had been seen in New York. Between 1931 and 1934 he exhibited at the Julien Levy Gallery; his work was also seen in the two important exhibitions of 1936 at the Museum of Modern Art, "Fantastic Art, Dada and Surrealism" and "Cubism and Abstract Art."

5. Cohen, Interviews with Herbert Bayer, p. 64.

6. Chanzit, Interview with Herbert Bayer, March 1981; Cohen, Interviews with Herbert Bayer, p. 64.

7. "I have a terribly regretful feeling about leaving you there to work without any help, but it is absolutely impossible for me to be with you to help to build up the exhibition as I am so heavily booked up here" (unpublished letter from Walter Gropius to Herbert Bayer, 22 October 1938).

8. Cohen, Interviews with Herbert Bayer, p. 61.

9. Bayer had been separated from his first wife, Irene, since 1932.

10. Quote from Herbert Bayer in John Farrell, "Interview with Master Artist and Designer Herbert Bayer," *Santa Barbara Magazine* 8, No. 1 (February–March 1980): 30.

11. Bayer, sketchbook, 1943, p. 90.

12. Cohen, Interviews with Herbert Bayer, p. 67.

13. Bayer, sketchbook, 1943, pp. 81–83.

14. Ibid., p. 107.

15. Ibid., pp. 83–85. In addition to feeling personally uprooted, Bayer surely felt the emotional effects of wartime. The late 1930s and early 1940s saw the artist expressing insecurity and anxiety in paintings, the only outlet in which he could vent his fears. (See *interstellar exchange,* 1941, resembling a horrific explosion, and *sticks and stones,* 1939, and *archaic chamber,* 1940, both with violent images resembling some perverse transformation of his earlier, peaceful renditions of farm implements.) Clearly Bayer's public works of the same period give no hint of this personal anxiety.

16. Ibid., pp. 109–10. Perhaps the answer to the question he posed to himself lay in a new life in Aspen. Bayer told me that the move to Aspen was not accompanied by much financial promise, and yet he eagerly made the move to a mountain community which recalled the landscape of his youth, terrain which he had greatly missed in the metropolis. Aspen also provided a place to realize a dream (much as the Bauhaus had), starting with a rundown old mining town, but rebuilding with youth and determination.

17. Ibid., pp. 95–98.

18. Magdalena Droste, "Herbert Bayer in USA," in *Herbert Bayer, Das künstlerische Werk 1919–1938,* p. 139.

19. Walter Paepcke died in 1960.

20. The move to southern California was due largely to Robert O. Anderson's prodding. Bayer was still able to spend summers in Aspen through 1981, but eventually even that became too difficult. Regardless, his heart remained in Aspen and in several conversations with me he referred to leaving Aspen as a "tragedy."

Chapter 6 Graphic Design and Typography

1. I am indebted to Philip Meggs's excellent book in which these examples are cited (Philip B. Meggs, *A History of Graphic Design* [New York: Van Nostrand Reinhold, 1983], pp. 276–84). Meggs, p. 277, cites sources for concrete poetry as far back as the Greek poet Simias of Rhodes, of ca. 33 B.C.

2. Ibid., pp. 295–98.

3. Although van Doesburg would have liked a position teaching at the Bauhaus, it was never offered, probably because it was felt that he would never be a part of a "team." His dogmatic approach prevented him from being considered. According to Bayer, "Gropius felt that his theories were [too fixed]. . . . they didn't fit and also, as a person, he came on very strong. He was a pusher, and I think the other masters did not take very much to his theories, [he] being too . . . aggressive" (Cohen, Interviews with Herbert Bayer, p. 31).

4. Ibid., p. 51.

5. *Staatliches Bauhaus Weimar 1919–1923* (Weimar, Munich, Berlin, 1923), p. 141.

6. Prior to this time there had only been a small "artistic" graphics shop and actual printing of all commercial work had to be sent out.

7. Stationery in the Herbert Bayer Collection and Archive, Denver Art Museum, contains such a note.

8. Magdalena Droste, "Herbert Bayer's künstlerische Entwicklung 1918–1938, pp. 39–40, and Ute Brüning, "Zur Typografie Herbert Bayers," p. 118, both in *Herbert Bayer, Das künstlerische Werk 1918–1938.*

9. Herbert Bayer, "basic alfabet," Herbert Bayer, *herbert bayer, painter, designer, architect,* p. 78.

10. Droste, p. 40.

11. "Herbert Bayer," *Gebrauchsgraphik* Nr. 5, 8, 1931, pp. 1–19; "Herbert Bayer," *Gebrauchsgraphik* Nr. 6, 15, 1938, pp. 1–16.

12. Droste, p. 77.

13. Gertrude Snyder, "Pro.File: Herbert Bayer," *Upper and Lower Case* (New York: International Typeface Corporation, December 1977), p. 12. Margaret Breuning, writing in 1931 in response to Bayer's prize for the cover of the *Bauhaus* magazine, states of American graphic design of the day: "Our advertising tends to illustration, the use of the article is demonstrated by its happy users. Far more often, and to many of us more effectively, the foreign advertisement presents the article itself in some unusual character which gains for it a provocative, arresting angle of contour or mass, exaggerated, distorted,

if you will, but given a witty, sophisticated accent instead of the usual stodgy, literal explanation." Margaret Breuning, "Foreign Commercial Photographs Make Brilliant Showing," *New York Evening Post,* March 7, 1931.

14. Droste, p. 55. Bayer's reluctance to lecture at the Bauhaus may be explained, in part, by his self-described shyness during those years. Bayer stated that not only was he shy, but he also felt that he was too young to teach at that time since he had just come up the ranks from being a student (Cohen, Interviews with Herbert Bayer, pp. 37 and 45).

15. Towards the end of his Bauhaus tenure, Bayer had even devised a plan for systematizing the Bauhaus workshops.

16. Droste, p. 58.

17. Ibid.

18. Ibid., p. 61.

19. Herbert Bayer, "a contribution to book typography," *Print* 13 (March–April 1959), and Herbert Bayer, "un contributo alla tipografia del libro," *Linea Grafica* (March–April 1960).

20. Herbert Bayer, Unpublished statement on "fifty books show," 10 February 1939. (This statement may have been included in some printed material about the exhibition, as Bayer wrote a note at the end to a Mr. Bennett, "I hope this article will be satisfactory and that it will reach you in time.")

21. Percy Seitlin, "Herbert Bayer's Design Class," *A-D* 7 (June–July 1941). Bayer's course was taught for at least two years.

22. Herbert Bayer, Unpublished "notes for design class," 1940.

23. Herbert Bayer, Unpublished "plan for twelve courses at the advertising guild," 1940.

24. Bayer dated the main thrust of this article 1937, which illustrates that the ideas formulated in Europe guided his American goals. Herbert Bayer, "contribution toward rules of advertising design," *P.M.* (December–January 1939–40): 6–16.

25. Bayer dated this article 1935. Herbert Bayer, "towards a universal type," *P.M.* (December–January, 1939–40): 27–32.

26. Herbert Bayer, Unpublished lecture delivered at the Art Directors' Club, Philadelphia, 26 February 1939 (or 1940).

27. Herbert Bayer, Unpublished letter to Monroe Wheeler, 27 October 1943. A follow-up letter was sent to Mrs. Resor, 25 September 1944 (Herbert Bayer Collection and Archive, Denver Art Museum).

28. In addition Gropius and Breuer were teaching architecture at Harvard, Albers was teaching painting at Black Mountain College, and Mies headed up the Illinois Institute of Technology (formerly the Armour Institute) in Chicago.

29. Bayer recalled that Walter Paepcke once told him, "Well, Moholy's not a person whom I can introduce to businessmen who may support him. He's too unusual an animal, you know" (Cohen, Interviews with Herbert Bayer, p. 61).

30. Herbert Bayer, "basic alfabet," 1958–60, reprinted in Bayer, *herbert bayer, painter, designer, architect,* pp. 78–80.

31. Ibid., p. 79.

32. Herbert Bayer, "design analysis of five posters," 1937, reprinted in Bayer, *herbert bayer, painter, designer, architect*, p. 46.

33. Herbert Bayer, Unpublished lecture, "typography and graphic communication," Dartmouth College, 9 December 1976, p. 8.

34. Letter from Stanley Morison to Walter Lewis, 25 July 1934. Published in Nicolas Barker, *Stanley Morison* (Cambridge, Mass.: Harvard University Press, 1972), p. 336.

35. Alfred Barr wrote to Gropius for advice on how to address the issue: "'We have already heard reports that the exhibition is considered 'Jewish.' Many Americans are so ignorant of European names that they conclude that, because the Nazi Government has been against the Bauhaus, the names Gropius, Bayer, Moholy-Nagy, etc., are probably 'Jewish-Communist.'" Barr suggested an explanation of why the Nazis were against the Bauhaus and a clarification which included the following: "Architecturally the Bauhaus under Gropius and Mies van der Rohe was deliberately non-political in character. Its radical innovations were confined entirely to the field of art and education. It should be stated that, although the Bauhaus welcomed Jewish students, there were no Jews on its faculty (or there were only two Jews out of fourteen on its faculty, or whatever the proportion was)" (Unpublished letter from Alfred Barr to Walter Gropius, 10 December 1938. Department of the Registrar, Museum of Modern Art, New York).

 Gropius's reply to Barr states: "We think, also, that it might be well to make a statement as to the Nazi Government. . . . I think we should not, in any case, defend ourselves against the Jewish question. I decline to give any arguments with them about this matter. As a fact, we have had only one Jew among seventeen artists on the Bauhaus faculty throughout the years, and not one on the technical staff . . . but I see no reason why we should have to defend ourselves, nevertheless, against the foolish point of view of Hitler's" (Unpublished letter from Walter Gropius to Alfred Barr, 15 December 1938. Department of the Registrar, Museum of Modern Art, New York).

Chapter 7 Exhibition Design

1. As an important center of artistic activity, the Bauhaus drew visitors from virtually every sector of the modern art world. Certainly visitors like van Doesburg and Lissitzky presented interesting ideas to Bayer and others. Lissitzky became a particularly important source for Bayer. Bayer first met Lissitzky briefly at the Bauhaus and again in Rome, before working with him in 1928. (Bayer mentioned meeting Lissitzky at the Bauhaus and in Rome in Cohen, Interviews with Herbert Bayer, p. 32.)

2. Herbert Bayer quoted from *A Tribute to Herbert Bayer,* unpublished transcript of a multimedia presentation, International Design Conference, Aspen, Colorado, 10 May 1979.

3. Bayer and Moholy-Nagy designed the displays; the ramps and structures were designed by Gropius.

4. Although Bayer's participation in the "Deutscher Werkbund" and "Building Workers Unions" exhibitions is well documented, the fact that he participated in the 1928 "Pressa" exhibition is less well known. His participation there is not mentioned in the early Bayer literature, except in a very few biographical listings (without mention of Lissitzky) or in

innocuous brief mentions of the exhibition in text, treating this experience as a minor fact. While it is true that Bayer's contribution to the "Pressa" was minimal (he designed a room of book displays), his presence at the exhibition was major in terms of the impact that it had on his future direction in exhibition design. What is missing in most accounts is Bayer's contact with El Lissitzky. This much overlooked association with the Russian artist in 1928 provides a logical chain of continuity between what Lissitzky was accomplishing and Bayer's later exhibitions. Christopher Phillips ("Steichen's Road to Victory," *Exposure* 18 [1980]) acknowledges Lissitzky's influence and even discusses Bayer's mention of Lissitzky; yet the article misses the "Pressa" altogether. Phillips illustrates another Lissitzky exhibition (at Dresden, 1929) to compare with Bayer's designs (p. 41).

5. Two exhibition projects conceived by Bayer at the Bauhaus are a small exhibition pavilion at an industrial fair (for Regina), and an exhibition pavilion with a revolving sphere covered with electric bulbs, both of 1924. (These projects are illustrated in Dorner, *The Way beyond Art*, p. 136. For a discussion of Lissitzky's exhibition design see Sophie Lissitzky-Küppers, *El Lissitzky, Life, Letters, Texts* [London: Thames and Hudson, 1968], pp. 365–67.)

6. Cohen, Interviews with Herbert Bayer, p. 35. Even earlier, Bayer acknowledged his association with Lissitzky at the "Pressa," in an interview with the author in March 1981.

7. The Landesmuseum, Hannover, was the site of the modern gallery designed by El Lissitzky at the request of Alexander Dorner: the "Room of Abstract Art" of 1925. This installation is illustrated and discussed in Dorner, *The Way beyond Art*, pp. 17–18 and 114–15, and in Samuel Cauman, *The Living Museum* (New York: New York University Press, 1958), pp. 98–104.

8. Dorner, p. 199.

9. Herbert Bayer, "Aspects of Design of Exhibitions and Museums," *Curator* 4 (1961): 267. The sentence following the one quoted indicates that Bayer may have thought that the "Pressa" was the first example of Lissitzky's new techniques, as he mistakenly states, "At the 'Pressa' and subsequently at the Trade Fair in Leipzig El Lissitzky first used montage techniques with photoenlargements." In fact, the exhibition at Leipzig came in 1927, the year before the "Pressa." Nowhere in the article does Bayer mention his own presence at Lissitzky's exhibition. Only in personal discussion did Bayer affirm his presence at the "Pressa" or give any indication of what the experience meant to him.

10. This list comes from a brief biography of Bayer printed on an exhibition leaflet of 1949 for a one-man exhibition at Baldwin Kingrey, 160 East Ohio Street, Chicago.

11. Cohen, Interviews with Herbert Bayer, pp. 63 and 204–5.

12. These documents are found in the Department of the Registrar, Museum of Modern Art, New York City.

13. The exhibition, which was scheduled to open in spring 1938, was delayed because Bayer needed more time to collect the material and to write the catalog. After originally being wired that it would be impossible to delay the exhibition (although the catalog could be delayed), Bayer received a subsequent telegram in Berlin: "Show definitely postponed until Fall. Hope this pleases you. Happy New Year. McAndrew." The exhibition opened fall 1938 (Records of the Registrar's Office, Museum of Modern Art, New York City).

14. Bayer was well prepared for his exit from Europe. He had obtained the proper documents and had received letters from people in the United States supporting his immigration,

including a letter from Alfred Barr stating that Bayer should have no difficulty earning a living here. But when he tried to pick up his permit to leave Germany he was delayed because of material he had left on exhibition in London which the German authorities thought might be of value. Then, after he went to Bremen to board the boat for America, he realized that his passport had been stamped that he was to report for duty in the German army. (After the Anschluss, his Austrian passport had been taken away and replaced with a German one, making him a German citizen.) By chance, the authorities did not notice the stamp and he was allowed to leave. Finally, Bayer was almost not permitted to disembark the boat upon entering the United States, because, amazingly, he had not passed a color blindness test which was part of the testing given to prospective immigrants. Bayer explained to me that he took the tests after several days of waiting on a crowded embassy floor and in his exhaustion, must have given some incorrect answers (Chanzit, Interview with Herbert Bayer, March 1981, and Cohen, Interviews with Herbert Bayer, pp. 206–8 and 214).

15. One particularly antagonistic letter to the editor, by Natalie Swann, who had spent a year at the Bauhaus, caused a great uproar. It appears that there may have been some extenuating circumstances as Barr noted that she was working for Kiesler at the time (Department of the Registrar, Museum of Modern Art, New York City). Bayer indicated to me that although there were no animosities between Kiesler and the Bauhäusler, Kiesler was not on best terms with the Museum of Modern Art; apparently he was offended that he had not been invited to exhibit in some major shows (Chanzit, Interview with Herbert Bayer, September 1983).

16. Lewis Mumford, "The Sky Line: Bauhaus—Two Restaurants and a Theatre," *The New Yorker* (31 December 1938): 40–42.

17. Alfred Barr, Unpublished "Notes on the Reception of the Bauhaus Exhibition," 1938. Department of the Registrar, Museum of Modern Art, New York City.

18. Unpublished letter from Alfred Barr to Walter Gropius, 3 March 1939, Museum of Modern Art, New York.

19. It appears that Bayer was hired in March 1942. In a memo from Beaumont Newhall, Curator of Photography (later to be succeeded by Edward Steichen), Newhall stated that he had offered the job to Herbert Bayer (Memo of 13 March 1942 from the records of the Museum of Modern Art, New York). Apparently a Mr. Dyer had done some early plans for the exhibition, which were superseded by those of Bayer. In a memo of 12 December 1941, Mr. Dyer defended his latest revisions (Memo from records, Museum of Modern Art). Apparently these revisions must not have been acceptable and Bayer, known to the museum for his work on the Bauhaus exhibition, was hired.

 Bayer also noted that "they asked Herbert Matter and me in a quasi-competition to submit ideas. I made . . . a model of my intended design, which really sold the whole thing to the trustees" (Bayer, sketchbook, April 1943).

20. For a more complete discussion of "Road to Victory" and especially Steichen's contribution, see Phillips, "Steichen's Road to Victory."

21. The name "Road to Victory" was given to the exhibition only after the United States entered the war. Early Museum of Modern Art memos refer to the exhibition as the "Panorama of Defense"; according to Christopher Phillips, "Arsenal of Democracy" was another early title (p. 40).

22. Another original three-dimensional model of the exhibition is in the Herbert Bayer Collection and Archive, Denver Art Museum, Denver, Colorado.

23. In discussions with me, Bayer indicated that Steichen laid the groundwork for the exhibition and chose the photographs that were to be exhibited. Steichen devised the general theme of the exhibition and Bayer designed the spaces and planned the approximate sequence of the photographs within that "story." With this beginning and through successive meetings between himself and Steichen, Bayer drew up plans and a model, determining the sizes of the photographs and their arrangement within the total design of the exhibition hall (Chanzit, Interview with Herbert Bayer, March 1981).

24. Paul Hill and Thomas Cooper, "Herbert Bayer, Interview," in *Dialogue with Photography* (New York: Farrar, 1979), p. 125.

25. The following description of constructing the large photomurals was given in the museum's bulletin: "To make the large murals, the negatives were enlarged in sections upon strips of photographic paper forty inches wide. The museum wall was first sized, then covered with a layer of wallpaper, next with one of cloth, and then the photographs were pasted on the cloth by paper hangers. The seams were lightly airbrushed, imperfections were retouched by hand, and finally the whole mural was painted with dull varnish to eliminate the glaring reflections rendered by the surface of photographic paper ("Road to Victory," *The Bulletin of the Museum of Modern Art* 9, Nos. 5–6 [June 1942]: 19).

26. Phillips, "Steichen's Road to Victory," p. 42.

27. The accounts of "Road to Victory"'s itinerary vary: "It was quickly scheduled to proceed to Chicago, St. Louis, Portland, and Rochester, N.Y., while smaller 'replicas' were shipped to Britain, South America, and the Pacific" (Phillips, p. 38).

 "Running six months in New York, it moved on to Cleveland, Chicago, St. Louis, and has been scheduled for San Francisco, Portland, Oregon, and many other cities. One replica . . . reached London. . . . Another went to Honolulu and will go to Australia and other parts of the Pacific. Still another started in Colombia, South America, for travel southward, and a second replica, shown first in Uruguay, toured northward. At one embarkation port the army has put the show into regular use among troops waiting for transports. And in pocket form 'Road to Victory' is in continuous use among the armed services at home and abroad" (Carl Sandburg, *Home Front Memo* [New York: Harcourt Brace, 1943], p. 307).

 In the Museum of Modern Art library, one finds blueprints for installing exhibitions at Cleveland, Chicago, St. Louis, and San Francisco, all with Bayer's "Y" monogram (*C/E File: "Road to Victory,"* Museum of Modern Art library, New York).

28. *C/E File: "Road to Victory,"* Museum of Modern Art library, New York.

29. At least one reference to this exhibition used the title "Sky Roads." This title was found in a letter to the museum from the Department of Commerce, Washington, D.C., of December 1943 (Department of the Registrar, Museum of Modern Art, New York).

30. A special section of the magazine *Skyways,* a feature on weather and warfare, February 1944, reproduced some of Bayer's panels from the section of "Airways to Peace" entitled "The Nature of the Atmosphere" (documents from the Department of the Registrar, Museum of Modern Art, New York. Note: Some pages of this article may be found in the Herbert Bayer Collection and Archive, Denver Art Museum).

31. In an unpublished interview with the author (March 1981), Bayer stated that he did not know of the Duchamp exhibition. However, because of the marked visual relationship between the ''strung'' exhibitions and because of the mutual associations of Bayer and Duchamp through the Julien Levy Gallery and the exhibition ''Fantastic Art, Dada and Surrealism,'' I could not dismiss the issue immediately. In further discussions (July 1983 and September 1983), Bayer indicated to me that he did remember seeing an exhibition with string, but by Kiesler. Examination of photographs from Duchamp's ''First Papers of Surrealism'' indicated to Bayer that the exhibition which he had seen and attributed to Kiesler was indeed by Duchamp.

32. A memo of 30 January 1945 from Mr. Wheeler to Miss Ulrich states that the outside-in globe was sold to Mr. Ben Stern, director of information and statistics, Department of Commerce, Civil Aeronautics Administration, Washington, D.C., for $500 (from the records of the Exhibition Department, Museum of Modern Art, New York).

 In the Museum of Modern Art installation list of 7 April 1944, the globe is inventoried as follows: ''Eleven foot diameter globe in ten sections. It takes at least six men to lift this globe into place on three stands'' (installation list, p. 2, from the Department of the Registrar, Museum of Modern Art, New York).

33. A 1945 article by Siegfried Giedion provides the following list of American exhibitions planned and designed by Herbert Bayer: 1938, ''Bauhaus'' exhibition at Museum of Modern Art, New York. 1939, Displays for State of Pennsylvania at World's Fair, New York. 1941–42, Packaging exhibits for Aluminum Company of America. 1941–42, Travelling Exhibition for the Coordination of Inter-American Affairs. 1941–42, ''Women and the War'' exhibition for the Australian News Bureau. 1942, ''Road to Victory'' exhibition for the Museum of Modern Art. 1942, ''Arts in Therapy'' exhibition for the Museum of Modern Art. 1943, ''Airways to Peace'' exhibition for the Museum of Modern Art. 1944, Medical Products exhibition in Chicago. 1945, Exhibition at the Art Institute of Chicago for the Container Corporation of America (Siegfried Giedion, ''Herbert Bayer and Advertising in USA,'' *Graphis* 6, Nos. 11 and 12 (October–November–December 1945): 423).

34. The gap between 1946 and 1959 in Bayer's exhibition activity no doubt owes itself to the fact that by 1946 Bayer had begun a full-time commitment to Walter Paepcke for Container Corporation and for the development of Aspen, Colorado.

35. Herbert Bayer, ''Aspects of Exhibitions and Museums,'' *Curator* 4, No. 3 (1961): 258. (This journal did not adhere to Bayer's preference for lower case. Hence the article appeared with standard capitalization.)

36. ''Herbert Bayer is tops in a new kind of artist's 'profession' which the modern world needs but for which a name has not yet been found. We might call the profession that of a 'creative designer.' '' Julien Levy, ''From a Portfolio of Photomontages by Herbert Bayer,'' *Coronet* 7 (January 1940): 30.

37. Alfred Barr wrote a letter in support of Bayer's immigration visa. (Bayer's first wife and his daughter were Jewish, so immigration proved to be very important.)

38. Herbert Bayer, ''fundamentals of exhibition design,'' *P.M.* (1939).

39. Bayer, ''Aspects of Design of Exhibitions and Museums.''

40. It is in this regard that Bayer is unique even among his contemporaries in avant-garde design. What is unusual about Bayer is that he always took time to write and talk about

his work. Public understanding of his work and of its importance in the world was always important to Bayer.

41. Bayer, "fundamentals of exhibition design," p. 18.

42. These ideas are discussed more completely in Bernard Rudofsky, "Notes on Exhibition Design," p. 62, and Bayer, "Aspects of Design of Exhibitions and Museums," p. 260.

43. Bayer cited some examples of early attempts to organize floorplans of exhibitions. One is particularly amusing: "In an exhibition in the newly opened Zeughaus, in Berlin, 1844, it was evidently deemed necessary to guide the visiting public along a predetermined path. Lacking other means in the rigidly symmetrical museum building, the visitors were moved in the desired direction in a Prussian soldierly fashion, by spoken commands" (Bayer, "Aspects of Design of Exhibitions and Museums," p. 258).

44. Rudofsky, "Notes on Exhibition Design," p. 63.

45. Bayer, "Aspects of Design of Exhibitions and Museums," p. 267.

46. Herbert Bayer, Unpublished notes on "10 tinker toys to play with," a memo in his personal files. Also see Bayer, "Aspects of Design of Exhibitions and Museums."

47. Others used innovative display techniques here, but no one was more visible than Bayer with his series of Museum of Modern Art designs and with his energy in presenting his ideas in print. In discussing Bayer's avant-garde display in America, one author has stated, "Of the handful of exhibition designers . . . few have taken the trouble to record their findings. The notable exception is Herbert Bayer, pioneer and leading exponent of the art of exhibition design" (Rudofsky, p. 62).

48. One such study, by a Yale psychologist, is Arthur W. Melton, "Problems of Installation in Museums of Art," *Studies in Museum Education* (Washington, D.C.: The American Association of Museums, New Series, Number 14, 1935).

49. Good timing also contributed to Bayer's success in America. Bayer had passed up an earlier opportunity to come to the United States because he had felt that there would have been no place for him in America at that time. He was probably correct; most likely his ideas would have been too unconventional to have been accepted in the 1920s.

50. Not only did the American critics see nothing here which related to Bayer's installations, they also did not make reference to display techniques being practiced in Europe; this omission indicates a lack of knowledge here of avant-garde developments in European exhibition design.

51. George Nelson, *Display* (New York: Whitney, 1953), p. 108.

52. Another New York installation of the same time, far more daring, was Marcel Duchamp's "Sixteen Miles of String" for the exhibition of the "First Papers of Surrealism," 1942. But at the Armory building on Madison Avenue, and for a specialized audience, this exhibition received far less national exposure. (See p. 131.)

Chapter 8 Environmental Design

1. Herbert Bayer, Unpublished "future lecture 'on environment,'" 1972, p. 4.

2. Ibid.

3. Ibid., p. 1.

4. Ibid. Bayer also discussed his ideas for light projects in a sketchbook entry of 1943?, pp. 19–20.

5. Bayer's Unpublished "future lecture," pp. 1–2.

6. See Bayer's *grass mound,* Aspen, Colorado, 1955.

7. See Bayer's project for Mill Creek Canyon Park, Kent, Washington, 1979.

8. In July 1983, Bayer attended the unveiling of Noguchi's sculpture at Little Tokyo, Los Angeles. Despite frail health, Bayer insisted on making the two-hour car trip because of his great respect for and friendship with Noguchi.

9. Actually it was Elizabeth Paepcke who had first discovered Aspen in the winter of 1939 while seeking what were then very primitive skiing opportunities with friends, Mr. and Mrs. Curtis Munson (James Sloan Allen, *The Romance of Commerce and Culture. Capitalism, Modernism, and the Chicago-Aspen Crusade for Cultural Reform* [Chicago: University of Chicago Press, 1983], pp. 114–15).

10. Herbert Bayer, "a statement for an individual way of life," *Print* 16 (May–June 1962): 29.

11. Allen, *The Romance of Commerce and Culture,* pp. 114–31.

12. Bayer, "a statement for an individual way of life," p. 19.

13. Although Aspen's population may have reached 15,000 during the "boom" years of mining (1892–93), by the 1940s the town's population was under 800 (Joel Katz, *Aspen Visible, A Guidebook to the Natural and Manmade Environment in and Around Aspen, Colorado* [Aspen: International Design Conference, 1972], p. 14).

14. Bayer, "a statement for an individual way of life," p. 30.

15. Bayer received his architectural license in 1960.

16. Bayer, *herbert bayer, painter, designer, architect,* p. 112.

17. By 1947 Paepcke had entered into partnership with Friedl Pfeifer, an Austrian ski instructor who had been stationed at nearby Camp Hale, in Leadville, during World War II. Together they formed the Aspen Skiing Corporation in 1947 (Joel Katz, *Aspen Visible,* p. 7).

18. Bayer regretted that there was never enough money to buy up more land early; also, Walter Paepcke was not amenable to committing himself to long-term plans.

19. Bayer, *herbert bayer, painter, designer, architect,* p. 13.

20. Bayer, p. 112.

21. Herbert Bayer, Unpublished lecture, "art in the modern world," delivered at the Aspen Institute, 27 August 1974, p. 6.

22. Bayer, Unpublished lecture, "art in the modern world," p. 14.

23. Herbert Bayer, Unpublished "fragmentary thoughts for 1962 aspen design conference," 1961, p. 4.

24. In fact, Bayer's influence has been international in scope; it also has not hurt his stature that Aspen Institute branches have been established at Berlin, Tokyo, and Honolulu. He lectured at these locations on numerous occasions.

25. "Hexagonal Seminar Building," *Architectural Forum* 101 (July 1954): 106.

26. One structure, the central building of the Aspen Meadows Complex, with restaurants, lounges, and offices, does incorporate local stone. For the author, the building is less successful than others at the site since it is much more ordinary and might easily have been constructed at any number of other mountain towns.

27. The *kaleidoscreen* at Aspen was produced under commission from the Aluminum Company of America (ALCOA) as a prototype which explored new uses of aluminum under ALCOA's "Forecast Program," a consideration of future uses of aluminum.

28. Herbert Bayer, Curriculum Vita, November 1983.

29. There are other outdoor structures at Aspen, outside of the Aspen Institute itself, which fit into the category of "environmental works." These include Bayer's brightly colored birdhouses for the wildlife of the mountains and the memorial sculpture to Walter Paepcke at the Aspen cemetery.

30. It would be almost twenty-five years later, in 1979, when Bayer would participate in the King County Arts Commission's "Earthworks: Land Reclamation as Sculpture."

31. "Aspen: New Shapes in the Mountains," *Architectural Forum* 105 (July 1956): 151.

32. Herbert Bayer, Unpublished letter to Margaret Sheffield, Rome, Italy, 3 August 1978.

33. Cohen, Interviews with Herbert Bayer, p. 131.

34. Bayer commented on works by earthwork artists, such as Smithson and Heizer: "The difference between scratching or painting on a canvas and an abstract design in the desert seems to be only in its size, location, and material" (Herbert Bayer, unpublished future lecture "on environment," p. 3). (Published in German in *Herbert Bayer, Das künstlerische Werk 1918–1938*, p. 35.)

35. Bayer was pleased that the original format of placing all sculptures at the Olympic Village was changed in order to place them along the highway route. As he stated, the original plan "would have resulted in yet another outdoor museum, only of gigantic forms." The new plan "raised new and challenging problems" (Herbert Bayer, Unpublished statement "on mexican sculpture, construction for route of friendship, mexico, 1968," p. 2). Bayer's last sculptural commission prior to his death was a double-scale *articulated wall*, visible from the highway in Denver, Colorado. This work was dedicated in June 1985.

36. Ibid., p. 2.

37. Bayer, Unpublished "future lecture, " p. 1. Part of this statement has been published in the German text cited above in note 34 but this particular paragraph was omitted.

38. Bayer, Unpublished statement "on mexican sculpture," p. 2.

39. Bayer, Unpublished "future lecture," p. 1 (German text, p. 33).

40. Bayer, Unpublished statement "on mexican sculpture," p. 3.

41. Bayer, Unpublished "future lecture," pp. 1–2 (German text, pp. 33–34).

42. Bayer, Unpublished "future lecture," p. 3.

43. All of these examples are illustrated in *Herbert Bayer, Das künstlerische Werk 1918–1938,* pp. 33–35.

44. It is hoped that more projects will be realized as money becomes available.

45. Deloris Tarzan, "Kent Finds Earthwork is Good Economics," *The Seattle Times,* Thursday, 2 September 1982, Section D, p. 1.

46. Although Smithson's work reclaiming land between the years 1971 and 1973 has been cited as a precedent for the Kent projects (Robert Hobbs, "Editor's Statement, Earthworks: Past and Present," *Art Journal* 42, No. 3 [Fall, 1982]: 193–94), it is unlikely that Smithson is a direct source for Bayer. If Smithson's example has been beneficial to the Kent project, surely it has been at another level, that of convincing the authorities that land reclamation as sculpture could be a viable solution.

47. The Breakers itself, as a unified site (once a former residence and now an ARCO executive training and conference center), could be thought of as a unified environment. But because of its corporate function, treatment of this complex will be reserved for the chapter on corporations, which follows.

48. Bayer's ideas are becoming known today both by way of Bayer's own designs and through those of younger artists who have experienced Bayer's Aspen.

Chapter 9 Corporate Projects

1. Herbert Bayer, Unpublished paper "on design" presented at the International Design Conference, Aspen, 1951.

2. Herbert Bayer Interview, in Hill and Cooper, *Dialogue with Photography,* pp. 129–30.

3. Bayer's basic beliefs did not change. Comparing his 1948 presentation in absentia for the Conference on Business and Art with his Ford-Unimark speech (1967), one sees virtually the same points made and conclusions drawn (unpublished paper read in Bayer's absence, Conference on Business and Art, Milwaukee Art Institute, December 1948; unpublished address to Ford-Unimark, Detroit, 1967.)

4. Container Corporation instituted companywide color standards and published a widely used color manual, *Color Harmony Manual,* which is described by Rosamund Frost as "the first attempt to standardize color in America" (Rosamund Frost, "This Business Ties Art into a Neat Package," *Art News* 44 [15–31 May 1945]: 13). The company's interest in color must have interested Bayer when he accepted a position there, given his prior interest in this subject.

5. Susan Black, ed., *The First Fifty Years, 1926–1976* (Chicago: Container Corporation of America, 1976), p. 7.

6. Bayer related Paepcke's reaction to the fact that Albert Schweitzer at first expressed doubt that he could attend the Goethe Celebration in 1949. Bayer remembered that Paepcke was undaunted, convinced that he could persuade Schweitzer to come to Aspen. Paepcke's feeling was that "everybody has a weakness or a price" (Herbert Bayer,

"walter paepcke," *Print* 14 [September 1960]: 34). Schweitzer's visit was nationally acclaimed, helping Aspen become known.

7. Gwen Chanzit, Interview with John Massey, June 1982.

8. Bayer himself had seen Cassandre's Container Corporation advertisements in *Gebrauchsgraphik* just as he was leaving Europe (Herbert Bayer, Unpublished "notes sent to *print*," 1960, p. 1).

9. Black, *The First Fifty Years*, p. 30.

10. Egbert Jacobson was Container Corporation's art director then and it was he who chose the works and wrote an essay for the catalog.

11. Walter P. Paepcke, "Art in Industry," introduction to catalog, *Modern Art in Advertising, An Exhbition of Designs for Container Corporation of America* (Chicago: Art Institute of Chicago, 1945), n.p.

12. Paepcke knew Gropius even before Bayer's arrival in America. They conferred on the future of Moholy-Nagy's New Bauhaus and Gropius visited Aspen in August 1945, almost five months before Bayer (Bayer had also been invited in August, but illness prevented him from making that visit).

13. In 1946 Paepcke also moved up the corporate structure from president to chairman, and the design laboratory was established under the direction of Albert Kner, as the company looked to self-service merchandising where package design plays an important role in buying incentive (Black, *The First Fifty Years*, p. 50). The design laboratory was primarily concerned with the design of products and consumer acceptance, while the department of design shaped the image of the company itself.

14. Bayer, Unpublished "notes sent to *print*," p. 7.

15. The N. W. Ayers advertising company administered the campaign.

16. Herbert Bayer, "design as an expression of industry," in Bayer, *herbert bayer, painter, designer, architect*, p. 87.

17. Herbert Bayer, Unpublished lecture on the "great ideas campaign," delivered in Denver, 1961?, p. 6.

18. The committee included members of the company, Mrs. Paepcke, and representatives of the N. W. Ayers agency (Herbert Bayer, typescript of "Preface to Container Corporation of America," *Great Ideas of Western Man* [Chicago: Container Corporation of America, July 1975]).

19. Bayer; Ralph Eckerstrom, director of advertising and design; people of the N. W. Ayer's agency, notably Charles T. Coiner. (Bayer, Unpublished lecture on the "great ideas campaign," p. 8.)

20. This collection was given to the National Museum of American Art, Smithsonian Institution, in 1985. Container Corporation was sold to the Jefferson Smurfit Corporation of Alton, Illinois in 1986.

21. In assessing the number of readers of an advertisement, the Starch Reports rated advertisements as "seen," "seen and associated," and "read most." According to Bayer, "cca advertisements have consistently ranked among the first ten for 'read most' among

the seventy or more full and 2/3 page advertisements in *time,* the most widely circulated of the national publications in which they appear'' (Herbert Bayer, Unpublished essay "design as an expression of industry," 1962, p. 12). Note: Other versions of this essay have been published, but none includes this material.

22. Black, *The First Fifty Years,* pp. 30–31.

23. Bayer's interest in nature as his primary source of imagery, with the human figure almost totally absent, may be attributed to his lifelong attachment to the natural world, especially to mountains. Bayer also attributed this predilection to the fact that he never received formal art training, which would have included life drawing (Cohen, Interviews with Herbert Bayer, p. 189).

24. J. F. M., "Bayer's Geo-Graphics," *Industrial Design* 1 (February 1954): 95.

25. Herbert Bayer, Unpublished "notes on the *world geo-graphic atlas,*" 1953, p. 9.

26. For example, in 1951 Bayer developed designs and packaging for Noreen, a hair product company whose owners, the Baums, he met in Aspen. In 1953 he designed a corporate graphic style and gas stations for Wilshire Oil Company, a West Coast oil company owned by Robert O. Anderson. Anderson sold the company (which Bayer noted grew tremendously *after* the implementation of the new designs) before joining the Atlantic Refining Company, which he directed to its present magnitude as the Atlantic Richfield Company.

27. Herbert Bayer, Unpublished Curriculum Vita, 1983, p. 2.

28. Herbert Bayer, Unpublished letter to John McCormick, 1 August 1978.

29. Bayer collaborated on this large project with John Massey (later Container Corporation's director of visual communication). Massey, who in the late 1960s was director of the Center for Advanced Research in Design, Chicago, created the ARCO "spark" logo.

30. *Atlantic Richfield: Art and Design,* p. 4.

31. Early in 1984 Robert O. Anderson retired as ARCO's chairman of the board. At this time the entire American oil business was feeling the effects of a soft market. The immediate result was a drastically reduced commitment to the arts, including the closing of the highly successful ARCO Center for the Visual Arts. It remains to be seen what the long-term effect will be.

32. Lesley Wenger, "Art, like Religion, Only Works If You Believe in It," *Currânt* 1 (February–March–April 1976): 25.

33. Herbert Bayer, Unpublished "proposal for beautification of the arco refinery, philadelphia," 12 December 1972.

34. Rex G. Goode, interior designer who collaborated with Bayer on the design of the fifty-first floor, repeating Anderson's directives ("Masters of Arts," *Interior Design* 49 [August 1978]: 140). Morganelli-Heumann was the interior design firm for the rest of the building (Wenger, "Art, like Religion," p. 25.)

35. Wenger, p. 25.

36. Herbert Bayer, Unpublished letter to John McCormick, 1 August 1978, p. 2.

37. It is interesting that in Philip Meggs's *A History of Graphic Design,* Bayer is mentioned as a consultant, never as the chairman of design at Container Corporation. The art directors Jacobson, Eckerstrom, and Massey are named; Bayer's contributions are mainly found in another section dealing with Aspen. Perhaps this omission is simply a shortcoming, but it may also be indicative of Bayer's reputation and the relative importance of Aspen to his career.

Chapter 10 The Anthologies

1. Although some similar themes appear in the anthologies, they are combined in new ways; also they appear more as references to Bayer's earlier work than as the original subject's orientation to the world.

2. Even late in life, when Bayer repeatedly requested fewer responsibilities at Atlantic Richfield (requests which according to Bayer often were met with a deaf ear), he still found himself designing numerous ARCO complexes, as well as a plethora of projects brought to him from others. Each time he determined to reject all projects that would keep him from painting, a challenging, interesting proposal presented itself.

3. Even a subtle effect is difficult to declare, since his style already had begun to be transformed while he was still in Aspen, in works such as *potpourri géométrique,* 1973 (Cohen, Interviews with Herbert Bayer, p. 122).

4. Bayer, *herbert bayer, painter, designer, architect,* p. 185.

5. Herbert Bayer, *world geo-graphic atlas* (Chicago: Container Corporation of America, 1953).

6. It is interesting that Bayer chose to include a capital "N" rather than the small "n" that would be his own trademark. This fact supports the idea that the "N" is simply a piece from a commercial typeface set.

7. In addition to the *walk in space painting* that eventually was realized in full scale at the Breakers, in 1987 a large Bayer gate was erected on the beach at Santa Barbara.

8. Herbert Bayer, Unpublished statement on "the gate," January 1972, p. 2.

9. It should be pointed out that although Bayer continually created compositions influenced by Bauhaus concerns, he also produced, simultaneously, private romantic works such as the pictures of owls and butterflies. These romantic works, however, were not meant for exhibition. In a discussion with the author, cited previously, Bayer stated that these were almost embarrassingly personal and only late in life were they first exhibited.

10. Bayer kept a geometry notebook from his school days to which he continually referred (Cohen, Interview with Herbert Bayer, pp. 15–16 and 196–98). Though his own geometry notebooks were lost, Bayer considered them important enough that he used two given to him by a former classmate.

11. For a discussion of these murals, see chapter 1.

12. Herbert Bayer, Unpublished sketchbook, 1956 (section labeled "shadows"), p. 2.

13. As an example, the sketch which surely serves as the source for the aspen "eyed" photomontage of 1959, *in search of times past,* is found in Bayer's sketchbook of 1947.

Next to the sketch Bayer wrote, "fotograph aspen trees with eyes. superimpose two negatives in order to fill the *whole space* with trees. no background around trees should be visible" (Herbert Bayer, Unpublished sketchbook, 1947, n.p.).

14. Bayer, *herbert bayer, painter, designer, architect,* p. 12.

Epilogue

1. Eventually these ideas have been disseminated throughout the world, with international branches of the Aspen Institute now established.

2. Wolf von Eckardt, "What Ever Became of the Future?," *Time* (27 June 1983): 58.

Bibliography

PRIMARY SOURCES

Published Writings by Herbert Bayer

Bayer, Herbert. "Aspects of Design of Exhibitions and Museums." *Curator* 4 (1961): 257–88.
_____. "basic alfabet." *Print* 18 (May–June 1964): 16–19.
_____. "a contribution to book typography" (written 1936). *Print* 13 (March–April 1959): 58–61.
_____. "contribution toward rules of advertising design." *PM Magazine* (December 1939–January 1940): 6–16.
_____. "Künstlerische Gestaltung—ein Ausdrucksmittel der Industrie"/"Design as an Expression of Industry." *Gebrauchsgraphik* 23 (1952): 57–60.
_____. "design, designer and industry." *Magazine of Art* 44 (December 1951): 324–25.
_____. "fundamentals of exhibition design." *PM Magazine* (December 1939–January 1940): 17–26.
_____. "goethe and the contemporary artist." *College Art Journal* 11 (Fall 1951): 37–40.
_____. *herbert bayer, book of drawings*. Chicago: Theobald, 1961.
_____. *herbert bayer, painter, designer, architect*. New York: Reinhold, 1967.
_____. "my position as a non scientist." In "Personality in Print." *Print* 9 (July–August 1955): 44.
_____. "on typography." *Print* 14 (January–February 1960): 86–88.
_____. "preface." In Erberto Carboni, *Esposizioni e Mostre*. Milan: Silvana Editore, 1954.
_____. "a statement for an individual way of life." *Print* 16 (May–June 1962): 26–33.
_____. "towards the book of the future." In Marshall Lee, ed., *Books for Our Time*. New York: Oxford University Press, 1951.
_____. "towards a universal type." *Industrial Arts* 1 (London) (1936).
_____. "towards a universal type." *PM Magazine* (December 1939–January 1940): 27–32.
_____. "typography and design." *Concepts of the Bauhaus: The Busch-Reisinger Collection*. Cambridge, Mass., 1971: 99–101.
_____. "un contributo alla tipografia del libro." *Linea Grafica* (Milan) (March–April 1960).
_____. "walter paepcke." *Print* 14 (September 1960): 34–36.
_____, ed. *world geo-graphic atlas*. Chicago: Container Corporation of America, 1953.
Bayer, Herbert, Gropius, Walter, and Gropius, Ise, eds. *Bauhaus 1919–1928*. New York: Museum of Modern Art, 1938.

Interviews

Chanzit, Gwen. Interviews with Herbert Bayer.
 Montecito, California. March 1981.
 Denver, Colorado. August 1982.
 Montecito, California. July 1983.
 Denver, Colorado. October 1983.
_____. Interview with John Massey, Director of Visual Communication, Container Corporation of America. Chicago, Illinois. June 1983.
Cohen, Arthur A. Interviews with Herbert Bayer. Oral History Program. Archives of American Art/Smithsonian Institution, San Francisco, California. Montecito, California. 3–6 November 1981. (Citations are to a preliminary, unedited transcript provided to the author.)

Unpublished Letters

Barr, Alfred. Letter to Herbert Bayer. 5 November 1937. Museum of Modern Art, New York.
_____. Letter to Herbert Bayer. 11 November 1938. Museum of Modern Art, New York.
_____. Letter to Leonard Cox. 8 January 1939. Museum of Modern Art, New York.
_____. Letter to Walter Gropius. 15 September 1938. Museum of Modern Art, New York.
_____. Letter to Walter Gropius. 10 December 1938. Museum of Modern Art, New York.
_____. Letter to Walter Gropius. 3 March 1939. Museum of Modern Art, New York.
_____. Letter to Lewis Mumford. 8 January 1939. Museum of Modern Art, New York.
_____. Letter to Natalie Swann. 4 January 1939. Museum of Modern Art, New York.
_____. Telegram to Herbert Bayer. December 1937. Museum of Modern Art, New York.
Bayer, Herbert. Letter to Alfred Barr. 23 October 1937. Museum of Modern Art, New York.
_____. Letter to Alfred Barr. 10 November 1938. Museum of Modern Art, New York.
_____. Letter to Felix Beltran. 29 September 1980. Herbert Bayer Collection and Archive. Denver Art Museum, Denver, Colorado.
_____. Letter to Yve-Alain Bois. 24 July 1970. Herbert Bayer Collection and Archive. Denver Art Museum, Denver, Colorado.
_____. Letter to Gwen Chanzit. 5 January 1981.
_____. Letter to Tim Gidal. 16 September 1977. Herbert Bayer Collection and Archive. Denver Art Museum, Denver, Colorado.
_____. Letter to W. F. Kieschnick. 16 March 1981. Herbert Bayer Collection and Archive. Denver Art Museum, Denver, Colorado.
_____. Letter to John McAndrew. 4 November 1937. Museum of Modern Art, New York.
_____. Letter to John McAndrew. 3 December 1937. Museum of Modern Art, New York.
_____. Letter to John McAndrew. 5 January 1938. Museum of Modern Art, New York.
_____. Letter to John McAndrew. 16 February 1938. Museum of Modern Art, New York.
_____. Letter to John McAndrew. 28 February 1938. Museum of Modern Art, New York.
_____. Letter to John McAndrew. 13 May 1938. Museum of Modern Art, New York.
_____. Letter to John McCormick. 1 August 1978. Herbert Bayer Collection and Archive. Denver Art Museum, Denver, Colorado.
_____. Letter to Patricia Moore. 13 October 1972. Herbert Bayer Collection and Archive. Denver Art Museum, Denver, Colorado.
_____. Letter to Walter Paepcke. 13 June 1945. Manuscript Collection. Library of the University of Illinois at the Chicago Circle Campus, Chicago, Illinois.

_____. Letter to Peter Schneider. 14 March 1979. Herbert Bayer Collection and Archive. Denver Art Museum, Denver, Colorado.

_____. Letter to Margaret Sheffield. 3 August 1978. Herbert Bayer Collection and Archive. Denver Art Museum, Denver, Colorado.

_____. Letter to Monroe Wheeler. 27 October 1943. Herbert Bayer Collection and Archive. Denver Art Museum, Denver, Colorado.

Gidal, Tim. Letter to Herbert Bayer. 26 August 1977. Herbert Bayer Collection and Archive. Denver Art Museum, Denver, Colorado.

Gropius, Walter. Letter to Alfred Barr. 15 December 1938. Museum of Modern Art, New York.

_____. Letter to Herbert Bayer. 22 October 1938. Museum of Modern Art, New York.

_____. Letter to Herbert Bayer. 15 December 1938. Museum of Modern Art, New York.

McAndrew, John. Letter to Herbert Bayer. 1 December 1937. Museum of Modern Art, New York.

_____. Letter to Peyton Boswell, Jr. 6 January 1939. Museum of Modern Art, New York.

_____. Telegram to Herbert Bayer. ca. January 1938. Museum of Modern Art, New York.

Mumford, Lewis. Letter to Alfred Barr. 16 January 1939. Museum of Modern Art, New York.

Paepcke, Walter. Letter to Herbert Bayer. 15 June 1945. Manuscript Collection. Library of the University of Illinois at the Chicago Circle Campus, Chicago, Illinois.

_____. Letter to Walter Gropius. 15 June 1945. Manuscript Collection. Library of the University of Illinois at the Chicago Circle Campus, Chicago, Illinois.

_____. Letter to Jesse A. Jacobs. 20 December 1944. Manuscript Collection. Library of the University of Illinois at the Chicago Circle Campus, Chicago, Illinois.

_____. Letter to Earl Kribben. 20 September 1950. Manuscript Collection. Library of the University of Illinois at the Chicago Circle Campus, Chicago, Illinois.

Read, Herbert. Letter to David Stevens. 18 October 1946. Manuscript Collection. Library of the University of Illinois at the Chicago Circle Campus. Chicago, Illinois.

Archives and Collections

Herbert Bayer Studio, Montecito, California

Bayer, Herbert. Curriculum Vita. November 1983.

Unpublished sketchbooks. 1930–85. (All but the most recent sketchbook are available on microfilm in the Herbert Bayer Collection and Archive. Denver Art Museum, Denver, Colorado.)

Manuscript Collection, Library of the University of Illinois at the
Chicago Circle Campus, Chicago, Illinois

"The Institute of Design."

"School of Design—For Living."

Wingler, Hans M. "Is the Bauhaus Relevant Today?." Address delivered at the Illinois Institute of Technology. 20 April 1967.

Herbert Bayer Collection and Archive, Denver Art Museum,
Denver, Colorado

Transcript manuscripts by Herbert Bayer. (Some of these manuscripts have subsequently been published in various versions of the typed originals given to the Herbert Bayer Collection and Archive by the artist. These manuscripts are arranged chronologically.)

"on stationery." 1926.

"fifty books show." 10 February 1939.

"the poster." Lecture delivered at A-D gallery, New York City. Wednesday, 2 October 1939.

"notes given to alexander dorner for his writings about Bayer's exhibition design." c. 1940.

"notes for design class." New York City. 1940.

"plan for twelve courses at the advertising guild." New York City. 1940.

Lecture delivered at the Art Directors' Club. Philadelphia. 26 February 1940.

"presentation and display." Lecture delivered at N.Y.U. 5 December 1940.

Presentation for SKOL (Gallowhur Products). 28 May 1945.

Paper read in Bayer's absence at the Conference on Business and Art. Milwaukee Art Institute. December 1948.

"our world of color." Preliminary script for Container Corporation of America color film. 1949.

"excerpt on painting *verdure* from letter to *harvard crimson*." 8 November 1950.

"on the painting *verdure,* harvard university." 1950.

"on trademarks." For Egbert Jacobson, *Seven Designers Look at Trademark Design*. 1950.

"on design." Paper delivered at the International Design Conference. Aspen, Colorado. 1951.

"towards the book of the future." Written on the occasion of the exhibition "Books of Our Time." 1951.

Paper presented at Container Corporation's Conference on the Role of Design in Business Today. June 1951.

"design analysis and plan for noreen inc." September 1951.

Lecture on *world geo-graphic atlas*. 1953.

Tape-recorded transcript from International Design Conference. Aspen, Colorado. 1953.

"on communication." Paper delivered at the International Design Conference. Aspen, Colorado. June 1955.

"culture in the u.s. government." 21 April 1958.

"statement on *blue architectural* 1959." 1959.

"typography usa." New York. 1959.

"education, the designer for the future." 1960.

"herbert bayer, a statement for an individual way of life" (for *Print*). 1960.

"design reviewed." Lecture delivered at World Design Conference. Tokyo. May 1960.

"notes sent to *print*." 1960.

"typografen unserer zeit." *Der Polygraph*. Frankfort. May 1960. (A version of this essay appears in English as "on typography," in Herbert Bayer, *herbert bayer, painter, designer, architect,* 1967.)

"fragmentary thoughts for 1962 conference." International Design Conference. Aspen, Colorado. 1961.

"great ideas campaign." Lecture delivered in Denver, Colorado. 1961?

"credo." 1962.

"design as an expression of industry" (for *Gebrauchsgraphik*). 1962.

"general statement." 1962.

"on environment." Paper delivered at International Design Conference. Aspen, Colorado. June 1962.

"notes for lecture on the great ideas." Knoxville, Tennessee. March 1963.

"exhibition design." Paper delivered at International Design Conference. Aspen, Colorado. 28 June 1963.

"the role of aesthetics in business." Lecture (translated from the German by Herbert Bayer) delivered in Berlin, Germany. 4 October 1963.

Keynote address. Art Directors Club. New York City. 27 May 1964.

Speech at Walter Paepcke Design Award Dinner. New York City. 29 October 1964.

"notes on harvard symposium 'communication through typography, prospects and problems.'" Carpenter Center for the Visual Arts. Harvard University. 15 January 1965.

"art in relation to our industrial society." Aspen Institute for Humanistic Studies. Aspen, Colorado. 14 July 1965.

Address delivered to Colorado Council on the Arts and Humanities. February 1967.

Address delivered to Ford-Unimark. Detroit. February 1967.

"general statement." 3 August 1967.

"*articulated wall* at 'route of friendship.' " Mexico City. 1968.

"on *articulated wall* sculpture, mexico olympics." 1968.

"aspects of environment." Lecture delivered at the University of Southern California. Santa Barbara, California. February 1969.

"total design." Lecture delivered at the University of Southern California. Santa Barbara. February 1969.

"observations on a series of paintings with linear motifs." 1970.

"on chromatic paintings." 12 October 1970.

"on paintings by vasarely and bayer." 1970.

"on 'soft form' paintings." 1970.

"art in relation to our industrial society." Paper delivered to University Club. Mexico City. 20 March 1970.

"statement on 'moving mountains' paintings." 1970.

"typography and graphic design." Lecture. Buenos Aires. August 1970.

Address delivered at opening of Bauhaus Exhibition. Tokyo, Japan. 5 February 1971.

"the new typography." For *Concepts of the Bauhaus.* April 1971.

"study to visually improve the arco refinery, philadelphia." 19 April 1971.

"the gate." January 1972.

"sculptures with prefabricated elements." January 1972.

"*double ascension* sculpture, arco plaza, los angeles." 22 February 1972.

"surf sculpture." April 1972.

"statement on wall hangings, tapestries." 12 June 1972.

Comments, End Session, Aspen Executive Seminar. Aspen, Colorado. 20 August–2 September 1972.

"environment." September 1972.

"proposal for beautification of the arco refinery, philadelphia." 12 December 1972.

Address at dedication of *double ascension* sculpture. Arco Plaza, Los Angeles. 30 January 1973.

Lecture at the Denver Art Museum. Denver, Colorado. 8 November 1973.

"environment." December 1973.

Remarks delivered on the occasion of the 25th Anniversary Celebration of the Aspen Institute for Humanistic Studies. Aspen, Colorado. 7 July 1974.

"art in a modern world." Inaugural lecture on becoming a fellow of the Aspen Institute. Aspen, Colorado. 27 August 1974.

"about fotomontages." 7 May 1975.

Preface to *Great Ideas of Western Man.* Container Corporation of America. Chicago, July 1975.

"typography and graphic communication." Lecture delivered at Dartmouth College. Hanover, New Hampshire. 9 December 1976.

Presentation of *chromatic gates* sculpture to Philadelphia City Art Commission. 21 December 1976.

Introduction to Seminar "The Role of Art and the Artist in Our Society" (to be read at the Aspen Institute, Berlin, 9–14 October 1977.) June 1977.

"statement on fibonacci progressions, remarks on the painting *two curves with progressive colors, 1977."* 1977.

"anaconda sculpture." 1978.

Address at Seminar on Financing the Future: The Arts. Aspen Institute for Humanistic Studies. Aspen, Colorado. 22–24 August 1978.

"statement on 'anthologies' paintings." 1978.

Address delivered at "bayer evening." Contemporary Arts Forum. Santa Barbara, California. 18 October 1979.

Address for the opening of the Herbert Bayer Archive. Denver Art Museum, Denver, Colorado. 31 October 1980.

"kaleidoscreen." n.d.

"note for container corporation of america stationery." n.d.

Notes in answer to an article, "ten tinker toys to plan with." n.d.

"statement on the wallpainting workshop at the bauhaus, weimar." n.d.

The Museum of Modern Art, New York City

Barr, Alfred. "Notes on the Reception of the Bauhaus Exhibition." 1938. Department of the Registrar.

Bauhaus Subject File. Museum of Modern Art Library.

Bayer, Herbert. Artist file. Museum of Modern Art Library. Includes press releases and statements by Josef Albers, Charles Coiner, Walter Gropius, Egbert G. Jacobson, László Moholy-Nagy, and James Johnson Sweeney.

C/E File. "Airways to Peace." Museum of Modern Art Library.

_____. "Bauhaus 1919–1928." Museum of Modern Art Library.

_____. "Road to Victory." Museum of Modern Art Library.

Exhibition Department Records, including memoranda, press releases, organizational notes and charts, exhibition checklists, correspondence, etc.

Photography Department Records, including memoranda, press releases, organizational notes and charts, exhibition checklists, correspondence, etc.

Registrar's Department Records, including memoranda, press releases, organizational notes and charts, exhibition checklists, correspondence, etc.

SECONDARY SOURCES

"About Herbert Bayer." Press release at dedication of *double ascension*. Los Angeles, January 1973.

"Across the Line." *Time* (9 March 1953): 68.

"Ad Aspen, Colorado." *Domus* (Milan) (February 1958):4–8.

ADCC Record of Advertising Art, a Record of the Exhibition of Advertising Art Sponsored by the Art Directors Club of Chicago and Presented at the Chicago Art Institute. Chicago: Kroch, 1944.

Ades, Dawn. *Photomontage.* New York: Pantheon, 1976.

"Airways to Peace, An Exhibition of Geography For the Future." *The Bulletin of the Museum of Modern Art* (New York) 11 (August 1943).

Allen, James Sloan. *The Romance of Commerce and Culture. Capitalism, Modernism, and the Chicago-Aspen Crusade for Cultural Reform.* Chicago: University of Chicago Press, 1983.

Aloi, Roberto. *Esposizioni—Architetture—Allestimenti.* Milano:Ulrico Hoepli Editore, 1960.

"The American Idea in Houses." *House and Garden* (February 1952): 43-57.

"Anaconda Tower." *Interior Design* 51 (May 1980): 212–21.

Atlantic Richfield: Art and Design. Los Angeles: Atlantic Richfield Company, 1981?

Atlantic Richfield Company. *The Meadows, A New Center for Innovative Chemistry.* n.d. (ca. 1982–83).

Bach, Otto. Introduction. *herbert bayer, a total concept.* Denver, Colorado: Denver Art Museum, 1973.

Banham, Reyner. *Theory and Design in the First Machine Age.* 2nd ed. London: The Architectural Press, 1960.

_____, ed. *The Aspen Papers, Twenty Years of Design Theory from the International Design Conference in Aspen.* New York: Praeger, 1974.

Barker, Nicolas. *Stanley Morison.* Cambridge, Mass.: Harvard University Press, 1972.

Barr, Alfred H., ed. *Fantastic Art, Dada, and Surrealism.* New York: Museum of Modern Art, 1936.

Barron, Stephanie and Tuchman, Maurice, eds. *The Avant-Garde in Russia, 1910–1930: New Perspectives.* Los Angeles: Museum Associates of the Los Angeles County Museum of Art, 1980.

Bevlin, Marjorie Elliott. *Design Through Discovery.* 2nd ed. New York: Holt, 1970.

Bigelow, M. S. *Alphabets and Design.* Minneapolis: Burgess, 1967.

Biggs, John R. *Basic Typography.* New York: Watson-Guptill, 1968.

Black, Carl, Jr. *Two Visions of Space, Herbert Bayer and Ingeborg Ten Haeff.* Yonkers, N.Y.: Hudson River Museum, 1969.

Black, Misha. "Design for Ceremony and Exhibitions." In *The Practice of Design.* London: Lund Humphries, 1946.

_____. "Exhibitions 1943–1944." In *Architects' Year Book.* London: A. Paul Elek, 1945.

_____, ed. *Exhibition Design.* London: Architectural Press, 1950.

Black, Susan, ed. *The First Fifty Years, 1926–1976.* Chicago: Container Corporation of America, 1976.

Bleicher, Edward. "Presentational." *Museum News* 46 (October 1967): 20–23.

Bojko, Szymon. *New Graphic Design in Revolutionary Russia.* New York: Praeger, 1972.

Booth-Clibborn, Edward and Baroni, Daniele. *The Language of Graphics.* New York: Abrams, 1980.

Breuning, Margaret. "Foreign Commercial Photographs Make Brillian Showing," *New York Evening Post.* March 7, 1931.

Brian, Doris. "Bayer Designs for Living." *Art News* 42 (15–31 March 1943): 20

"Buildings in Brief: Aspen: New Shapes in the Mountains." *Architectural Forum* 105 (July 1956): 148–51.

Bultman, Janis. "Many Paths From the Bauhaus, An Interview with Herbert Bayer." *Darkroom Photography* 3 (January–February 1981): 44–50.

Burt, Sir Cyril. *A Psychological Study of Typography.* London: The Syndics of the Cambridge University Press, 1959.

Burton, Lawrence. *A Choice over Our Heads.* Westfield, N.J.: Eastview, 1979.

Caplan, Ralph. Introduction and Text. *Design in America, Selected Work by Members of the Industrial Designers Society of America.* New York: McGraw, 1969.

Carmel, James H. *Exhibition Techniques.* New York: Reinhold, 1962.

Cauman, Samuel. *The Living Museum.* New York: New York University Press, 1958.

"Centre Sportif, Aspen, Colorado." *Aujourd'hui* 12 (April 1957): 66–69.

Chanzit, Gwen. *herbert bayer, early works on paper.* Denver, Colorado: Denver Art Museum, 1983.

_____. "Herbert Bayer, From Bauhaus to Aspen." *Artspace* 5 (December 1980): 32–39.

Chanzit, Gwen and Vanderlip, Dianne. *the herbert bayer archive inaugural exhibition.* Denver, Colorado: Denver Art Museum, 1980.

Childs, Marquis. "The World of Walter Paepcke." *Horizon* 1 (September 1958): 96-103 and 133–34.

Clasen, Wolfgang. *Expositions, Exhibits, Industrial and Trade Fairs.* New York: Praeger, 1968.

Clay, Grady. "King County's Earthworks Symposium Breaking New Ground with Land Reclamation as Sculpture." *The Arts, Newsletter of the King County Arts Commission: Seattle* 8 (July 1979): 1–2.

Cleaver, James. *A History of Graphic Art.* New York: Greenwood Press, 1963.

Coffin, Patricia. "Aspen." *Look* (8 November 1949): 60–67.

Cohen, Arthur A. *Herbert Bayer, The Complete Work.* Cambridge, Mass.: MIT, 1984.

"Concrete and Marble among the Mountain Streams at Aspen." *Interiors* 116 (April 1957): 118–21.

Conklin, Groff. "World Geo-Graphic Atlas" in "Personality in Print." *Print* 9 (July–August 1955): 44–51.

Container Corporation of America. *Great Ideas of Western Man.* Chicago: Container Corporation of America, 1964.

"Corporate Decisions on Decor: Some Go It Alone, Some Don't." *The Wall Street Journal,* Wednesday, 24 September 1980: 27.

Criticism (editorial). *Industrial Design* 12 (April 1965): 31.

"Designer at Play, George Nelson Hits on an Oversized Tinker Toy for Grown Ups." *Interiors* 107 (March 1948): 80–89.

Ditmer, Joanne. "Herbert Bayer: The World Is His Canvas." *Denver Post, Empire Magazine,* 4 November 1973: 10–13.

Dorner, Alexander. *The Way beyond "Art"—The Work of Herbert Bayer.* New York: Wittenborn,1947.

Earthworks: Land Reclamation as Sculpture. Seattle: King County Arts Commission, 1979.

Eckhardt, Wolf von. "The Bauhaus." *Horizon* 4 (November 1961): 58–75.

_____. "Heraldry for the Industrial Age." *Time* (18 October 1982): 84–85.

_____. "Whatever Became of the Future? At Aspen, a Search for an Alternative to the Modernist Vision." *Time* (27 June 1983): 58.

El Lissitzky. New York: Pinacotheca, 1949.

"Elementare Typographie." *Typographische Mitteilungen.* Leipzig, 1925.

Elliott, David. Introduction. *El Lissitzky 1890–1941.* Oxford, England: Museum of Modern Art, 1977.

Ewing, Max. *Herbert Bayer, the Man and His Work.* A Film. Aspen, Colorado: Aspen Institute for Humanistic Studies, 1975.

Exhibition Techniques, A Summary of Exhibition Practice. New York: New York Museum of Science and Industry, 1940.

An Exhibition of Water Colors, Gouache, Serigraphs, Lithographs and Drawings Executed Within the Past Two Years by Herbert Bayer. Chicago: Baldwin Kingrey, November 1949.

"The Eyrie on Red Mountain: Bayer's Studio." *Interiors* 110 (June 1951): 88–93.

Farrell, John. "Interview with Master Artist and Designer Herbert Bayer." *Santa Barbara Magazine* (February–March 1980): 22–32 and 62–66.

Ferebee, Ann. *A History of Design from the Victorian Era to the Present.* New York: Van Nostrand Reinhold, 1980.

50 Jahre Bauhaus. Württembergischer Kunstverein, Stuttgart, 1968; Royal Academy of Arts, London, 1968; Stedelijk Museum, Amsterdam, 1968; Musée National d'Art Moderne, Paris,

1969; Illinois Institute of Technology, Chicago, 1969; Art Gallery of Toronto, Toronto, 1969; Pasadena Art Museum, Pasadena, California, 1970; Museo del Bellas Artes Buenos Aires, 1970; National Museum of Modern Art, Tokyo, 1971.

50 Years Bauhaus. Supplement. (See above for full citation.) 1968–71.

"Focus: Amity and Art: XIX Olympiad." *Architectural Forum* 129 (October 1968): 66–71.

Foote, Nancy. "Monument-Sculpture-Earthwork." *Artforum* 18 (October 1979): 32–37.

Forecast: New Scene Stealer: The Alcoa Kaleidoscreen. Pittsburgh, Penna.: Aluminum Company of America, n.d.

Franciscono, Marcel. *Walter Gropius and the Creation of the Bauhaus in Weimar: The Ideals and Artistic Theories of Its Founding Years.* Urbana: The Board of Trustees of the University of Illinois, 1971.

Frenzel, H. K. "Herbert Bayer." *Gebrauchsgraphik* (Berlin) 5 (1931): 2–19.

Frost, Rosamund. "It Pays to Advertise." *Art News* 42 (August–September 1943): 11–23 and 38–39.

_____. "This Business Ties Art into a Neat Package." *Art News* 44 (15–31 May 1945): 13.

Fulton, Robert E., Jr. "Atlas." *Saturday Review* (20 March 1954): 37.

Gardner, James and Heller, Caroline. *Exhibition and Display.* New York: F. W. Dodge, 1960.

Gebhard, David. Foreword to *herbert bayer, paintings, architecture, graphics.* Roswell, N.M.: Roswell Museum and Art Center, 21 January–2 March 1962.

Gidal, Tim N. *Modern Photojournalism: Origin and Evolution, 1910–1933.* English translation by Maureen Oberli-Turner. New York: Macmillan, 1973.

Giedion, Siegfried. "Herbert Bayer und die Werbung in Amerika/Herbert Bayer and Advertising in the U.S.A." *Graphis* 6 (October–November–December 1945): 348–58 and 422–24.

Gluck, Felix. *World Graphic Design, Fifty Years of Advertising.* London: Studio Vista Ltd., 1968.

Glueck, Grace. "Revealing the Painterly Side of an Eclectic Artist." *New York Times,* Art Section, Sunday, 21 October 1984: 37 and 42.

Goeritz, Mathias. "Advertencia sobre y para Herbert Bayer." *Arquitectura Mexico* 107 (1972): 220–31.

Gowans, Alan. *The Unchanging Arts.* Philadelphia: Lippincott, 1971.

Grannis, Chandler B. *Heritage of the Graphic Arts, A Selection of Lectures Delivered at Gallery 303, New York City Under the Direction of Dr. Robert L. Leslie.* New York: Bowker, 1972.

Graphic Forms, the Arts as Related to the Book. Cambridge, Mass.: The President and Fellows of Harvard College, 1949.

Green, Gloria. "City of Kent Approves Herbert Bayer's Earthwork Design." *The Arts, Newsletter of the King County Arts Commission: Seattle* 9 (June 1980): 1 and 4–5.

Grote, Ludwig. Foreword. *Herbert Bayer.* London: Marlborough Fine Art Ltd., 1968.

"habitation de l'architecte herbert bayer à aspen, colorado." *Aujourd'hui* 36 (February 1966): 48.

[W.A.H.] "Künstler von Weltruf im Dienst der Werbung"/World-Famed Artist in the Service of Advertising." *Graphis* 1 (September–October 1944).

Hahn, Peter. "Herbert Bayer, zur Einführung," in *herbert bayer, das druckgrafische werk bis 1971.* Berlin: Bauhaus-Archiv, 1974.

Hambidge, Jay. *The Elements of Dynamic Symmetry.* New York: Dover, 1967. Reprinted from "The Diagonal," 1919, by Yale University Press.

Hardt, Hanno and Ohrn, Karin B. "The Eyes of the Proletariat: The Worker-Photography Movement in Weimar Germany." *Studies in Visual Communication* 7 (Summer 1981): 46–57.

"Harvard Builds a Graduate Yard." *Architectural Forum* 93 (December 1950): 62–71.

"Health Buildings: Four New Types." *Architectural Forum* 107 (July 1957): 124–34.

"Herbert Bayer." Sonderdruck der *Gebrauchsgraphik*. Nr. 5, 8 (1931): 1–19.

"Herbert Bayer." Sonderdruck der *Gebrauchsgraphik*. Nr. 6, 15 (1938): 1–16.

Herbert Bayer, Das künstlerische Werk 1919–1938. Exhibition catalog with texts by Hans Wingler, Magdalena Droste, Stanislaus von Moos, Eckhard Neumann and Ute Brüning. Berlin: Bauhaus-Archiv, 1982.

Herbert Bayer: Kunst und Design in Amerika 1938–1985. Exhibition catalog with texts by Eckhard Neumann and Magdalena Droste. Berlin: Bauhaus-Archiv, 1986.

"Herbert Bayer: Design as an Expression of Industry." *Gebrauchsgraphik*. (Munich) 9 (1952): 57–60.

"Herbert Bayer: International Design Conference Paper." *Print* 9 (July–August 1955): 12.

"Herbert Bayer, la casa e le opere." *Domus* 306 (1955): 11–18.

"Herbert Bayer y Fritz Benedict, Aspen Meadows, Colorado." *Revista Informes de la Construcción*. Madrid: Instituto Técnico de la Construcción y Del Cemento, June–July 1958.

herbert bayer, recent paintings. New York: Marlborough Gallery, 1982.

herbert bayer, recent works. New York: Marlborough Gallery, 1979.

"Hexagonal Seminar Building." *Architectural Forum* 101 (July 1954): 106–07.

"Highlights from Past Aspen Conferences." *Print* 14 (September 1960): 47–55.

Hill, Paul and Cooper, Thomas. "Herbert Bayer Interview" (November 1977). In *Dialogue With Photography*. New York: Farrar, 1979.

Hirschfeld. "Umbo-Herbert Bayer." *Gebrauchsgraphik* (Berlin) 7 (1930): 44–51.

Hobbs, Robert. "Editor's Statement, Earthworks: Past and Present." *Art Journal* 42 (Fall 1982): 191–94.

Hofmann, Armin. *Graphic Design Manual*. New York: Reinhold, 1965.

Hölscher, Eberhard. "Herbert Bayer." *Gebrauchsgraphik* (April 1936): 18–28.

_____. "Herbert Bayer." *Gebrauchsgraphik* (Berlin) 15 (1938): 2–16.

Hornung, Clarence P. and Johnson, Fridolf. *200 Years of American Graphic Art*. New York: George Braziller, 1976.

"Hotels: The Aspen Meadows Development." *Interiors* 115 (March 1956): 87–89.

Hurlburt, Allen. *Publication Design, A Guide to Page Layout, Typography, Format and Style*. New York: Van Nostrand Reinhold, 1971.

Hyman, Sidney. *The Aspen Idea*. Norman: University of Oklahoma Press, 1975.

Imhof, E. "World Geo-Graphic Atlas." *Graphis* (Zurich) 11 (1955): 428–33.

J. F. M. "Bayer's Geo-graphics." *Industrial Design* 1 (February 1954): 94–97.

Jacobson, Egbert. Introduction. "Personality in Print: Herbert Bayer." *Print* 9 (July–August 1955): 33–51.

_____, ed. *Modern Art in Advertising*. Chicago: Container Corporation of America, 1946.

_____, ed. *Seven Designers Look at Trademark Design*. Chicago: Paul Theobald, 1952.

Jenkins, Nicholas. *Photo Graphics, Photographic Techniques for Design*. London: Studio Vista; New York: Van Nostrand, 1973.

Kaleidoscreen Prospectus. Aluminum Company of America, n.d.

Kamekura, Yusaku. "Herbert Bayer." *Idea* (Tokyo) 2 (March 1955): 2–17.

Kandinsky, Wassily. *Concerning the Spiritual in Art*. Translated and with an introduction by M. T. H. Sadler. New York: Dover, 1977.

Katz, Joel. *Aspen Visible, A Guidebook to the Natural and Manmade Environment in and Around Aspen, Colorado*. Aspen: International Design Conference, 1972.

Kepes, Gyorgy. *Language of Vision*. Chicago: Paul Theobald, 1944.

Kraus, H. Felix. "Herbert Bayer—Architect and Artist." *Art and Industry* 33 (July 1942): 9–13.

Kuh, Katherine. "Explaining Art Visually." *Museum* (Paris) 1 (December 1948): 148–53 and 214.

Lane, Bradley. "Noreen. Integrated Design." *Advertising Requirements* (1955).

Lang, Rudolph. *Win Place and Show, Effective Business Exhibiting.* New York: Oceana, 1959.

Lee, Marshall, ed. *Books for Our Time.* New York: Oxford University Press, 1951.

Leonard, R. L. and Glassgold, C. A., eds. *Modern American Design.* New York: Ives Washburn, 1930.

Levy, Julien. "From a Portfolio of Photomontages by Herbert Bayer." *Coronet* 7 (January 1940): 30–37.

Lewis, John. *Typography, Basic Principles, Influences and Trends since the 19th Century.* London: Studio Vista; New York: Reinhold, 1966.

———. *Typography: Design and Practice.* New York: Taplinger, 1978.

Lindbeck, John. *Design Textbook.* Bloomington, Ill. McKnight and McKnight, 1963.

Lippincott, J. Gordon. *Design for Business.* Chicago: Paul Theobald, 1947.

Lissitzky-Küppers, Sophie. *El Lissitzky, Life, Letters, Texts.* London: Thames and Hudson, 1968.

Lohse, Bernd. "Photo-Journalism: The Legendary Twenties." *Camera* (Lucerne) (April 1967): 5–23.

Lohse, Richard. "Der Einfluss der Modernen Kunst auf die zeitgenössische Grafik/The Influence of Modern Art on Contemporary Graphic Design/L'Influence de l'art moderne sur la graphique contemporaine." *Neue Graphik/New Graphic Design/Graphisme Actuel* (Zurich) 1 (1958).

———. *Neue Ausstellungsgestaltung (New Designs in Exhibitions).* Erlenbach-Zürich: Verlag für Architektur, 1953.

Lucie-Smith, Edward. *A History of Industrial Design.* New York: Van Nostrand Reinhold, 1983.

Luckhurst, Kenneth W. *The Story of Exhibitions.* New York: Studio Publications, 1951.

"'Man and Clay,' Ceramic Exhibition at the Walker Art Center Is a Forceful Demonstration of the Art of Display." *Interiors* 108 (November 1948): 110–13.

Mansbach, Steven A. *Visions of Totality, László Moholy-Nagy, Theo Van Doesburg, and El Lissitzky.* Ann Arbor: University Microfilms International, 1978.

Margolin, Victor, Brichta, Ira, and Brichta, Vivian. *The Promise and the Product, 200 Years of American Advertising Posters.* New York: Macmillan, 1979.

"Masters of Arts." *Interior Design* 49 (August 1978): 140–51.

McAndrew, John. "Bauhaus Exhibition." *The Bulletin of the Museum of Modern Art* (New York) 6 (December 1938).

McLean, Ruari. *Modern Book Design from William Morris to the Present Day.* London: Faber and Faber, 1958.

Meggs, Philip B. *A History of Graphic Design.* New York: Van Nostrand Reinhold, 1983.

Melton, Arthur W. "Problems of Installation in Museums of Art." *Studies in Museum Education.* Ed. Edward S. Robinson. Washington, D.C.: The American Association of Museums, New Series, Number 14, 1935.

Middleton, Michael. *Group Practice in Design.* New York: Braziller, 1969.

"Modern Art Gets Down to Business. Herbert Bayer Uses New Method in Design of Brochures to Announce Forthcoming Berlin Exhibition." *Commercial Art and Industry* (London) 18 (April 1935): 156–61.

Modern Art in Advertising, An Exhibition of Designs for Container Corporation of America. Chicago: Art Institute of Chicago, 1945.

Moholy-Nagy, László. *Vision in Motion.* Chicago: Paul Theobald, 1947.

———, ed. *Staatliches Bauhaus in Weimar 1919–1923.* Weimar, Munich, Berlin, 1923.

Moholy-Nagy, Sibyl. *Moholy-Nagy, Experiment in Totality.* New York: Harper, 1950.

Morris, Robert. In *Earthworks: Land Reclamation as Sculpture.* Ed. Richard Hess. Seattle, Wash.: Seattle Art Museum, 1979.

Müller-Brockmann, Josef. "Herbert Bayer: The Bauhaus Tradition." *Print* 23 (January–February 1969): 40–44.

_____. *A History of Visual Communication.* Teufen AR, Switzerland: Arthur Niggli Ltd., 1971.

Mumford, Lewis. "The Sky Line: Bauhaus—Two Restaurants and a Theatre." *The New Yorker* (31 December 1938): 40–42.

Nardin, Warren, and Radoczy, Albert. "Para-sol for the Next World's Fair." *Interiors* 108 (January 1949): 116–20.

Nelson, George, ed. *Display.* New York: Whitney, 1953.

Nelson, Roy Paul. *Publication Design.* 2nd ed. Dubuque, Iowa: William C. Brown, 1978.

Neumann, Eckhard. *Functional Graphic Design in the 20s.* New York: Reinhold, 1967.

_____. "Herbert Bayer's Photographic Experiments." *Typographica* (London) (June 1965): 34–44.

_____. "Typografie, Grafik und Werbung am Bauhaus/Typography, Graphic Design and Advertising at the Bauhaus/Art typographique, graphique et publicitaire du 'Bauhaus.' " *Neue Graphik/New Graphic Design/Graphisme Actuel* (Zurich) 17/18 (1965): 29–54.

_____, ed. *Bauhaus and Bauhaus People.* New York: Van Nostrand and Reinhold, 1970.

Newhall, Beaumont and Rice, Leland. *herbert bayer: photographic works.* Los Angeles: Atlantic Richfield Company, 1977.

"New Scene-Stealer: The Alcoa Kaleidoscreen." *Forecast.* Pittsburgh, Penna.: Aluminum Company of America, n.d.

Niece, Robert Clemens. *Art in Commerce and Industry.* Dubuque, Iowa: W. C. Brown, 1968.

"Packaging Offices." *Architectural Forum* 88 (February 1948): 65–73.

Painters of the Bauhaus. London: Marlborough Gallery, 1962.

Pearlman, Judith. "Revisiting the Bauhaus." *The New York Times Magazine* (14 August 1983): 22–25, 50–55, 57.

Perkin, Robert L. "Herbert Bayer Changing the Town's Face." *Rocky Mountain News,* Denver, Colorado, Tuesday, 27 September 1955: 3.

Peter, John. "Heritage of the Bauhaus: A Conversation with Walter Gropius." *Print* 18 (May–June 1964): 8–15 and 114.

Phillips, Christopher. "Steichen's 'Road to Victory.'" *Exposure* 18 (1980): 38–48.

Pick, Beverley. *Display Presentation, Exhibitions, Window and Outdoor Displays.* London: Crosby Lockwood and Son, 1957.

Pollock, Duncan. "Herbert Bayer: A Lion of Art." *Rocky Mountain News.* Denver, Colorado, Beaux Arts Section, 11 November 1973: 1 and 8.

Prampolini, Ida Rodríguez. "herbert bayer." In *herbert bayer neue werke und projekte.* German translation from the Spanish by Anna Revay. Zurich: Marlborough Galerie AG, March–April 1974.

_____. *herbert bayer, un concepto total.* Mexico City, Mexico: Instituto de Investigaciones Estéticas, University of Mexico, 1975.

Pulos, Arthur J. *American Design Ethic, A History of Industrial Design to 1940.* Cambridge, Mass.: MIT, 1983.

Rand, Paul. *Thoughts on Design.* New York: Wittenborn, Schultz, 1947.

Read, Herbert. Introduction. *The Practice of Design.* London: Lund Humphries, 1946.

"Rebirth of a Boom-Town Opera House." *Architectural Forum* 115 (July 1961): 119.

Rice, Leland. "Herbert Bayer and Photography." *Exposure* 15 (1977): 32–35.

Righyni, S. L. "The Work of Herbert Bayer." *Art and Industry* (London) 22 (May 1937): 205–09.

"Road to Victory." *The Bulletin of the Museum of Modern Art* (New York) 9 (June 1942).

Roh, Franz. "Die Zwischenposition von Herbert Bayer." *Die Kunst* (May 1956): 290–93.

Roters, Eberhard. *Painters of the Bauhaus.* New York: Praeger, 1969.

Rouve, Pierre. "Discovery of Lissitzky." *Art and Artists* 6 (October 1966): 20–23.

Ruder, Emil. *Typography, A Manual of Design* New York: Visual Communication Books, Hastings House, 1981.

Rudofsky, Bernard. "Notes on Exhibition Design." *Interiors* 106 (1947): 60–77.

Rush, David. "Herbert Bayer's Multifaceted Creativity." *Artweek* (Oakland, Cal.) 8 (21 May 1977): 1, 11.

Sandburg, Carl. "Road to Victory." In *Home Front Memo.* New York: Harcourt, Brace, 1943.

Schärer-Wynne, M. J. *Basic Typography.* Translated by Ruedi Rüegg and Godi Frölich. Zurich: ABC Edition, 1972.

Schonberg, Harold C. "Sculpture on Road in Mexico Fuels Debate, 19 Works Line Route to Olympic Village." *New York Times,* 14 November 1968.

Schutte, Thomas F., ed. *The Uneasy Coalition, Design in Corporate America.* Philadelphia: University of Pennsylvania Press, 1975.

Scigliano, Eric. "Earthworks, the New Land Battle." *Argus* 87 (20 June 1980): 1.

"Sculptured Garden by Herbert Bayer." *Arts and Architecture* (Los Angeles) 82 (August 1965): 21.

"A Second House Becomes the One-and-Only." *House Beautiful* 108 (February 1966): 116–19.

Seitlin, Percy. "Herbert Bayer." *PM Magazine* (1939): 1, 26, 32.

_____. "Herbert Bayer's Design Class, Sponsored by the American Advertising Guild." *A-D* 7 (June–July 1941): 18–32.

"Silver Built Aspen, then Nearly Ruined It." *Denver Post,* Contemporary Section, 16 January 1983: 16, 18.

Sinisi, J. Sebastian. "Aspen Looks to Its Future and Holds onto Its Past." *Denver Post,* Contemporary Section, 16 January 1983: 10–12, 19, 32.

Snyder, Gertrude. "Pro File: Herbert Bayer." *Upper and Lower Case.* New York: International Typeface Corporation, December 1977.

Spencer, Herbert. *Pioneers of Modern Typography.* New York: Visual Communication Books, Hastings House, 1970.

_____. *The Visible Word.* Rev. 2nd ed. New York: Visual Communication Books, Hastings House, 1969.

Stahly, François. "Aspen, An American Culture Center." *L'Oeil* 74 (February 1961): 52–59.

_____. "9 Triennale; A New Style of Three-Dimensional Exhibition Design." *Graphis* 7 (1951): 458–61, 471.

Tarzan, Deloris. "Kent Finds Earthwork is Good Economics." *Seattle Times,* 2 September 1982, Section D, p. 1.

A Tribute to Herbert Bayer (A.K.A. *Bayer Tribute*). Unpublished transcript of multimedia presentation. Originated by Jack Roberts, directed by Louis Danziger, produced by Tom Woodward, International Design Conference, Aspen, Colorado, 10 May 1979.

Tschichold, Jan. *Asymmetric Typography.* (Translation by Ruari McLean of 1935 *Typographische Gestaltung,* Basel). New York: Reinhold, in cooperation with Cooper and Beatty Ltd., Toronto, 1967.

_____. *Die neue Typographie. Ein Handbuch für zeitgemäß Schaffende.* Berlin, 1928.

_____. *Treasury of Alphabets and Lettering.* New York: Reinhold, 1966.

van der Marck, Jan. "exercise in polarities, the paintings and sculpture of herbert bayer." Introduction to *herbert bayer, recent works.* New York: Marlborough Gallery, January–February 1971.

_____. *herbert bayer: from type to landscape.* Hanover, New Hampshire: Trustees of Dartmouth College, 1977.

Vanderlip, Dianne and Chambers, Marlene, with the cooperation of Gwen Chanzit. *herbert bayer, sixty years of painting*. Denver, Colorado: Denver Art Museum, 1982.

Warford, H. S. *Design for Print Production*. New York: Visual Communication Books, Hastings House, 1971.

Washburn, Gordon B. "Structure and Continuity in Exhibition Design." In *The Nature and Art of Motion*. Edited by Gyorgy Kepes. New York: Braziller, 1965.

Wescher, Herta. *Collage*. translated by Robert E. Wolf. New York: Abrams, 1968.

Wenger, Lesley. "Art, like Religion, Only Works If You Believe in It." *Curránt* 1 (February–March–April 1976): 22–29 and 46.

Westheim. "Herbert Bayer. Photograph und Maler." *Das Kunstblatt* (Berlin) (1929): 151–53.

Wills, F. H. *Fundamentals of Layout*. New York: Dover, 1971.

Wilson, Kenneth M. "A Philosophy of Museum Exhibition." *Museum News* 46 (October 1967): 13–19.

Wingler, Hans M. *Bauhaus in America*. Berlin: Bauhaus-Archiv, 1972.

_____. *The Bauhaus. Weimar, Dessau, Berlin, Chicago*. Cambridge, Mass. MIT, 1969.

_____. Foreword, with Introduction by Peter Hahn. *herbert bayer das druckgrafische werk bis 1971*. Berlin: Bauhaus-Archiv, 1974.

Wollheim, Peter. "Herbert Bayer. A Modernist Drama." *Vanguard* 9 (Vancouver, B.C., May 1980): 17–19.

Additions to Bibliography for the 2005 Edition

Books

Chanzit, Gwen F. *The Herbert Bayer Collection and Archive at the Denver Art Museum*. Denver, Colorado: Denver Art Museum, 1988.

Sobel, Dean. *One Hour Ahead: The Avant-Garde in Aspen, 1945-2004*. Aspen, Colorado: Aspen Art Museum, 2004.

Widder, Bernhard. *Herbert Bayer, Architektur, Skulptur, Landschaftsgestaltung*. Vienna and New York: Springer, 2000.

Articles and Museum Brochures

Anderson, Hugo. "Remembering Herbert Bayer." *Colorado Modern*, 1 (November 2003): 16, 18–19.

Chanzit, Gwen F. *Herbert Bayer and Aspen*. Aspen, Colorado: Aspen Institute for Humanistic Studies, 1999.

_____. "Herbert Bayer: Artistic Force Behind the Aspen Institute." *Aspen Magazine* Special Edition in Conjunction with the Aspen Institute for Humanistic Studies' Fiftieth Anniversary (June 2000): 50–59.

_____. "Herbert Bayer Returns." *Aspen Magazine*, 26 (December 1999): 58.

_____. *Herbert Bayer: The Aspen Years*. Denver, Colorado: Denver Art Museum, 1990.

_____. *Herbert Bayer: The Bauhaus and Pre-Bauhaus Years*. Denver, Colorado: Denver Art Museum, 1992.

_____. *Herbert Bayer: The Berlin and New York Years*. Denver, Colorado: Denver Art Museum, 1991.

_____. *Herbert Bayer: The California Years*. Denver, Colorado: Denver Art Museum, 1990.

_____. "Herbert Bayer's Aspen." *Aspen Music Festival Fiftieth Anniversary Season* (June 1999): 40–43.

Cuomo, David. "Bringing Bauhaus to Colorado." *Colorado Modern*, 1 (November 2003): 17.

Index